Ape to Apollo

Ape to Apollo

Aesthetics and the Idea of Race in the 18th Century

DAVID BINDMAN

CORNELL UNIVERSITY PRESS

ITHACA, NEW YORK

For Frances – an anniversary present

First published in the United States of America in 2002
by Cornell University Press

Originally published in the United Kingdom in 2002 by
Reaktion Books Ltd
79 Farringdon Road
London EC1M 3JU

First published 2002

Copyright © David Bindman 2002

ISBN 0-8014-4085-8

Printed and bound in Great Britain by
Biddles Limited, Guildford and King's Lynn

Librarians: Library of Congress Cataloging-in-Publication Data
are available

Contents

Preface

The idea for this book emerged from an abortive project, with colleagues from the History of Art Department at University College London, to produce the eighteenth-century volume of 'The Image of the Black in Western Art' series for the Menil Foundation. In the end it was not published, but the work on it fired an interest in the visual representation of non-Europeans. It also raised doubts about the intellectual basis for isolating in the context of the eighteenth century one 'race' from wider attitudes to non-Europeans in general, and indeed the word itself from other apparent synonyms. At the same time it was clear to me as an art historian that attitudes towards non-European peoples were almost always linked to some notion of physical beauty, or the capacity of an observer for aesthetic response. So this book is concerned not with the visual representation but with the idea of race as an aspect of human variety, and its relationship to aesthetic ideas in the Enlightenment.

The question of race even in distant ages can still arouse understandable feelings of guilt and recrimination. We are all too aware of the appalling consequences that followed from theories of human difference, and we can still be embarrassed by views held by people we might otherwise admire, like David Hume and Immanuel Kant. Nonetheless I have taken the view that I should not labour the obvious by indulging in retrospective moral judgements, but maintain a dispassionate tone in the book. Therefore I have avoided the tendency to jeer when blatantly prejudiced figures like Edward Long and Christoph Meiners make an appearance, or applaud the more sympathetic Georg Forster and G. C. Lichtenberg, though it must be said that no one in the eighteenth century is completely free from assumptions that would

rightly be offensive to present opinion. Though many of the arguments discussed are unpleasant to contemplate, I hope that the book will offer in compensation a sense of the fragile and unstable nature of the concept of race in the period of its emergence, and indeed in any period.

The book is intended to be suggestive rather than comprehensive, so I have concentrated on a small number of interlinked texts. These are mainly British and German, because of the continuities between British writings on aesthetics and human variety in the first half of the century, and German writings in the second half, culminating in Blumenbach and Kant, though, of course, I look also at the work of the Frenchman Buffon and the Dutchman Camper in some detail. I have chosen these writers because it is possible to place them in a kind of conversation with each other, over the course of the century. The works of the Earl of Shaftesbury, Addison and Hume, for instance, were well known to Herder and Kant, who, of course, read each other, and whose works were in varying degrees familiar to Georg Forster, Blumenbach and Camper at the end of the century. Winckelmann and Lavater were familiar in Germany and in England. In chronological terms, the volume pivots around the year 1775, when important works by Kant, Blumenbach and Lavater were published. The year is also a key moment in the European reception of the South Sea voyages of Bougainville and Cook.

The book crosses over a number of academic fields that were unfamiliar to me when I began, so I have incurred debts to scholars in other subjects as well as in my own. Among those who read the book in manuscript, or made extremely helpful suggestions, or saved me from egregious errors are Malcolm Baker, Frances Carey, Charles Ford, Jos Hackforth-Jones, Angela Rosenthal and, especially, Steven Lukes. I also want to thank the anonymous readers for Reaktion Books, who were both critically astute and encouraging. I have benefited from conversations on the subject with, among many others, Raph Bernstein, Geoffrey Bindman, Werner Busch, Karen Dalton, Tom Gretton, Nick Grindle, Andrew Harrison, Andrew Hemingway, Tamar Garb, Ludmilla Jordanova, Timothy McFarland, Andrea Meyer-Ludowisy, Alex Potts and Helen Weston. Katharina Krosny translated articles by

Kant and Georg Forster for me. In some cases I have used early translations where they exist and are satisfactory, or I have made my own with advice, in most cases, from native German speakers.

The Deutsche Academische Austauschdienst gave me a grant for a month's study at the wonderful library at Wolfenbüttel, where I owe a particular debt to Dr Jill Bepler. I also had a month's fellowship at the Yale Center for British Art, New Haven, where I enjoyed conversations with many friends there, including Patrick McCaughey, Elizabeth Fairman and Gillian Forrester. The Wellcome Institute gave me space towards the end of the writing, and support for many of the photographs. I am particularly grateful to William Schupbach for his assistance. I would also like to thank Dr Brian Allen and the Paul Mellon Centre for Studies in British Art in London, who made it possible for the volume to contain colour plates.

The biggest debt of all has been to my colleagues in the History of Art Department at UCL, who have been immensely supportive and understanding, and have created an atmosphere of intellectual exchange and comradeship that represents the best of academic life. My warmest thanks are due to them.

Human Variety, Race and Aesthetics

This book is about ideas of human variety in the eighteenth century and their relationship to ideas of beauty. Race was seen then essentially as a new category of human variety, and it is argued that aesthetics played an important part in its emergence in the last quarter of the century. My account offers a kind of explanation for the emergence of that particular conjunction of science and ideas of race that became known in the nineteenth century as 'racial science', but I have tried, as far as I can, not to read back later attitudes into the eighteenth century. As Michel Foucault pointed out, the whole academic–disciplinary context was then quite different: 'neither literature, nor politics, nor philosophy and the sciences articulated the field of discourse, in the seventeenth or eighteenth century, as they did in the nineteenth century'.[1]

Broadly speaking, the idea of race as a categorical division, in Hippolyte-Adolphe Taine's words, a 'community of blood and intellect which . . . binds its offshoots together',[2] is a nineteenth-century one. This is not to deny the existence in previous centuries of ingrained prejudice nor the casual employment of demeaning stereotypes of non-Europeans, even among pillars of the Enlightenment such as Hume and Kant. European attitudes towards non-Europeans had long before then been subject to what Peter Hulme calls 'stereotypical dualism'.[3] The latter were perceived by turns, as either murderously savage or peaceful and submissive, and capable of moving from one to the other. Until the later-eighteenth-century campaigns against the slave trade, it was commonplace for educated Europeans to believe that Africans were fitted by 'nature' for enslavement,[4] and that American 'Indians' were by contrast untamable. On the other hand the 'naturalness' of such peoples could be used as a trope to satirize the affectation and

insincerity of the over-sophisticated elite of the great European cities. Some peoples, like the Chinese, were, despite their reputation for despotism, given a special status by *philosophes* for their ancient wisdom and immunity from superstition, and Indians were thought by Voltaire and others to be the founders of civilization.[5] By the 1770s and 1780s, with the success of the anti-slavery campaigns, overt expressions of prejudice against Africans seem to have become less acceptable in enlightened society. But the same decades also saw the first methodical attempts at the taxonomic classification of the different varieties of humanity. It may come as a surprise to discover that the founding fathers of comparative racial taxonomy, Johann Friedrich Blumenbach and Pieter Camper, were fervently opposed to slavery, and challenged many of the arguments for European superiority over the rest of humanity. They, at least, in no way resemble that dismal creature the 'race scientist', resident in the nineteenth century in many academic institutions in Europe and America, measuring skulls (though both Blumenbach and Camper did that), weighing brains, and brooding on ways of improving the 'racial stock' by methods akin to Swift's *Modest Proposal*,[6] but without any satirical intent.

Aesthetics played a number of different roles in this process, most obviously because judgements of the beauty or ugliness of individuals could be applied to whole peoples. It was a commonplace of eighteenth-century writing on human variety that the most beautiful peoples on earth were to be found within the Ottoman Empire or further east, and the ugliest in the farthest north of Europe. Aesthetic judgements could thus become categorical distinctions, taking on scientific authority and the glamour of travel to exotic places. It was, furthermore, a widespread though not unchallenged assumption among the elite, that the exterior beauty or ugliness of a person could reflect their interior moral being, their 'soul', and this again could be generalized from the individual to the nation or 'race'. The ability to make aesthetic judgements could in itself be a way of dividing the 'civilized' from the 'savage'. For philosophers, aesthetics could be way of finding a proper balance between reason and instinct, a happy condition that was by definition easier for 'civilized' peoples to attain than others.

It may be objected that some features of modern racism predate the Enlightenment, and already existed in the sixteenth and seventeenth centuries, but I would argue that cultural prejudice in the sense of believing, say, that certain non-European peoples are untrustworthy, is not the same as racism, which must have as a foundation a theory of race to justify the exercise of prejudice. As Peter Fryer put it: 'Racism is to race prejudice as dogma is to superstition. Race prejudice is relatively scrappy and self-contradictory . . . Racism is relatively systematic and internally consistent . . . transmitted largely through the printed word.'[7] It has been argued by David Brion Davis that the sixteenth-century Spanish concern with purity of blood was a form of racism,[8] and Hugh MacDougall has claimed that the Anglo-Saxonism of English political thinkers in the seventeenth century often became racist in its claims of descent from Germanic peoples, who had 'preserv[ed] their blood, lawes and language incorrupted'.[9] Certainly the Anglo-Saxon myth relies upon an idea of the ancient Germans as a people of fierce independence who did not intermingle with others, thus preserving the purity of their blood. But this is perhaps best understood as biological nationalism rather than racism, as indeed was much that passed for racial theory in the nineteenth and twentieth centuries.

Enlightenment ideas of race, as opposed to human variety, were, I will argue, dependent on theories of humanity *in toto* and its origins; each race was a portion of the world's population, usually inhabiting one of the four or five continents that were supposed to make up the world, on the understanding that there were as many races as there were continents. Hence towards the late eighteenth century it became possible to talk of European, African, American or Asiatic races, each of which might include ever-shifting mixtures of peoples, but not to use such familiar nineteenth-century constructs as the 'Anglo-Saxon race' or the 'Jewish race'. Even so, eighteenth-century ideas of race were not static or consistent, but were fought over intensely. 'Europe' itself has always been fluid both as concept and geographical entity, and, as Christopher Miller noted, 'It was relatively recently that "Africa" came to be the sole representative of a single continent, differentiated and circumscribed.'[10]

Writers on modern ideas of race have often, and with some justification, sought the genesis of the Holocaust, mass enslavement of Africans and colonial exploitation in the eighteenth century. The Frankfurt School writers Max Horkheimer and Theodor Adorno, in *Dialectic of the Enlightenment*, written in 1944,[11] argued with the hindsight given by the rise of Fascism and its consequences that the Enlightenment had, in its disdain for myth, made science and technology objects controlled by the bourgeoisie, and in its hands forces for dehumanization: 'For the Enlightenment, whatever does not conform to the rule of computation and utility is suspect.'[12] Racism for the authors – and they were thinking primarily of anti-Semitism – emerges in the transformation of the Enlightenment idea of productive harmony in society into an idea of a productive national harmony.

George Mosse's classic book, *Toward the Final Solution: A History of European Racism*,[13] also looks to the Enlightenment for the origin of modern racism. It is important for the present work because Mosse makes a strong claim for the role of aesthetic ideas. He remarks that the 'continuous transition from science to aesthetics is a cardinal feature of modern racism [one might also add vice-versa]. Human nature came to be defined in aesthetic terms, with significant stress on the outward physical signs of inner rationality and harmony.'[14] Mosse reminds us of the use by Pieter Camper of an ideal Greek head as a standard of European beauty (see illus. 51,[15] an idea that, as will be discussed later, achieves a kind of apotheosis in Leni Riefenstahl's visual comparison between living German athletes at the 1936 Olympic Games and ancient Greek sculptures (see illus. 57).[16] Lorna Schiebinger has more recently noted the perceived importance of female beauty in shaping racial features through selective breeding, and in establishing the idea of the Caucasus, supposedly the home of the most beautiful women, as the cradle of humanity.[17]

The eighteenth century has also been seen as the originating period of a different kind of racism, one based on the inheritance of slavery and on skin colour, this time focused more on the slave trading and owning countries, Britain, France and the United States, rather than Germany, which had relatively little involvement with slavery. This is

the case, for instance, with Winthrop Jordan's classic book *White over Black: American Attitudes Towards the Negro, 1550–1812*, which looks more broadly at ideas of race than its title suggests. Roxann Wheeler, in *The Complexion of Race*,[18] has recently pointed out that this Anglo-American perspective on race can restrict scholarly enquiry to a system of binary oppositions: black and white, slave owner and slave, and so on. As a result the complexity of meanings around the power relationships become oversimplified, for 'whiteness' and 'blackness' of skin were only aspects of difference, and not always the most significant ones.

Martin Bernal's *Black Athena*, first published in 1987, has much to say on the relationship between aesthetic and racial ideas in the late eighteenth century, though his concern is with the modern appropriation of classical antiquity to support a racist teleology. His broad argument is an important touchstone for the present work, for he raises in a stark form many of the issues raised here. His argument can be summarized as follows: there are essentially two models of Greek history: the Aryan model and the Ancient model. The Aryan model sees Greece as essentially European, the Ancient one as Levantine. The Ancient model supposes that Greek culture arose from the colonization of Greece by the Egyptians and Phoenicians, so Greek culture belongs culturally to Africa rather than to Europe. The Aryan model, still the dominant interpretation of Greek history and achievement, is a more recent invention, developed only in the nineteenth century. It creates a clear difference between the Greeks and those peoples who derive from the African continent, making, against all the evidence, the Greeks into an Indo-European people rather than an African one. The racial implications are obvious (so Bernal claims); the Aryan model allows for a unified European race of superior accomplishment, linguistically and culturally separate from an Africa that brought forth blacks, Egyptians and Jews. Bernal further argues that though the Aryan model is essentially nineteenth-century in its full form, it is clearly prefigured in the Enlightenment, particularly in the work of Johann Joachim Winckelmann, who, he claims, was fully implicated in the implicit racism of elevating the Greeks at the expense of other Mediterranean peoples. This brought aesthetics into the service of race by denigrating the

Egyptians as ugly and lacking the ability to have great thoughts. I will take a different view of Winckelmann later in the book.

Other recent books have also taken up issues of race and aesthetics. Sander Gilman, in a 1975 article,[19] first raised the issue of the relationship between blackness of skin and eighteenth-century aesthetics, and this was taken further in *On Blackness without Blacks*,[20] which has an important chapter on 'The Image of the Black in the Aesthetic Theory of the Eighteenth Century'. Gilman draws out the way in which theories of the 'Ugly' were formed and applied to human types, especially Africans, in a dialogue between Moses Mendelssohn and Gottfried Ephraim Lessing.[21] This dialogue was not the first to position the physiognomy of blacks in opposition to European standards of beauty, but it brought the supposed feelings of disgust at the appearance of other peoples into the framework of aesthetic theory. Gilman also looks at the relativism of aesthetic perceptions of non-Europeans in Herder's writings and its denial by Kant, a question taken up in later sections of this book. Alex Potts in *Flesh and the Ideal: Winckelmann and the Origins of Art History* indicates the complexity of the relationship between aesthetic ideas and eighteenth-century notions of human variety, emphasizing the differences between Enlightenment Hellenism and its later, more 'racialized', versions.[22]

What then did the word 'race' mean in the eighteenth century? It was first given a precise definition as a universal concept by Immanuel Kant in an essay of 1775,[23] but his definition, though evidently known to others thinking about the subject, did not become widely accepted even by the end of the century. 'Race' in the eighteenth century was but one category of 'human variety', but confusingly 'varieties' and 'nations' (in Latin, *gens* or *gentes*, plural) were often used when 'race' appears to have been meant, and 'race' was sometimes used when it clearly was not. In other situations 'race' alternates unsystematically between 'nation' and '[human] variety'. The word 'race' (spelled either 'Rasse' or 'Race' in German, but the same way in French and English) before the eighteenth century tended to be associated with family or dynasty rather than a larger community, as Georg Forster noted in a contemporary challenge to Kant's definition.[24] This meaning remained current in

the eighteenth century, though it could be used to suggest a *people* united by family or dynasty.[25]

François Bernier (1625–88) writing in 1684 was the first to divide the world into four 'espèces ou races',[26] but the foundation moment of the modern idea of race, though not of the word itself, is usually seen to be the publication of Linnaeus' *Systema Naturae* in 1735. The great biologist extended his classification of plants and animals to incorporate mankind into the animal creation,[27] admittedly in a summary fashion. Following Aristotle, he claimed that as man was both animal and human, his animal or physical aspects could be brought into a taxonomy comparable to those he had applied to animals and plants. Man thus can have its own natural history, becoming the genus of *Homo sapiens*, united by the ability to mate with all other kinds of humanity. In a later edition of *Systema Naturae* (1758) Linnaeus offered a classification of humanity based on the Four Continents or Four Quarters of the Earth, and the Four Temperaments associated with each. The epithet 'sapiens' was attached only to the white European (*sapiens europaeus albus*), and he added a number of other categories, including the Wild Man and various forms of monster.[28] The fourfold division was compatible with the idea of a lost primeval unity, the Judaeo-Christian Garden of Eden, when the earth was populated by one people descended from one original couple, dispersed at the Fall. At one level Linnaeus' division of humanity can be seen as a challenge to classical theories of humanity based on the idea of the Great Chain of Being, or Chain of Nature (illus. 1), from the lowest forms of life to man as the highest.[29] Linnaeus' division was itself challenged by the gradualist and hierarchical view of the Comte de Buffon, who, though he accepted the idea of broad divisions of humanity, saw human variety as on a scale from savagery to civilization, contingent on climate and environment. Neither Linnaeus nor Buffon brought together the divisions of humanity with a consistent use of the word 'race'.

If enquiry into the varied nature of humanity became, as the century progressed, increasingly the province of the university rather than the philosophical amateur, the same was true of aesthetics. Its foundation moment as a separate subject of enquiry was the publication

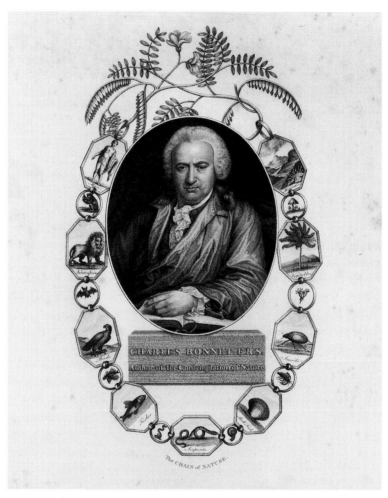

1 James Caldwall, *Charles Bonnet, framed by the Great Chain of Being or Chain of Nature*, 1802, engraving after an anonymous artist.

(in Latin) of Alexander Gottlieb Baumgarten's treatise *Aesthetica* in 1751, in which he defined aesthetics as the 'scientia cognitionis sensiti-vae' or 'science of sensual understanding'.[30] This is considerably wider than any modern understanding, which would assume aesthetics to be broadly about ideas of beauty applied to works of art or to nature. In the eighteenth century the term could be used, as Terry Eagleton has pointed out, to include 'the whole region of human perception and sensation, in contrast to the more rarified domain of conceptual thought'.[31] In other words the science of aesthetics was conceived of as a way of ordering and codifying the 'lower' mental processes in man that were not and could not be governed by reason. Baumgarten applied aesthetics to the understanding of works of literature, but later in the century it became more attached to the visual arts. Until Kant's later writings on the subject, it was always assumed to embody funda-mental issues of morality and human feelings.

All philosophers of the period were engaged with aesthetics in one way or another. Herder gave it a central place in his philosophy for the first two decades of his career, as did Kant in his mature work. There were also other ways of thinking about aesthetics that were no less important. A recent introductory anthology of essays on aesthetics gives no place at all to what was in the eighteenth century a central area of concern: the aesthetics of the human body.[32] The idea of the contempla-tion of the body as a purely aesthetic object lost credibility long before Freud in the face of awareness of the unavoidability of sexual desire in judgements of human beauty. In the eighteenth century, while the issues of sex and aesthetic perception were related in the sense that beauty was linked to the desire for procreation, the study of the human body was at the heart of artistic practice, and its representation the touchstone of academic achievement. Notions of what was beautiful and what was not were embedded in descriptions of the appearance of human beings, and in aesthetic treatises the appearance of real human beauty was often conflated with its representation, as if the artist simply reproduced the body before him. The beauty of a woman or man was generally assumed in the eighteenth century to be self-evident and incontrovertible, though it was often understood to vary in different cultures. Travellers usually

applied without qualification the word 'beautiful' or 'ugly' to a people they encountered, as did 'philosophical' writers like Buffon and Johann Reinhold Forster. Human beauty in this context was assumed to be a biological means of creating mutual attraction leading to procreation and the continuation of the species of humanity.

The recognition of beauty or ugliness in others might also imply an assessment of their relative civility. If the beautiful, whether in human beings, nature or objects, was assumed by philosophers to be morally good, and the ugly or deformed to be bad, then an aesthetic response could validate the moral elevation or denunciation of others. If such a judgement could be applied generally, to peoples, 'nations' and 'races', then the connection could be made explicit between characteristic appearance and moral expectations. Travellers' judgements of 'beautiful' or 'ugly' peoples were also often reinforced in physical images, in engravings and sometimes paintings, which provided a generally accessible pool of stereotypes, allegories and personifications. Of course, images of different 'races' were well established before the eighteenth century; the idea of a generic 'African' physiognomy might well have existed in visual form before its assumed characteristics were expressed in words.

Johann Caspar Lavater's claim in the 1770s to have proved scientifically the connection between physiognomy and soul, made the issue one of European-wide debate, with enormous consequences for concepts of human variety. There were essentially two arguments that could be made against such a connection, aside from a rejection of the very idea of the human soul. The first was that beauty is a lesser attribute of the physiognomy or the body, associated not with the masculine rigour of moral decision, but with the 'feminine' desire to please. This may be called the 'Sublime' argument, for it enabled moral heroism to be attributed to the defiant and virile hero, unrestrained by female graces. The second was the time-honoured one that beauty could deceive and be a veil for self-interest and moral turpitude, female beauty being the most dangerous trap for the male.

The emergence of racial science in the early nineteenth century is conventionally seen as the triumph of Enlightenment classification and

codification, but there is a less often told story of awareness of and resistance to the limitations of taxonomy. Herder, for instance, perceived the possible dangers of racial theory even without the privilege of hindsight. Furthermore, Kant argued forcefully and influentially that aesthetics was not tied to such material issues as those of human beauty. In *The Critique of Judgement* (1790) he argued for the separation of aesthetic judgement from other forms of judgement, embodying it in the disinterested perception of nature and works of art. Race appears, then, to play no part in his mature or 'Critical' theory of aesthetics, though it is argued later they are not wholly unconnected.[33] The relationship of aesthetics and race in the eighteenth century, therefore, cannot be seen in terms of a simple teleology, and this book is written in the hope of disentangling, or at least reframing, some of the seeming paradoxes.

Human Variety Before Race

Aesthetics, in both the broad sense of being about the non-rational aspects of the mind and in the narrower sense of being about beauty, had a vigorous and contentious life in Europe, especially in Britain, long before it was given definition by Baumgarten in 1751. In the first half of the century, and often later, matters of beauty and human variety were discussed primarily by philosophically minded generalists: 'Virtuosi' or Natural Philosophers in Britain, 'Philosophes' in France and 'Gelehrten' in the German lands. They were concerned with the deepest matters of human existence, unconfined by boundaries between academic disciplines. Hence pronouncements on both human variety and aesthetics were often made by the same people, not infrequently within the same discourse. The later part of the century, however, saw the triumph of academics in all fields to do with the history and interpretation of man; increasingly a distinction was made between amateur and professional.

Aesthetics and human variety as subjects of study followed ultimately from John Locke's enquiries into the human mind. They are both aspects of 'natural philosophy', the belief that the human mind was as knowable as the human body through 'unprejudiced Experience, and Observation' and the exercise of logic.[1] If aesthetics, even before the word was coined, became a way of enquiring into mankind's non-rational perceptions or feelings, then anthropology, again *avant la lettre*, became the study of the way that human beings came to differ from each other according to their environment or their means of subsistence, on the almost universal understanding that mankind was originally a single people. Of course there was resistance to Locke in England, and especially in Germany, on theological grounds, and in

France on grounds of Cartesian rationality. But empirical method, and the idea of man as an historical being, broadly prevailed in France and England. Aesthetics came to the fore as human behaviour came under philosophical scrutiny, and anthropology when theological objections to studying the history of man in secular terms could be overcome. If aesthetic response could be assumed to vary from person to person, and from one human group to another, then it made sense to enquire into the ways in which the aesthetic as well as other responses might be contingent on environment or other factors.

The primary division of the world inherited by early eighteenth-century Europe, the Four Continents of Europe, Africa, America and Asia, accounted for the whole of mankind within a single spatial frame. Everyone alive or who had ever lived could be given a physical and cultural locus in relation to the rest of humanity. The idea of 'nation' or people, on the other hand, had no set limits. Travellers could and did identify ever more peoples, and were able to observe differences from and similarities to others, sometimes across the already fluid boundaries of the traditional continents.

The Four Continents go back to the classical tripartite division of the world into Europe, Asia and Africa, to which America was added in the sixteenth century.[2] The identification of Europe with Christendom was made at least as early as the fifteenth century, and by 1700 the word 'Europe' was virtually synonymous with, and the preferred term to, 'Christendom'.[3] Europe was identified in Montesquieu's *Lettres Persanes* of 1721 as a place of frenetic activity and desire for enrichment, a puzzle to the visiting 'Persians', who were used to a static society and leisurely way of life.[4] The idea of Europe as synonymous with Christendom was effectively, if incompletely, replaced in the eighteenth century by the claim of European moral and intellectual superiority over non-Europeans. In *Le siècle de Louis XIV* (1751) Voltaire argued that the strength of Europe in its political diversity was based ultimately on common principles, and added the idea of cultural superiority, the 'republique litteraire', the scientific and artistic community created by the internationalism within Europe of academies and universities.[5] In 1756, in *Essai sur les moeurs et l'esprit des nations*, Voltaire argued that

Europe was now richer and more civilized than any other continent, even though civilization had originated in East, only being taken up in Europe at the end of the Middle Ages.[6] Voltaire heralded a period from the 1750s to the 1770s when the identification of Europe with civilization became associated with progress, and the traditional line between civilization and barbarism was drawn between Europe and the rest of the world. For the *philosophes*, Europe could represent not only civilization but harmony in diversity through the balance of power; freedom as opposed to the despotism of Asia or the slavery of Africa; and energetic activity versus passivity.

The association of Europe with liberty had an ancient precedent in the distinction made between the Greeks and the despotic Persians, but, despite the growing assumption towards the end of the century and beyond that ancient Greece at its height represented Europe's Golden Age, the Greeks had not necessarily thought of themselves as European at all. Aristotle saw the Greeks as a kind of buffer between Europe, represented by warlike Macedonia, and Asia and having the virtues of each; they were courageous like Europeans who lived in a cold climate, and skilled and intelligent as Asians, who lacked courage.[7] The Greeks then were free themselves but capable of ruling others. From as early as *circa* 400 BC, Hippocrates, who was frequently invoked in the eighteenth century, had claimed that climate had been a factor in determining the character of inhabitants of each continent; the volatile climate of Europe made its inhabitants active and warlike while the hot climate of Asia created lassitude and despotism.

If Europe became increasingly stable as a concept in the eighteenth century, it remained far from stable as a geographical entity. The only agreed border was the Mediterranean; beyond that the limits were vague. There was a sense also that the peoples beyond the eastern border of the Holy Roman Empire – the Circassians and others – were of exceptional contentment and beauty, as were those in parts of India; the presumption of their aesthetic superiority played a part in their incorporation into what was in the nineteenth century to become the 'Aryan' race. Furthermore 'Europe' had to co-exist with an increasing awareness, derived from exploration and trade, that peoples of differ-

ent nations within each continent also had a specific character. Even so, there is a tendency in much of the anthropological writing of the period to think of Europe as made up of an infinite number of peoples, and Africa of only one or two.

What constituted a 'nation' could be maddeningly imprecise throughout the eighteenth century. Hume noted that 'The vulgar are apt to carry all national characters to extremes', but 'Men of sense . . . allow, that each nation has a peculiar set of manners, and that some particular qualities are more frequently to be met with among one people than among their neighbours.'[8] While it was well understood that England (usually encompassing the whole of Britain), France and Germany (in the last case in defiance of political reality) were nations, it is not unusual even in the second half of the eighteenth century for the whole of Africa to be referred to as a nation in the same terms.

The Continents had a vigorous presence in public art from the seventeenth century onwards; decorative schemes enthroned Europe as the source of wisdom and truth, or at least as the premier continent of the four. They could be represented as under the dominion of the Holy Ghost in Jesuit or missionary churches, or Apollo in more secular contexts; in Alpers and Baxandall's words, 'the Four Continents below a Heaven ruled by the Sun-God Apollo [was] . . . the ultimate cliché of Baroque iconography'.[9] The respective iconography of the continents had been set down for painters by Cesare Ripa in his *Iconologia,*[10] and his method of providing personified female figures with appropriate attributes remains almost universal not only in wall paintings, frescoes and frontispieces to books (illus. 2), but in popular representations well into the early nineteenth century. Europe's mythical origins might be symbolized by Europa's bull, and her other attributes might be a horse, a temple of religion, emblems of war and of the arts – architecture, painting, sculpture and music.

The developing iconography of Europe and of the other three Continents tended to follow conventional formulae,[11] but Giambattista Tiepolo's *Africa* in the Würzburg Residenz (illus. 3) reveals a rich sense of the geography and economy of Africa in relation to the other continents. Tiepolo used the whole side of the ceiling to create a dense

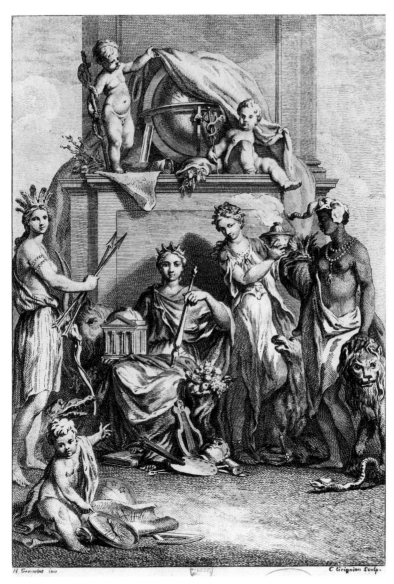

2 Charles Grignion, *The Four Continents*, *c.* 1740, engraving after Hubert Gravelot.

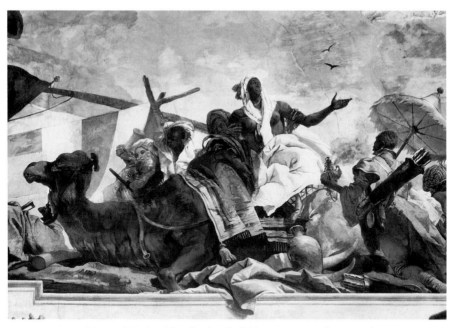

3 Giovanni Battista Tiepolo, detail of *Africa*, *c*. 1751–3, fresco on the staircase ceiling, Residenz, Würzburg.

image of trade and the carriage of goods from the interior of Africa to the Egyptian coast, and thence across the Mediterranean to Europe. The figure of Africa is set among a resting caravan train of Arab traders, and the ultimate destination of their goods is represented by two Europeans buying pearls from an oriental pearl-dealer. The interior and exterior of the geographical Africa are linked by the figure of the River Nile, which, from its mysterious origins, joins the dark heart of Africa and its Mediterranean periphery, where it faces Europe across the water.

CONSTRUCTING THE SAVAGE

If, according to Locke, the mind contained no innate ideas, this could be taken to mean that all human beings were born in a state of mental

equality, hence inequality must have been imposed by circumstances after birth. Locke did allow the mind an innate reasoning capacity that could vary from one person to another, but the idea of the mind as a *tabula rasa* taken literally would have meant that Europeans and non-Europeans were differentiated only by their differing experiences and education, not by inherent differences of ability. The denial of innate ideas could be used to argue against biological differences between peoples, and allow for the possibility that all human beings, whatever their heredity or circumstances, were capable of being educated. On the other hand, it could place just as absolute a gulf between those who were educated and those who were not. As Locke claimed at the beginning of *Thoughts on Education*, 'of all the Men we meet with, Nine Parts of Ten are what they are, Good or Evil, useful or not, by their Education'.[12] By education Locke meant, of course, the European kind, based on logic, observation and mental discipline.

Locke opened up the possibility of a historical and progressive view of man's development based on natural law. Man can be seen to move from a natural free state, in which he lives in a nomadic society, or 'America', to one in which he owns property and lives in a community, graduating to a political society based on financial exchange and obligation. If this was initially conceived as a temporal distinction, placing natural society in the primeval past and the dawn of mankind, it could readily become a spatial one, applying a similar hierarchy to the different peoples of the far-flung contemporary world. Locke's famous remark, in *Two Treatises of Government*, 'Thus in the beginning all the World was America',[13] conflates primeval pre-society with existing forms of life in the wild. Primitive or 'natural' society could still exist, as it did in the America of the native peoples, where natural men and women had neither progressed towards civility nor fallen into 'luxury' like Europeans. Those in the state of nature were free and equal 'within the bounds of the Law of Nature', and this applied to, among others, the 'Indians' of America and the hunter-gatherers of Africa. Those on the other hand who belonged to 'the Civiliz'd part of Mankind', lived in a world where laws govern property but also ensure justice and security.

If the implications of Locke's political theory were 'liberal' in the sense that it relieved the 'natural' man from the taint of paganism, it did not do anything for slaves, to whom, when he mentioned them at all, he denied all rights. They were placed by him in the state of 'Captives taken in a just War, . . . by the Right of Nature subjected to the Absolute Dominion and Arbitrary Power of their Masters'.[14] This is hard to reconcile with Locke's broader philosophy of human rights, but it can be understood as representing the 'political' Locke, who had drawn up the constitution of South Carolina, vesting absolute authority in slave owners. Locke was, after all, a realist who was fully aware of the importance of slavery to the English economy, and had himself invested in the Royal African Company.[15]

Locke's views were symptomatic of the widespread acceptance in the seventeenth and first half of the eighteenth century of slavery among the governing classes of Britain, and in those countries involved in the slave trade. Locke's distinction between those in a state of nature and in slavery was in non-philosophical discourse generally merged into the loose category of 'savage', applied to Africans and the native peoples of the Americas, North and South, but also within Europe to the peoples of the far north, and by the English to Scottish Highlanders and the Irish peasantry. Though the word 'savage' always implies difference and condescension, it does not preclude admiration. In satiric or sentimental discourses, American 'Indians' can appear as paragons of liberty, to be contrasted favourably with the London *haut monde* who are slaves to fashion. If for 'polite' Europeans vulgar aspirants to gentility were a permanent social irritant, 'savages', apart from the few 'tamed' as chattels in wealthy households, could easily become objects of fantasy, myth and legend, distanced to remote places, seen *in situ* only by the most adventurous. The state of savagery as a refreshing alternative to bogus and affected politeness is embodied in the oxymoron 'Noble Savage' that first appeared in the satire-laden climate of Restoration England.

The 'Noble Savage', though such an idea goes back to Montaigne and perhaps even further in time, was first named in Dryden's *Conquest of Granada* (1670),[16] and the type had currency in England and else-

where in Europe all through the eighteenth century, to be given a new meaning in the age of abolition. The most notable and enduring example is to be found in Aphra Behn's *Oroonoko* (1688), which became a popular and long-lasting play in Thomas Southerne's version.[17] The Noble Savage could be almost any 'race' or colour, but Behn's account of 'the Royal Slave' distinguishes the 'Indians' of Surinam from 'Those . . . whom we make use of to work in our plantations of sugar, [who] are negroes, black-slaves altogether, who are transported thither.'[18] The 'Indians' are handsome and beautiful, and though almost naked are 'extreme modest and bashful, very shy, and nice of being touched . . . These people represented to me an absolute idea of the first state of innocence, before man knew how to sin: and it is most evident and plain, that simple nature is the most harmless, inoffensive, and virtuous mistress.'[19]

Despite the difference made between 'innocent' Indians and servile blacks, Behn's eponymous hero Oroonoko was a prince of Coramantien, 'a country of blacks'. Furthermore, his family were themselves slave-traders, and he continued the family business. Oroonoko was nonetheless a paragon of gentlemanliness:

> 'twas amazing to imagine where it was he learned so much humanity; or to give his accomplishments a juster name, where it was he got that real greatness of soul, those refined notions of true honour, that absolute generosity, and that softness, that was capable of the highest passions of love and gallantry, whose objects were almost continually fighting men, or those mangled or dead, who heard no sounds but those of war and groans.[20]

Oroonoko's greatness of soul is matched by his physical presence: he was given by Behn all the physical attributes of a handsome European, differing only in skin colour, as well as all the nobility of character one might hope for, if not actually expect, in men of rank:

> He was pretty tall, but of shape the most exact that can be fancied: the most famous statuary could not form the figure

of man more admirably turned from head to foot. His face was not of that brown rusty black which most of that nation are, but a perfect ebony, or polished jet. His eyes were the most awful that could be seen, and very piercing; the white of them being like snow, as were his teeth. His nose was rising and Roman, instead of African and flat: his mouth the finest shaped that could be seen; far from those great turned lips, which are so natural to the rest of the negroes. The whole proportion and air of his face was so nobly and exactly formed, that bating his colour, there could be nothing in nature more beautiful, agreeable and handsome.[21]

Implicit within this noble image is Oroonoko's 'Other'; the 'Negro' stereotype of flat nose, large lips and short, crinkly hair. A good representation of this typology can be found in an impressive bust in black marble by an English sculptor resident in Italy, Francis Harwood (illus. 4). The bust is of a type known from Roman times and the Italian Renaissance, and though it has been claimed without any justification to be a portrait of an actual person, the conspicuous scar on the forehead makes it clear that it represents a 'savage' warrior. Oroonoko, by contrast, is able to have his hair down to his shoulders 'by the aids of art, which was by pulling it out with a quill, and keeping it combed'. He is the one (male) exception among his people, a kind of aristocratic landowner commanding the rude peasantry. Oroonoko is unusual not in his aristocratic typology, which is generic to the Noble Savage, but in being localized as a Surinamian black, rather than as variously an Inca, a 'Red Indian', 'Carib' or a generic 'African'. While the 'prince' or ruler may possess all the virtues and even the physical beauty of their European equivalents, their peoples are physically different, and may be bloodthirsty, superstitious and untrustworthy, and capable of committing all kinds of atrocities, including cannibalism.

The attitudes that pervade *Oroonoko* are, of course, those of the Restoration theatre, with its cynical view of the high life of London and its taste for the exotic. Theological and philosophical debates in England in the period that followed, which saw increased employment

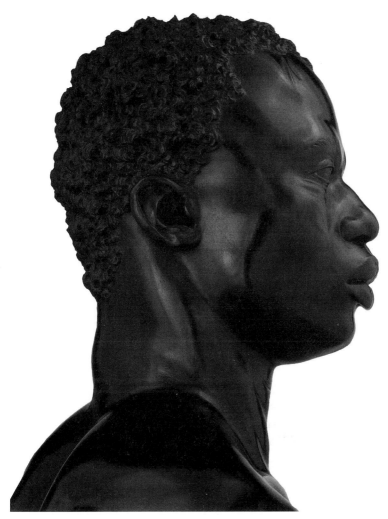

4 Francis Harwood, *Head of an African*, 1758, black marble. The J. Paul Getty Museum, Los Angeles.

of chattel slaves in opulent households, were more likely to be concerned with the question of whether those brought up as 'savages' could be educated and/or converted to Christianity. This question clearly lay behind the second Duke of Montagu's experiment with the Jamaican Francis Williams (illus. 5).[22] Locke's theory could place those presumed to be outside civil society[23] in the category of 'pre-civilized' beings like the world's earliest inhabitants, their minds empty of mental experience. Montagu (1688–1749), who had been Governor of the Windward Islands, was 'struck with the conspicuous talents of this Negroe [Francis Williams] when he was quite young and proposed to try whether, by proper cultivation, and a regular course of tuition at school and the university, a Negroe might not be found as capable of literature as a white person'.[24] Montagu sent Williams to school in England and possibly then to Cambridge. On his return to Jamaica Williams founded a school, becoming a noted pedagogue. With his mind imprinted by the experience of a British education, Williams was fully able to exhibit the accomplishments appropriate to his now privileged standing. He acquired enough learning to turn out occasional Latin verse,[25] but he had the posthumous misfortune to become the exemplum of David Hume's notorious denial that Africans could ever have the capacity for original thought. He was also brutally maligned by the apologist for slavery Edward Long,[26] who went to the trouble of translating one of Williams's Latin odes for the sole purpose of mocking its shortcomings, though as abolitionist James Ramsay later pointed out, 'there have been bred at the same university an hundred white masters of arts, and many doctors, who could not improve [on] them'.[27]

Perhaps the best way to grasp the complexity of attitudes towards 'savage' peoples in the early part of the eighteenth century, in Britain at least, is to study Daniel Defoe's *The Life and Strange Surprising Adventures of Robinson Crusoe*, first published in 1719.[28] The eponymous hero, as is well known, after a series of acts of disobedience to his father and, implicitly, to God, eventually fetched up alone on a remote island off the coast of South America, where he remained for 28 years before he was rescued. It is clear that Crusoe's previous career as a mariner was bound up with trading in slaves from Africa. On his first successful

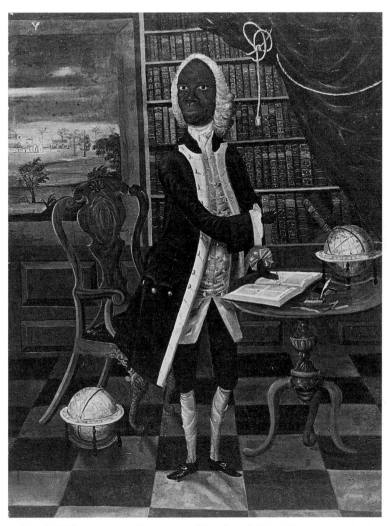

5 *Francis Williams*, *c*. 1735, oil on canvas. Victoria and Albert Museum, London.

adventure, which led eventually to his own capture and enslavement by pirates, he set up as a 'Guiney trader' with an honest sea captain. Guinea on the West Coast of Africa was a major source of slaves in the period, and indeed later Crusoe notes that a Portugese ship was 'bound to the coast of Guinea for Negroes'.

In his second phase of prosperity Crusoe settled in Brazil where he set himself up in the 'planting and making of sugar' and, after achieving a certain level of wealth, 'I bought me a Negro slave and an European servant also'. Becoming restless, he embarked on an expedition to Guinea with the express purpose of acquiring by barter 'Negroes for the service of the Brazils, in great numbers'.[29] As Crusoe points out, the profit lay in avoiding the *assientos* or permissions controlled by the Spanish and Portuguese kings. His part of the expedition was to manage the trade on the Guinea shore and have 'my equal share of the Negroes'. He was then shipwrecked on his way to Guinea and ended up on the famous island in the mouth of the Orinooko river. It has been suggested that Crusoe's shipwreck was divine retribution for his active engagement with the slave trade, but this is surely anachronistic.[30] Shipwrecks have a role in Crusoe's journey of life, but they are better understood as divine punishment for his disobedience to his father in refusing to accept a life of pious contentment and patient accumulation, continuing instead to seek out riches through speculative ventures. In other words he should, according to the author's intensely Protestant bourgeois ethic, have acquired slaves with sober purposefulness, slowly building up his wealth, not by going on risky expeditions. As Crusoe muses later: 'what business had I to leave a settled fortune, a well-stocked plantation, improving and increasing, to turn supercargo to Guinea, to fetch Negroes, when patience and time would have so increased our stock at home that we could have bought them at our door from those whose business it was to fetch them [?]'.[31]

For Defoe slavery was indeed controversial, not because of its inhumanity, but because of the issue of whether the trade in African slaves was best carried out through the state-controlled Royal African Company or through privately financed expeditions.[32] In that controversy, which attracted many pamphlets throughout the first decades of

the eighteenth century, Defoe argued for the long-term benefits of state intervention. There is, then, in Defoe's fiction and political writings an acceptance representative of the earlier part of the century of the institution of slavery, for its national economic benefits and of the employment of personal and domestic slaves as a natural part of the 'polite' life. But Defoe's account of Crusoe's most famous servant, Friday, shows a subtle awareness of some at least of the complexities of the relationship between master and slave.

In fact Friday only served his master for the last four years of his time on the island, and he was preceded before Crusoe reached the island by Xury, a 'Moorish' youth. Xury serves Crusoe faithfully after the latter, escaping from being enslaved himself by a pirate, agrees not to drown him. The ever-present fear to the two escapees is to land on the Barbarian coast, 'where whole nations of Negroes were sure to surround us with their canoes and destroy us; where we could ne'er once go on shore but we should be devoured by savage beasts, or more merciless savages of human kind'.[33] When they land, Xury is terrified of being eaten by 'the wild mans' but nonetheless agrees to offer himself as a sacrifice to allow his master to escape. The area the pair has landed in is the Maghreb 'lying between the Emperor of Morocco's dominions and the Negroes'. Crusoe's objective was to walk to the Gambia or Senegal where he might find a passage home with a slave trader. On the way they meet Africans who were 'quite black and stark naked' but not hostile, though this may have been because of their first experience of the effect of firearms.

Thus Africans, or 'savages' or 'Negroes', were pictured by Defoe potentially as either docile or as ferocious cannibals, a duality of attitude, as Peter Hulme has argued, that can be traced back as early as Christopher Columbus's first encounter with native Caribbeans.[34] The arrival of Friday, twenty-four years after Crusoe has settled on his island, is the occasion for an extended meditation on the transformation of a cannibalistic savage into a devoted, incorruptible and Christian servant. The savages who bring Friday to Crusoe's island are evidently his own people, but they are also cannibals who feast on their victims. Friday makes his appearance as their intended victim and after his

oppressors are killed by Crusoe's guns, Friday's first thought is to eat them himself. He 'was still a cannibal in his nature', but he is weaned off human flesh by Crusoe, who converts him to Christianity. Friday, in gratitude for his deliverance from death and from his former benighted heathen state, now becomes totally servile, making 'all the signs to me of subjection, servitude, and submission imaginable', placing Crusoe's foot upon his own neck.[35]

Friday's enslavement is thus presented as voluntary, a natural act of gratitude towards one who has spared his life and offered him the inestimable benefit of education. The relationship is obviously paternal: 'his very affections were tied to me, like those of a child to a father'. But to which people – we cannot use the word 'race' without anachronism at this point – did Friday belong? Was he African, American or something else? Friday is described as being almost European in physiognomy, and specifically not a 'Negro' in type: 'He had all the sweetness and softness of an European in his countenance, especially when he smiled' – and further on – 'His face was round and plump; his nose small, not flat like the Negroes; a very good mouth, thin lips, and his fine teeth well set, and white as ivory.'[36] Friday might have been intended to be a Carib, one of the aboriginal inhabitants of the Caribbean before the arrival of African slaves, but he is best understood as a generic Noble Savage whose colour and features are defined as much by social position as by the type of humanity he represents. Friday in having a nose that is *not* flat and lips that are *not* fat is, like Oroonoko, explicitly distinguished from the characteristic physiognomy attributed to the generic 'African', of flat nose and thick lips, surmounted by frizzy or woolly hair. Nonetheless, his conversion from cannibalism to servility evokes an 'African' typology distinct from that of the 'American' nomadic hunter.

It is insufficient to attribute such crude typology merely to ignorance of the non-European world. Africans at least were a significant presence in Europe not only as real people but as fictive representations, in portrait and subject paintings, but also in popular allegory, inn signs and coats-of-arms. Black servants in great families contributed to the aesthetic presentation of power. They played a role in courtly ceremony

38

in most of the princely and royal courts of Europe from the sixteenth century onwards. In the eighteenth century they continued to give an air of courtliness to a portrait even if the subject was now a merchant or seafarer, and in England their presence could invoke Van Dyck's portraits of the court of Charles i. In paintings their fine and colourful clothes were often more elaborate than those of their owners. Invariably they look up with deep awe towards their masters and mistresses, in recognition of their superiority. A good example is an early portrait by Joshua Reynolds of First Lieutenant Paul Henry Ourry (illus. 6), which includes an exotically dressed African adolescent whose name is known to have been Jersey.[37] Ourry is presented as a gentleman and sturdy naval officer, his hand firmly grasping the pommel of his sword as he gazes commandingly into the distance, oblivious to Jersey's admiring gaze. Jersey provides a vivid, exotic and polychromatic foil to the relative austerity of the First Lieutenant's figure. The contrast extends to Jersey's skin colour; a rich olive brown set off strikingly against the near white of his hat and shirt-ruffle, and against the First Lieutenant's ruddy features. The presence of the black servant suggests a consciousness of new horizons opening up through trade in distant and recently discovered lands, hinting at riches and new knowledge to be acquired by Britain under the aegis of gallant sailors.

In female portraits a servant's blackness can contrast with the whiteness of the mistress's skin, his or her features highlighting the latter's ideal perfection.[38] In Pierre Mignard's portrait of the Duchess of Portsmouth (illus. 34) the Duchess receives from a black child a 'tribute' to her beauty in the form of a piece of coral. This child is a body servant, of the kind who accompanied their wealthy mistresses even in their most private moments, and who became for satirists a sign of female extravagance, vanity and lax sexual morality. In *The Countess's Morning Levée*, in Hogarth's *Marriage A-la-Mode* series, represented here by the engraved version (illus. 7), a black child in a decorative turban points with a salacious grin to the horns on an ornamental figure, an Actaeon being transformed into a stag, a sign of cuckoldry. The little black boy's roguish aspect expresses his intimate knowledge of his mistress's sexual transgressions, and draws the spectator into complicity.

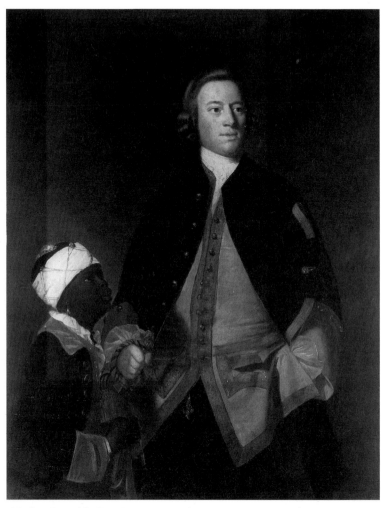

6 Joshua Reynolds, *First Lieutenant Paul Henry Ourry*, *c*. 1748, oil on canvas.
The National Trust, Saltram House, Devon.

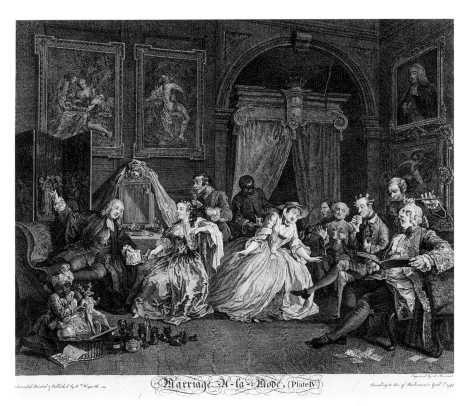

7 William Hogarth, 'The Countess's Morning Levée', *Marriage A-la-Mode*, plate IV, 1745, engraving by Simon Ravenet.

There is also an older black boy employed to serve refreshments to the guests, in this case a louche company of musicians and entertainers assembled in the new Countess's boudoir. If the little boy pointing to the horns is denatured and made precocious by his experience of luxurious life, his elder companion serving tea is still in awe of the sophistication of fashionable people, yet baffled by them. He is an ironical exemplar of the innocent 'savage' confronted with those who merely enact the superficial signs of civilization; he retains, despite his finery, a primordial simplicity that puts to shame the decadent behaviour of his

social superiors. Black servants in grand portraits and in satirical paint-
ings invoke nature's tribute to culture and savagery's tribute to gentility,
as well as referring to courtly ceremonial and magnificence. If, as Defoe
claims, Africans, even biddable ones like Friday, are in their natural
state potentially murderous or cannibalistic, then such paintings
subsume the implication that their masters or mistresses have tamed
their natural savagery into voluntary servitude either by force of
personality or by great beauty. The chattel slave in grand portraits is
both savage and ceremonial object, who might notionally return to
nature if the trappings of civility were removed. Such paintings show
the African, presumed in his native land to be an untamed fetish-
worshipper and hunter, now fashioned into an icon of courtly style.

As the association of Africans with slavery in paintings became a
familiar trope, so they were increasingly contrasted with native Ameri-
cans, who were characterized by their love of freedom but also repre-
sented the hunter-gatherer stage of humanity. It was later to become
commonplace that the ancient Germans were free spirits like the
American Indians, and that the latter could claim a certain kinship
with Europeans denied to Africans. This is clear in representational
typology based on the image of the warrior-hunter, from John White's
watercolours of 1585 to Verelst's representation of the four 'Indian
Kings' or Iroquois sachems who visited England in 1710, and beyond.
The 'Indian Kings' were the subject of four paintings now in the Public
Archives of Canada in Ottawa, painted from the sitters in London and
widely available as mezzotint engravings, yet they are shown as if in
their native habitat, in the forests of North America, albeit in a manner
familiar from European hunting portraits.[39] Three out of the four are
shown carrying weapons prominently. Etow Oh Koam holds a club in
his hand, with a large scimitar on his belt and tomahawk by his feet,
while in the background a figure is applying a club to another at his
feet. Sa Ga Yeath Qua Pieth Tow holds a musket almost as long as
himself, and in the background two Indians are shown using such
muskets in the pursuit of a deer (illus. 8). Their pursuits as 'kings' are
not differentiated from those of their fellow 'savages', yet their strong
individual presence within the landscape suggests their 'nobility'

42

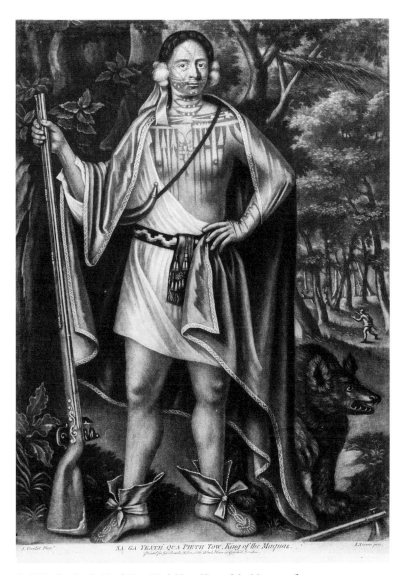

SA GA YEATH QUA PIETH TOW. King of the Maquas.

8 J. Verelst, *Sa Ga Yeath Qua Pieth Tow, King of the Maquas*, after 1710, mezzotint engraved by John Simon.

derives from being braver and better hunters than the rest of their people.

Despite the visual evidence presented here, it would be wrong to suggest that the differences between the African and the 'Red Indian' were perceived in Europe as absolute. There are images, particularly in decorated maps, of African peoples as hunter-gatherers, and distinctions were made by travellers between peaceable and warlike tribes. Furthermore, there was an irresistible tendency to impose European political hierarchies onto non-European structures of government. The four Iroquois sachems who arrived in London in 1710 were assumed to be kings, just as Behn's Oroonoko was described as a prince. London and Paris were visited frequently in the late seventeenth and early eighteenth centuries by 'princes', who stimulated exotic fantasies and sentimental tales.

A well-documented example is that of the wealthy African visitor William Ansah Sessarakoo, who, according to the *London Magazine* of February 1749, had been inadvertently sold into slavery by the captain of the ship taking him to England. On his recognition and release he was actually taken to a performance of *Oroonoko* with a black companion, and it was reported that 'they were so affected, that the tears flow'd plentifully from their eyes; the case of Oroonoko's being made a slave by the treachery of a captain being so very similar to their own'.[40] Sessarakoo was celebrated in a London journal as 'A Young African Prince, Sold for a Slave', and the treachery of the ship's captain who sold him in Barbados was recognized as that of a trader, on the model of the tale of *Inkle and Yarico*, selling his honour for commercial gain.[41] The inscription on the mezzotint print by John Faber after Mathias's painting of 1749 (illus. 9), makes much of the sitter's royal ancestry and his redemption from slavery.[42] He is presented as a gentleman in an elaborately brocaded jacket with a hat under his left arm, a stance often adopted by sea captains. It is not clear whether he is wearing a wig or his hair is combed into a wig-like shape; nonetheless it is very black and straight. The pose and the brocade suggest a person of distinction, but hardly the figure of romance created by the poetic dialogues written by Thomas Dodd and published in the *Gentleman's Magazine* in 1749.

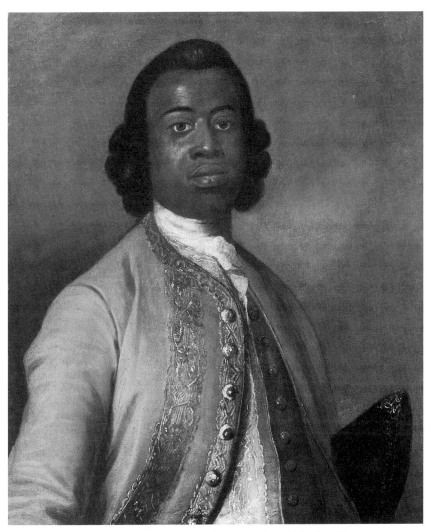

9 Gabriel Mathias, *Portrait of William Ansah Sessarakoo, Son of John Bannishee Carrante Chinnee of Anamaboe*, 1749, oil on canvas. Menil Foundation Collection, Houston, Texas.

There Sessarakoo is given a lover called Zara, for whom he sighs in captivity. Sessarakoo's romantic aura thus differentiated him from his less fortunate compatriots in service and on the plantations, and his success in being recognized as of high birth subtly reinforced the principle of aristocratic distinction. His enslavement allowed him to show his true mettle and overcome circumstances that might have condemned his less well-born fellows to resign themselves to a life of servitude.[43]

THE BEAUTY OF MORALITY AND THE MORALITY OF BEAUTY

In early-eighteenth-century accounts of non-Europeans, an implicit connection was often made between physical beauty and virtue, and between ugliness and vice. Oroonoko's virtue is made visible and transparent by his physical beauty and conformity to European ideal types. Similarly Friday's potential for redemption is bound up with his specifically defined non-Negroid physiognomy. The connection between outward appearance, especially of the face, and the proclivity of the 'soul' towards virtue or vice, lay at the heart of one of the most insistent debates in eighteenth-century aesthetics.[44] It was, however, one thing to ascribe a 'beautiful soul' to an individual, but another to ascribe it to the generic features associated with a particular nationality or human type.

The relationship between morality and aesthetics first emerges in the eighteenth century in the writings of the Earl of Shaftesbury, a pupil of Locke, though a critical one, and of Joseph Addison in the enormously influential journal *The Spectator*. They were bound together by the desire to promote the adoption of 'politeness'[45] by their fellow countrymen, by bringing, in *The Spectator*'s words, 'Philosophy out of Closets and Libraries, Schools and Colleges, to dwell in Clubs and Assemblies, at Tea-Tables, and Coffee-Houses'.[46] In Shaftesbury's case it was more associated with the desire, as Lawrence Klein put it, to 'remake the world in a gentlemanly image' of refined sociability.[47] In keeping with this ambition, Shaftesbury argued, a little paradoxically, that though the sense of beauty was common to all humanity, even the

uneducated, it needed to be cultivated to become 'natural', and therefore benefited from stringent criticism.[48]

Shaftesbury in effect proposed to conflate ethics and aesthetics; his concept of 'breeding' advocates not only the pursuit by the notional elite of high moral standards, but the simultaneous exercise of aesthetic discrimination: 'To philosophise, in a just signification, is but to carry good-breeding a step higher. For the Accomplishment of Breeding is, To learn whatever is *decent* in Company, or *beautiful* in Arts: and the Sum of philosophy is, to learn what is *just* in Society, and *beautiful* in Nature, and the Order of the World.'[49] The man of breeding could, therefore, perceive 'BEAUTY in *outward Manners* and *Deportment*' and 'a *Beauty in inward Sentiments* and *Principles*'. Such an ambition should be seen in the context of the ambitions of the Whig aristocracy in the period of the Restoration to create a public culture independent of Church and King, but Shaftesbury's aesthetics represent a position that lived on well beyond its original circumstances, and was to be particularly influential in Germany.

Shaftesbury distinguishes a taste for art from the perception of human beauty. The beauty of another person exists in the perceiving mind, and in the recognition of mind in others. True female beauty as it might be recognized by a man of taste was not a matter of physical desire but a recognition of the way in which the mind of the woman creates the desire itself. 'The admirers of beauty in the fair sex would laugh, perhaps, to hear of a moral part in their amours', but Shaftesbury argued that it was vital to male appreciation of female beauty. 'They must allow still, there is a beauty of the mind, and such is essential in the case', quite different from the 'other passions of a lower species . . . employed another way'.[50] Such a recognition divided 'men of elegance', who know that female beauty is a matter of mind, from 'men of pleasure', who can only see in it an incitement to lustful desire. There is always in Shaftesbury's aesthetics a gentlemanly response that can be clearly differentiated from lower responses, and which was to be cultivated and promoted in the public world.

Shaftesbury's underlying Platonism makes nature for him a reflection of a more perfect world beyond the senses:

For if we may trust to what our reasoning has taught us, whatever in Nature is beautiful or charming is only the faint shadow of that first beauty, so that every real love depending on the mind, and being only the contemplation of beauty either as it really is in itself or as it appears imperfectly in the objects which strike the sense, how can the rational mind rest here, or be satisfied with the absurd enjoyment which reaches the sense alone?'[51]

The perceiving mind's role is critical: 'the beautiful, the fair, the comely, were never in the matter, but in the art and design; never in the body itself, but in the form or forming power . . . Tis mind alone which forms. All which is void of mind is horrid, and matter formless is deformity itself.' But 'the forming mind' of the human body is God himself, hence the superiority of human form over 'The palaces, equipages and estates [which] shall never in my account be brought in competition with the original living forms of flesh and blood.'[52] There are then three forms of beauty: dead forms, which are formed but have no forming power; 'forms which form', therefore have intelligence, action and operation, 'giving a dead form lustre and force of beauty'; and finally the 'supreme and sovereign beauty', that which 'forms the forms which form', the principal source or fount of beauty in God.

There were, of course, Classical precedents for the idea that personal beauty was closely allied to goodness, and that beauty was not generated by physical causes. As George Berkeley put it in *Alciphron* (1732), Aristotle's idea was of a man 'who practiseth virtue from no other motive than the sole love of her own innate beauty'.[53] This is the Greek idea known as *kalokagathia*, which can be translated as something like beauty and goodness combined. Berkeley's *Alciphron*, however, regarded Shaftesbury as a dangerous freethinker and dissented from his argument that there was an indissoluble union between morality and beauty, on the grounds that it led to a downgrading of reason and to a self-regarding hierarchy of taste. Berkeley argued that beauty was a characteristic of morality, but not an imperative. Berkeley accepted that there is 'a beauty of the mind, a charm in virtue,

a symmetry and proportion in the moral world', but rejected the claim that beauty can be the foundation of morality if it were not based on order or harmony.[54]

The Scottish philosopher Francis Hutcheson, in *An Inquiry into the Original of our Ideas of Beauty and Virtue* (1724), followed Shaftesbury in making the claim that 'He [God] has made Virtue a lovely Form, to excite our pursuit of it; and has given us strong Affections to be the Springs of each virtuous Action.'[55] Virtue's beauty accordingly guarantees that it will remain an object before us, for though 'our Desire of Virtue may be counterballanc'd by Interest, our Sentiment or Perception of its Beauty cannot'. Beauty is thus a way of ensuring the disinterested perception of virtue without the need for God's direct intervention. Hutcheson claimed also that moral and aesthetic qualities are perceived by an internal sense with the aid of the affections; the 'sense of beauty' is separate from, but intimately bound up with, the 'moral sense', and may claim to be higher, because implicitly nearer to the divine, than the external senses identified by Locke.[56] The power of 'Custom, Education and Example' can affect our internal senses, but the sense of beauty is antecedent to them all. In human terms, as for Shaftesbury, beauty is in the character of the person not the form. Similarly, beauty that incites desire hardly figures in Hutcheson's treatise, for the recognition of beauty in a person is a recognition of moral qualities, which might be 'Sweetness, Mildness, Majesty, Dignity'. The sense of beauty in *things*, on the other hand, might respond to configurations, for example those that exhibit 'uniformity amidst variety', and can therefore 'excite in us 'ideas of beauty'. This sense might also be stimulated through the universal tendency to respond to regularity and uniformity; even Gothic, Indian and Eastern buildings all have some uniformity, though beauty can be distorted by association of ideas.[57]

Shaftesbury and Hutcheson, in their refusal to reduce aesthetic pleasure to the sensual, may be contrasted with Joseph Addison in his series of articles in *The Spectator* in 1712, later gathered together under the title *Taste and the Pleasures of the Imagination*.[58] Addison claimed that beauty or deformity did not exist 'more in one piece of matter than another', but in our various dispositions and ideas of beauty and in our

empathy with the object that stimulated an aesthetic response: 'every different species of sensible creatures has its different notions of beauty, and that each of them is most affected with the beauties of its own kind'.[59] We are likely to be most affected not only by the beauty of other human beings, but by those most like ourselves. Human beauty, however, is not for Addison a glimpse of the divine or synonymous with virtue; it is instrumental in the procreation of humanity, and designed by God to be so. God 'has made everything that is beautiful in our own species pleasant, that all creatures might be tempted to multiply their kind, and fill the world, with inhabitants'. Indeed if it were not so, 'unless all animals were allured by the beauty of their own species, generation would be at an end, and the earth unpeopled'.[60]

Addison makes a primary distinction between the beauty that is synonymous with sexual attraction, and the beauty we might find created by God elsewhere in the world. There are other forms of beauty given to man to incite wonder at God's goodness: 'the works of Nature and Art' which also 'entertain the imagination'. If, for philosophers like Shaftesbury, sexual desire belonged with the 'animal' being of mankind, unworthy of the attention of polite enquiry, for Addison, beauty's role in procreation is itself a sign of the infinitely wise and subtle work of the Creator. Addison does not, however, distinguish between male and female desire or the perception of beauty in the opposite sex, leaving unaddressed the tension between beauty as instinct and beauty as a sign of divine grace. If a sunset can be perceived as an adornment to life, a revelation of God's power and wisdom, human beauty might, according to Addison's logic, be nothing more than the object of primal desire and the need for survival.

Addison's resistance to the identification of beauty with virtue was undoubtedly influenced by Milton's image of Satan in *Paradise Lost*. Milton's Satan was the essence of immorality, but he was nonetheless of angelic beauty, his manhood exemplified in his active life and questioning mind. Satan's essential maleness may be compared to Milton's description of Adam as possessing beauty equal to Eve, but 'excell[ing it] . . . by manly grace'.[61] Male beauty is defined as of a different order from female beauty, and it was increasingly defined in the

eighteenth century as belonging to the 'sublime', which could invoke terror, awe and boundlessness, all by definition incompatible with accepted ideas of beauty.

UNIVERSAL OR DISCRIMINATING SUBJECT?: THE AESTHETICS OF THE PERCEIVER

In a pair of images from the Berlin printmaker Daniel Chodowiecki's series *Natural and Affected Attitudes*, 1778 (illus. 10),[62] two young male 'connoisseurs' contemplating in a 'natural', and therefore reflective and humble, way, an antique female statue, are contrasted with a vulgar pair who exclaim and gesticulate 'affectedly' before it. Chodowiecki thus discriminates between the ways of those who possess taste by nature and those who would claim it falsely. There can be no doubt as to which of the two we as spectators are expected to approve and indeed emulate, but the images themselves still contain teasing ambiguities.

Both pairs of observers are perceiving subjects, defined not by their appearance but by the way they choose to make an aesthetic judgement. They are in the act of judging, and it is part of the joke that the statue itself, by smiling or frowning discreetly, should also offer a judgement on them. But if we ask who they are, uncertainties arise. We could read the couples as the same persons in both images; in which case in one they perform as an exemplification of tasteful behaviour, in the other as an exemplification of vulgarity. In such a case they would become universal subjects, having no other existence but in their acts of judgement. We can also see them as interchangeable in other ways. The 'affected' ones could represent the state of humanity before it has acquired taste; they could become natural, and that would raise the question of what kind of education was required to achieve naturalness. It is equally plausible that the 'natural' ones might represent true, or even 'original' taste – note the other scene in the series where the naked Adam and Eve are contrasted with an overdressed couple (illus. 11) – while the 'affected' represent the over-ripeness of contemporary taste. Finally, we can see the pairs as completely different from each other; the 'natural' ones as people of

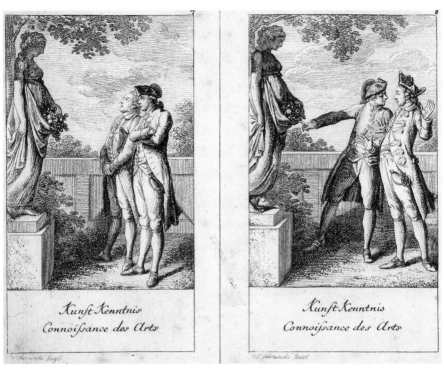

10 Daniel Chodowiecki, 'Appreciation of Art' from *Natural and Affected Attitudes*, 1778, etching.

refinement, perhaps young men of 'breeding', compared to their ghastly and inept bourgeois emulators.

Chodowiecki's prints introduce here the issue of how the act of aesthetic judgement could be a way of categorizing types of humanity. Those who argue that the inner nature of a person could be discerned from outward appearance have to take a view on whether the ability to descern is universal or confined to particular types of people, and if so what types. Or to put the issue another way, can this inner nature be recognized from outer appearance by any sentient person, or does it require special abilities, or what Pierre Bourdieu calls cultural competence derived from social position and/or education? Furthermore, do

11 'Nature and Affectation' from *Natural and Affected Attitudes*, 1778, etching.

those with the right level of cultural competence still require special training or experience in order to read the signs correctly? The act of discriminating inner character from appearance is a matter for what we have called 'human aesthetics', but if the ability to make aesthetic judgements becomes the criterion, then the judgements no longer need to be confined to, or even involve, judgements of the human body. An aesthetic 'sense' or aesthetic perceptions could arguably be judged as well or better by the level of aesthetic response to art objects, as they are in the Chodowiecki print, or to natural effects; in the same series the artist contrasts the 'natural' and 'affected' responses of two couples to a sunset (illus. 12).

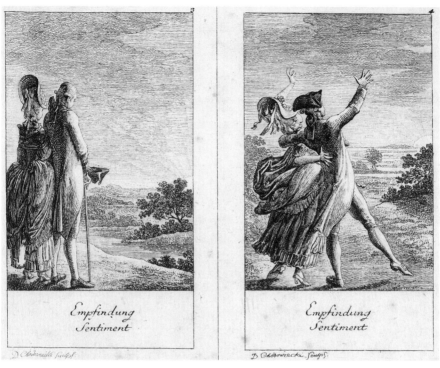

12 Daniel Chodowiecki, 'Sensibility' from *Natural and Affected Attitudes*, 1778, etching.

The aesthetic subject in eighteenth-century philosophical discourse was often assumed to be universal, on the grounds that aesthetic perception or 'taste' was an inherent part of the human mind, a sixth or seventh sense.[63] It could in that regard be exercised by any human if they chose to do so, regardless of origin or background. On the other hand aesthetic taste was very often regarded as something to be cultivated, as the defining attribute of 'politeness' or gentility, which had been associated by Shaftesbury with moral virtue. The ability to be at home with works of art of the best types was a principal purpose behind sending young men on the Grand Tour, and it is commemorated as a gentlemanly attribute in countless portraits by Pompeo

Batoni of aristocrats or would-be aristocrats from across Europe.[64] Such portraits of young men striding among, or reflectively contemplating, antiquities imply strongly that taste is the property of those of elevated social position, even if it needs to be perfected by experience and study. In practice, though, as in Batoni's painting of Peter Beckford (illus. 13), the subject might be a person of wealth – in this case derived from West Indian slave plantations – seeking to emulate what was supposed to come naturally to those of rank. Indeed much of the writing on aesthetic matters by Addison, Shaftesbury and others was part of a conscious enterprise to define and form the way that a truly cultivated elite should conduct their lives, and how those not born to it might reach up to its ideals. Their writings reinforce the line between 'men of taste' or 'virtuosi' and those who were outside their exalted company. Discernment was only open to those with particular abilities or who had achieved the learning that makes such discrimination possible.[65]

The main targets of such improving theories, in England at least, were an aristocracy that had lost its bearings in the Civil War and its long aftermath, and the newly prosperous merchant class, who had made enough money from trade to aspire to a cultivated life but needed guidance as to how to achieve it. This eventually became formalized in the emulation of aristocratic manners, the obligatory collection of Classical marbles, the Palladian house, etc., on the understanding that cultivation of taste would lead to 'the Man of Breeding and Politeness'.[66] Such a paragon would be able to apply as subtle discrimination to moral issues as he did to works of art, and discern true merit or otherwise in people from their outer appearance.

If Addison sees the aesthetic subject as a mind whose cultural competence has to be inscribed upon it, Shaftesbury's idea of 'the Well-Bred Man' equivocates between assigning taste to heredity or to education. Addison's specifically appointed audience, the members of 'Mr Spectator's' club: an elderly country squire, a City merchant, a lawyer, a soldier, an elderly bachelor and a clergyman, were all by definition beneath the political and social elite of the court and great country house. Yet in his theoretical letters in *The Spectator* Addison tends to refer to the human mind as if it must always react in the same way,

55

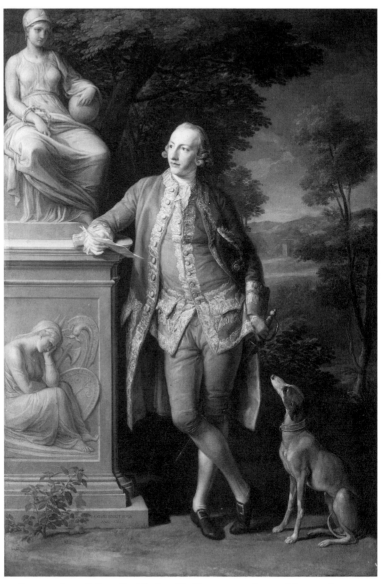

13 Pompeo Batoni, *Peter Beckford*, 1766, oil on canvas. Statens Museum for Kunst, Copenhagen.

whether before a sunset or an ancient statue.

Shaftesbury admitted that common experience did not support the fond hope that good or evil character is registered in appearance in an unmediated way. A beautiful plant might be poisonous, a noble animal dangerous, a beautiful woman treacherous and a handsome face, or house facade, might conceal a squalid interior. But fortunately the 'polite' have 'an inward eye [that] distinguishes, and sees the fair and shapely, the amiable and admirable, apart from the deformed, the foul, the odious, or the despicable'.[67] The 'Man of Breeding and Politeness' can make fine moral and aesthetic discriminations, and above all penetrate the surface of those he encountered, to strip away the finery, the masks or 'screens' that men and women in public life use to conceal their inner nature. He is also aware of objects, sights and even people, which evoke strong and pleasurable emotion but are by no standards beautiful. Wild nature and extreme climatic conditions could be visually and emotionally stirring, the tragic fate of a flawed hero might be pleasurable to behold in the theatre, an ugly man like Socrates might be morally heroic, and there may even be heroism in the struggle of the forces of evil against their fate.[68]

It follows that those who are not 'polite', in which category he presumably places Deists and 'reasoning' philosophers as well as aspiring merchants, and indeed everyone but a chosen few, lack that 'inward eye': 'All own the standard, rule and measure: but in applying it to things disorder arises, ignorance prevails, interest and passion breed disturbance.'[69] The impolite by definition cannot conceive of a beauty that is not sensual. In answering the question 'Why beauty may not be the object of the sense', Shaftesbury argues that sensual pleasure is merely brutish, for the mind plays no part in it: 'For never can the form be of real force where it is uncontemplated, unjudged of, unexamined, and stands only as the accidental note or token of what appeases provoked sense, and satisfies the brutish part.' Those that lack 'mind' lack all moral and aesthetic faculties, and are on the same level as animals: 'neither can man by the same sense or brutish part conceive or enjoy beauty; but all the beauty and good he enjoys is in a nobler way, and by the help of what is noblest, his mind and reason'.[70] Shaftesbury

is, however, not specific about the identity of those excluded from aesthetic discrimination, though he does note that in a body lacking 'inward form . . . the mind [would] be monstrous or imperfect, as in an idiot or savage'. Those without aesthetic response are defined *only* by their lack of politeness; not by membership of any particular group, but by their inability to join the only one that matters.

Shaftesbury was to be a constant presence in German philosophy throughout the eighteenth century – Herder even praised Kant in his early maturity as 'a German Shaftesbury'[71] – but the Earl was a more equivocal figure in Britain, often perceived as an aristocratic dilettante. If a more functional view of aesthetics tended to predominate in Britain, in the German-speaking countries the relationship between outer and inner beauty remained a crucial problem of aesthetics and philosophy until the end of the century and beyond. It emerges in Kant's pre-Critical writings, in Herder's attempts to define an idea of culture, and most publicly in the early 1770s with the appearance of Lavater's sensationally successful *Physiognomische Fragmente*, a work that promised a way of identifying the true nature of the soul by 'scientific' study of the face, offering the virtuous, so Lavater claimed, a practical instrument of incalculable benefit in the struggle against vice.

CLIMATE, SUBSISTENCE AND NATION

In this section I want to look at the main theories of human variety that came to the fore in the middle of the century, and whose mutual and sometimes antagonistic relationship created the material of debates on aesthetics and human variety for the rest of the century. The first two are theories of human development: climatic theory, which made geographical conditions the primary determinant of the nature of a people, and subsistence theory, which divided the peoples of the earth according to four stages of social development based on their means of subsistence. The third main theory, the taxonomic, is of a quite different nature, for it began as an attempt by Linnaeus to classify humanity as he had classified plants and animals. All these theories could be reconciled with each other, but they also had the potential to expose

serious rifts among those writing on human variety. They could also put under pressure traditional theological explanations of human development, and for many the central issue was to protect the Judeo-Christian account of the Creation from material explanations while incorporating modern discoveries.

Climatic and subsistence theories had by the middle of the century become the most widely accepted material explanations of human variety. Climatic theory was compatible with the Creation story, for it assumed that there was once an original unitary people that was forced by some kind of Fall into a diaspora, spreading to the four corners of the earth. Peoples were formed who developed over time a distinctive appearance and way of life, according to the conditions of the places in which they settled. Those at the antipodes of north and south, Lapps and Africans, took on the most extreme characteristics; the former became nomadic hunters stunted by deprivation in extreme cold, the latter, scorched by the sun, were made lazy by the heat and the fecundity of nature. Europe, wherever its boundaries were deemed to lie, was in all definitions temperate, enabling a balanced way of life that encouraged activity and allowed reflection, and therefore civilization. But climatic theory was hard to reconcile with the idea of separate continents, for no continent, and indeed very few countries, were uniform in climate.

Climatic theory was assumed to be of ancient origin and was associated with Hippocrates, but it made a modern appearance in J. B. Du Bos's *Reflexions critiques sur la poesie et sur la peinture* (1719), in the context of the cultural difference between one country and another, which was attributed to 'the different qualities of the air [in each country]'.[72] In *De l'esprit des lois* of 1748, Montesquieu explicitly connected climate with political systems, defining Europe as a temperate zone stretching all the way from Spain to Scandinavia. Asia, he argued, was by contrast more variable and extreme in climate, with powerful countries in cold climates, made hardy by dealing with the cold, next to weak countries in hot climates, the latter debilitated by the heat.[73] As a result, conquest within Asia was easy for the strong, for 'In Asia the strong and weak nations face each other', while 'In Europe . . . strong

nations face the strong.'[74] This co-existence of equals in Europe necessitated a balance of power and healthy competition; it also made the enslavement of Europeans impossible. European government, furthermore, was distinguished by the separation of powers, even in autocratic societies, so Europe was, unlike Asia, supposedly free of the kind of despotism where all decisions were made directly by the ruler.

Subsistence, or the four-stage theory, in the form adumbrated by John Locke made the key determinant of a people's stage of civilization not their location but their mode of acquiring food and necessities. The earliest peoples were hunters, who could progress successively through pastoralism and agriculture to commerce, the last being synonymous with civilized life.[75] Climatic theory tended to locate the aboriginal peoples in Africa, and subsistence theory to find them in America, whose 'rude nations' were assumed to be still nomadic. Subsistence theory was taken up by the French philosophe Turgot and, in particular, Scottish thinkers like Adam Smith. It offered, together with climatic theory, with which it was broadly compatible, a widely acceptable framework for human history. The four stages could readily be applied to the Four Continents, and indeed the Four Temperaments, here satirized by Chodowiecki in his design of four men reacting, each according to their temperament, in front of a painting of a tragic scene (illus. 14).[76]

If climatic theory encouraged moral, historical and theological reflection, subsistence theory suited those who saw Europe as an alliance of trading nations, whose civility and taste rested on the foundation of successful commerce. Subsistence theory denied aesthetic taste to those who 'depend for food on bodily labour', for though they might possess innate sensibility, they can have no education or leisure by which to cultivate it. The 'cultivated life' based upon commerce rather than land ownership was one in which the arts become 'those Arts by which Manufactures are embellished, and Science is refined'. This phrase comes from the dedication of the President of the Royal Academy of Arts, Joshua Reynolds, to his *Seven Discourses delivered in the Royal Academy*, 1778. He also notes that 'The regular progress of cultivated life is from Necessaries to Accommodations to Ornaments.'[77]

14 Charles Grignion, after Daniel Chodowiecki, 'Representatives of the Four Temperaments reacting to a painting of "The Farewell of Calas"', from John Caspar Lavater, *Essays on Physiognomy* (London, 1789–98).

Subsistence and climatic theories both provide ways of categorizing peoples according to relative scales, but it was Linnaeus who provided the first rudimentary human taxonomy, in the revised edition of 1758 of his *Systema Naturae*.[78] This he did by placing man among the primates, creating four varieties of humanity, in conformity with the Four Continents in the four corners of the earth, the Four Temperaments, and the four elements of air, earth, fire and water.[79] The European *Europaeus albus* is in the dominant position as 'ingenious, white, sanguine, [and] governed by law' over the others, who are: *Americanus*

rubescus, 'happy with his lot, liberty loving, tanned and irascible, governed by custom' (choleric); *Asiaticus luridus,* 'yellow, melancholy, governed by opinion' (melancholy); *Afer niger,* 'crafty, lazy, careless, black, governed by the arbitrary will of the master' (phlegmatic). Though Linnaeus does not attribute relative beauty to the four peoples, by making whiteness a defining attribute of the European he created unavoidably an aesthetic hierarchy of skin colour.[80]

Such a rigorously schematic attempt to organize humanity was not an outright rejection of climatic influence, but its taxonomic method was anathema to the Comte de Buffon, whose series of volumes under the title of *l'Histoire naturelle*, which began to appear in 1749, provided the fullest and most influential realization of climatic theory.[81] Buffon insisted on an empirical method, the autonomy of matter, the generation of living forms, and physical truth in its complexity, without the need to construct a taxonomy or a unified theory of man. In reflecting on the nature of evidence and what we can derive from the study of nature, Buffon argued that we should consider 'natural forms that interest us because of their relation to us', seeking 'an order relative to our nature'. We should formulate generalizations by analogy, testing them against further observation.[82] Though Buffon himself notoriously did not do any fieldwork, he was fully aware that with travellers' accounts he was dealing with probability not certainty, the partiality of observers and the permanent need for updating and change. By contrast Linnaeus's systems of classification appeared to him to be a new form of nominalism, a desire merely to give names to things rather than to study nature in all its richness.[83] It is ironical, therefore, that Chodowiecki, in his design for a title-page to a German edition of Buffon, should represent his enterprise by an image of *Adam naming the Beasts* that might have been more appropriate to Linnaeus (illus. 15).

Buffon insisted that class concepts had to rest on physical effects, though he did believe that a 'primitive and general design' for humanity could be observed, whatever 'degeneration' there might have been from the archetypal form of man. He accepted a clear separation between man and animal, but also that all forms of life are part of the

15 Daniel Chodowiecki, etched frontispiece and title-page vignette to *Herrn von Buffons allgemeine Naturgeschichte* (Berlin, 1771).

same natural history, placing humanity and all living things on a continuous scale, with infinite and potentially fluid variations in-between. Observable differences in physiognomy, colour and physical type, he argued in accordance with standard climatic theory, arose over many generations, following dispersal into different climates and environments. It follows that those who went north became lighter in colour and different in physique from those who went south, and that those who settled in fertile temperate valleys developed more regular features and more peaceful and cooperative ways of life than those forced into a hard existence.

Buffon offered a division of humanity into six types: the Lapp Polar, Tartar, South Asian, European, Ethiopian and American,[84] but these were not permanent categories as they were for Linnaeus or, later, Kant. His main division is between the 'two humanities', of which there was 'one progressive, the other static and animal-like'; the gulf between 'the little savage nations of America' and 'our great civilised peoples' is absolute. There is a comparable distance between human and animal faculties, with the former distinguished from the latter by thought, language, perfectibility and sociability. According to Buffon, in the state of barbarity 'Man ceases to be man . . . man becomes at last without education without morality, reduced to leading a solitary and savage life, offering instead of his noble nature, one that is degraded to beneath the animal.'[85] Native Americans, characterized by Locke as living in the state of the world's original inhabitants, 'are as much morally and physically in the state of pure nature, without clothes, religion, or society but for a few family scattered across large distances'.[86]

Buffon in general used the word 'race' with imprecision, to differentiate peoples living in similar climatic conditions, especially where one has migrated from elsewhere, but sometimes the word is used to denote a cluster of peoples, like 'les Noirs'. The unfortunate inhabitants of Lapland are a 'race of men of small stature',[87] whose 'physiognomy is as savage as their customs', and they live 'in a climate uninhabitable to all other nations'.[88] Buffon's indicators of difference between peoples are colour, form and size, all of which may be subject to aesthetic judgement, and moral nature and customs. The Lapps, for instance, in Buffon's account, all share the same physiognomy of large, flat faces, snub-noses, squashed eyelids pulled back, high cheekbones, large mouths and swarthy skin. Even though there are variations among them, their aesthetic deficiencies bordering on the unnatural are taken for granted: 'Among all these peoples the women are as ugly as the men, and indeed resemble them so strongly that one cannot tell them apart.'[89] The Lapps' ugliness is a direct function of the climate, and it is united with other forms of degeneracy: 'they are equally coarse, superstitious, stupid . . . most are idolaters, and all are extremely superstitious; they are coarser than savages, without courage or self-respect or

modesty; this abject people has customs one can only despise'.[90]

The degeneracy of the Lapps has an equivalent at the other end of the climatic scale in the inhabitants of Africa. Buffon appears to accept the notion of a unitary African 'race', but at the same time he distinguishes between different African peoples, pointing out justly that 'there are as many varieties of the race of blacks as there are among whites'.[91] He does, nonetheless, wish to divide Africans into two broad racial types: 'It is necessary to divide blacks into different races, it seems to me that one can reduce them to two main ones; "Negres" and "Cafres."'[92] In claiming that it is a long-standing error to confuse Ethiopians with Nubians, who are of a different 'race', he notes that the natural colour of Ethiopians is brown or olive like Arabs, arguing that they must be of partial Arab ancestry. Furthermore, the Ethiopians are 'demi-policé', or partly civilized, suffering under a rapacious nobility. Just as there are as many varieties among the black races as there are among the white, so there are as many varieties of colour: 'Finally, in examining carefully the different peoples who make up each of the black races we can see among them as many varieties as among the white races, and we can find all the nuances from brown to black, as we have found all the nuances from brown to white among the white races.'[93]

According to Buffon, of the 'races' of 'Negres' and 'Cafres' that make up Africa, the latter include the nomadic Hottentots, but Arabs or 'Maures' are also in the mix. The 'Negres' are described in their variety, from 'Les Jalofes', who are emphatically black in colour but share 'our' ideas of beauty,[94] to the poor but cheerful 'Negres de Gorée', who take the same pride in blackness of skin as whites do in their whiteness. Even so Buffon cannot forbear to generalize on the character of 'Negres' in general, who are described as cheerful or melancholy, friendly or unfriendly, according to how they are treated. They are collectively relegated to their 'natural' status as servants, who will serve willingly a good master but hate mistreatment: 'As long as you feed them well and do not mistreat them, they are contented, happy and willing to do anything, and their spirit is visible on their faces; but if one treats them badly they take their distress strongly to heart, and often die

of melancholy.'[95] Nonetheless Buffon did speak out strongly against slavery as an essentially lawless system that can neither restrain greed nor guarantee limits to the misery of its victims.[96]

Between the antipodes of Lapps and Africans are those who live in relatively temperate climates. They are beautiful, virtuous, peaceful and well fed, except for those in the mountains or on bleak plains. Invasion and intermixture can, however, lead to very different peoples living in proximity to each other. The Tartars, for instance, vary between those living by the Caspian Sea, described by a traveller as 'the ugliest and most deformed under Heaven',[97] with flat and large faces and an enormous gap between the eyes, and the 'petit Tartares' who live near the Black Sea. These latter, however, have 'lost some of their ugliness, because they have mixed with the Circassians, Moldavians, and other neighbouring peoples'.[98]

Buffon's 'beautiful peoples' live between 20 to 30 or 35 degrees of latitude north, from 'Mogol to Barbarie', and from the Ganges to Morocco. Despite the mixture of conquerors and conquered peoples, the men are brown or swarthy, but beautiful and well proportioned. Those in the most temperate climes, Persians, Turks, Circassians, Greeks and all European peoples, constitute 'the most beautiful, the whitest, best-formed people on the whole of the earth'.[99] This connection between Indians, Eastern Europeans, Greeks, Turks and Europeans was to provide Blumenbach with the basis of the 'Caucasian' type and nineteenth-century race scientists with the notion of an 'Indo-European' race of exemplary beauty,[100] which was to be identified as the 'Aryan race'. For Buffon the attribution of beauty or ugliness to individual peoples was a matter of empirical observation. Beauty was often claimed as a general attribute of a people, but in the case of individuals and small groups it is almost always applied to females rather than the males, who are usually characterized as well or ill formed. In such judgements aesthetics, morality and the level of civility slide imperceptibly into each other; the relationship between human beauty, sexual attractiveness and propagation is always implicit.

Wolf Lepenies has pointed out that Buffon was the last 'Naturforscher' to be recognized primarily as an author, and the first to lose

his reputation for that reason.[101] Georg Forster's remark in 1777 that he was to meet 'den grossen, dichterischen Buffon' (the great poetical Buffon) perhaps suggests an ironical attitude towards the latter's scientific prowess. Even so, Buffon's belief that it was the duty of a natural historian to dramatize the hardships of the Lapps, and to evoke the pastoralism of life in the temperate valleys, influenced the most scientifically minded of the next generation – Forster himself, and Forster's great pupil, Alexander von Humboldt. For Buffon poetry and truth were not incompatible with each other. His critique of Linnaeus rested precisely on the latter's attempt to subsume nature within the realm of reason – a reason that Buffon claimed could not comprehend the living, and disallowed human feelings of closeness to and warmth towards nature,[102] the aesthetic in the sense defined by Baumgarten. In differentiating peoples, Buffon's claim was that mankind's path from original unity to fragmentation, degeneration and dispersal was an historical process, reflecting the finite existence of the earth itself. The perception of history required not the cold application of reason or a taxonomic method, but an awareness of the perceiver as making discriminations guided by personal desires and interests. Buffon thus demands of the enquirer into the history of the earth and its inhabitants, an aesthetic discrimination that allows for, indeed depends upon, an empathetic and engaged response, quite different from the passionate desire for 'apodictic' certainty that, as Georg Forster remarked later, drove Kant's taxonomies of humanity.[103]

Despite the enormous influence of Buffon's *Variétés Humaines*, climatic theory did not go unchallenged. The most considered objection was offered by David Hume in his essay *Of National Characters* (1748),[104] probably responding to the publication of Montesquieu's *Esprit des Lois* which appeared in the same year, just before Buffon's great work. Montesquieu gave a certain physiological coloration to the classical division between the vigorous, courageous yet undersexed men of the north and the more relaxed, 'luxurious' and timid men who lived in hot climates. Indians, by whom Montesquieu meant those who lived in the 'Indies', were his paradigm of cowardice, barbarity and indolence. At the opposite pole were the Germanic peoples of the Roman

age (Montesquieu claimed them as ancestors of the French), who maintained an active community without any of the elements of civilization. The east was static and unchanging, and created an ethic of inaction, while the wise Chinese promoted active virtue. The 'esprit général' of a nation was made up of climate as well as religion, laws, etc., but 'nature and climate almost alone dominate savages'.

Hume's essay, by contrast, distinguishes two general causes of the character of nations, the moral and the physical. By the former he meant 'all circumstances which are fitted to work on the mind as motives or reasons, and which render a peculiar set of manners habitual to us'. By the latter, 'those qualities of the air and climate which are supposed to work insensibly on the temper, by altering the tone and habit of the body'.[105] But while the advocates of climatic theory had argued strongly for physical causes, Hume claims that moral causes predominate. All sorts of circumstances within a society could create differences that were more important than those created by climate: 'poverty and hard labour debase the minds of the common people, and render them unfit for any science and ingenious profession'; oppressive governments might curtail civilized activities. Professions impose different characters on people, so that priests, for example, are more like each other than anybody else: 'so these men, being elevated above humanity, acquire an uniform character, which is entirely their own, and which, in my opinion, is, generally speaking, not the most amiable that is to be met with in human society'.[106] These differences within human society are also precisely what distinguish human beings from animals: 'men [do not] owe any thing of their temper or genius to the air, food or climate', but horses may be susceptible to their influence.

Nations, then, take on their character from sociability and the human desire to take on the character of the group. The character of a nation depends on 'signs of a sympathy or contagion of manners, none of the influence of air or climate'.[107] If variations can occur that owe nothing to climate, then so can consistent features of a society; in China a long-standing government has tended to promote uniformity of character despite climatic variation. Small countries next to each other can be very variable, like Athens and Thebes, as can different parts of cities;

Hume adds that 'no one attributes the difference of manners in Wapping and St James's to a difference of air or climate'.[108] Furthermore, national character tends to follow the borders of a country precisely, and these have been created by 'accidents of battle, negotiations, and marriages'. He notes also the changeability of manners over time, as in the case of modern and ancient Rome, and that close communication breeds similarity. If climate can affect animals more than human beings, then Hume argues that its influence is only at the 'vulgar' bodily level. If northerners like drink, and southerners go after 'love and women', this is because climate works on the 'grosser and more bodily organs of our frame', and not 'upon those finer organs, on which the operations of the mind and understanding depend'.[109]

If, Hume argues, the manners of a country are subject to the type of government, then the English have the most varied because of their mixed constitution. The real problem with the climatic theory, then, is a hidden political agenda, for it makes the implicit claim that only southern climes have produced men of genius; 'but our island has produced as great men, either for action or learning, as Greece or Italy has to boast of'. He does, however, accept a north–south divide: 'there is some reason to think that all the nations which live beyond the polar circles, or between the tropics, are inferior to the rest of the species, and are incapable of all the higher attainments of the human mind'.[110] But this is not a matter of climate but of 'moral' conditions: the poverty of the north and the indolence of the south, neither of which are attributable to the sun's influence or its lack. He does allow that a taste for beauty is more southern, but the linguistic arts depend on the 'manners of the people', which are fixed essentially by the great writers of the past.

It is in the context of arguing that 'almost all the general observations, which have been formed of the more southern or more northern people in these climates, are found to be uncertain and fallacious' that Hume inserted in the 1754 edition the notorious and influential footnote in which he claimed 'to suspect the negroes to be naturally inferior to the whites'.[111] This is on the grounds that 'There scarcely ever was a civilized nation of that complexion, nor even an individual eminent

either in action or speculation. No ingenious manufactures amongst them, no arts, no sciences.' The underlying reason for this prejudiced judgement, however, is, as David Brion Davis has pointed out,[112] to challenge Christian insistence on monogenesis and the Creation story, for 'Such a uniform and constant difference could not happen in so many countries and ages, if nature had not made an original distinction between these breeds of men.' It was an attack as much upon the authority of scripture as upon Africans, as his clerical opponent James Beattie noted.[113] It might also have been an expression of irritation at the 'testing' of those supposedly in a state of nature, like Francis Williams, by amateur intellectuals such as the second Duke of Montagu. Nonetheless, by arguing that 'There scarcely ever was a civilized nation of that complexion', Hume implicitly places 'negroes' in the position of animals, and therefore susceptible to the influence of climate. He appears also to condone slavery in noting 'Negro slaves dispersed all over Europe, of whom none ever discovered any symptoms of ingenuity'; they are therefore slaves because of their very lack of ingenuity.

Hume's essay *Of National Characters* was influential on Kant, as discussed in the next section, but it did not overturn climatic theory, which besides being compatible with belief in the Creation, satisfied a desire to bring some order to the diversity of humanity. It also kept alive the dream of an as yet undiscovered place that might allow a perfect harmony between physical and moral (in Hume's sense) conditions, lost to courtly societies and to modern cities. In that sense climatic theory had a strongly aesthetic resonance, conjuring up a vision of a world in which everyone might be contented, beautiful and in harmony with nature, a world that might really exist if we were to travel far enough.

KANT AND NATIONAL CHARACTER

In 1763, Immanuel Kant, in a prize essay for a competition on the question of whether metaphysics could achieve the same certainty as the science of geometry, proclaimed momentously that 'The true method of metaphysics is basically the same as that introduced by Newton intro-

duced into natural science and has been of such benefit to it.'[114] This turn to Newtonian method led away from the Cartesian metaphysics of Christian Wolff, and the deductive method of Leibniz that rested on mathematics as the model of certainty for metaphysical conclusions. The new 'science' of aesthetics came directly out of Wolff, for his pupil Baumgarten understood aesthetics to have a quite specific purpose within the framework of Wolffian metaphysics. As 'the science of sensate cognition', dealing with the world of the senses, it represented a lower faculty than that of reason, unable to attain metaphysical truth, but it could achieve a lesser perfection within the terms of sensate discourse. This privileging of a deductive method in relation to the senses was an important development, but it was not readily compatible with British reflections on the meaning of beauty. On the other hand, the very problems of assimilation and change raised by such reflections provided a stimulus for the vitality of German aesthetics in the second half of the eighteenth century, as did the study of human variety.

This chapter makes a claim for the importance of one of Kant's lesser-known treatises of the pre-Critical period, the *Beobachtungen über das Gefühl des Schönen und Erhabenen* (Observations on the feeling of the beautiful and sublime) of 1764, as a work that pioneers the absorption of current ideas of human variety into aesthetic discourse. It is Kant's only study devoted to aesthetics before *The Critique of Judgement,* though as Schiller pointed out acidly to Goethe on 19 February 1795, 'The explanation is only anthropological, and one learns nothing of the ultimate reasons for beauty.'[115] It is true that it is quite different in tone, and perhaps in seriousness, from the three great later Critiques; it has the air of a work for the general public, designed to be pleasantly instructive. The extensive notes that survive for it, however, suggest that it was boiled down from what was initially conceived as philosophically a much more ambitious work, a critique of Rousseau based on the latter's distinction between man in nature and man in society.[116] The ideas of human variety in the book owe less to Buffon than to Hume's *Of National Characters,* and the aesthetic viewpoint is, as the title makes clear, a response to Edmund Burke's *A Philosophical Enquiry into the Origin of our Ideas of the Sublime and Beautiful*, published in 1757.

In British aesthetics the sublime and the beautiful became defined as opposing rather than complementary principles, to the extent that it ceased to be possible to describe any single thing as both beautiful and sublime, a process effectively completed by Burke's *Enquiry*. Judith Hodgson has argued that beauty as applied to the human figure essentially loses ground in the eighteenth century to the masculine sublime, becoming associated with the female.[117] Sublimity had long been attributed not only to male beauty but to a range of objects, both natural and man-made, that might excite pleasurable sensations of awe, terror and wonder. Addison, for instance, mentioned 'the Prospects of an open Champaign Country, a vast Desert, a huge Heap of Mountains, high Rocks and Precipices, or a wide Expanse of Waters', the Colosseum, and Milton's *Paradise Lost*, especially the figure of Satan.[118] Burke effectively shifted the debate away from the nature of the objects that stimulated the sublime, to the feelings they provoked and why; in other words towards the psychological mechanisms of perception.[119]

Kant in the *Beautiful and Sublime* raises the further question: who might experience the sublime and the beautiful, on the understanding that different people, and indeed different peoples, are likely to react more to one than the other? Addison, Shaftesbury and Burke all discuss the ways in which stormy scenes or dramatic cliffs can provoke differing feelings from a competent observer. They do not raise the possibility that people with equal competence might have differing responses and associate *themselves* more with the beautiful than the sublime, or vice versa.

In Addison and Shaftesbury the perceiving subject is to be instructed in moral and aesthetic discrimination, whereas Burke in the *Sublime and Beautiful* insists that responses to the sublime and beautiful are universal. Nor are they dependent on the deliberate cultivation of the faculties: 'it is probable that the standard both of Reason and Taste is the same in all human creatures'.[120] For Burke the sublime is associated with things that would be terrifying if experienced directly, but which are pleasing if mediated through art. The beautiful, on the other hand, is clearly placed in the female domain: 'By beauty I mean, that quality, or those qualities in bodies, by which they cause love, or

some passion similar to it,' and it is 'confined to merely sensible qualities of things'.[121]

Burke argues that taste is itself a faculty of mind, made up of three aspects: the senses, which involve imagination and judgement; sense perception; and pleasure; all of which are common to all mankind. In doing so he explicitly rejects the self-improving subject of Addison and the learned gentleman of Shaftesbury: 'the pleasure of all the senses, of the sight, and even of Taste, that most ambiguous of the senses, is the same in all, high and low, learned and unlearned'.[122] What is more, even 'barbarians' share a sense of the sublimity of obscurity: 'Almost all the heathen temples were dark. Even in the barbarous temples of the Americans at this day, they keep their idol in a dark part of the hut, which is consecrated to his worship.'[123] The trope of the universal perceiving subject was probably not intended to be 'democratic' in the modern sense, but to bolster the book's claim in its title to be 'philosophical' in nature. Burke, we may assume, wished to have the work treated, not as a series of occasional essays directed towards an urban public, like *The Spectator* and its numerous imitators, but as a contribution to the debate on sense perception initiated by Locke, to whom he defers continually in asserting the primacy of the senses.

Yet Burke makes a Shaftesbury-like separation of lust, as a 'brutish' desire, from love: 'The passion which belongs to generation, merely as such, is lust only.' Men may be carried away by lust, 'but they are attached to particulars by personal beauty'. Because 'beauty [is] a social quality', its object is associated with 'such things as induce in us a sense of affection and tenderness'.[124] Burke also explicitly rejects the traditional connection between beauty and proportion, on the grounds that proportion is related to understanding, while beauty acts on the senses and imagination: 'beauty demands no assistance from our reasoning'. In the case of the human body good proportions are found equally in ugly bodies, and in any case there is no agreement over what might constitute correct proportion. Burke rejects explicitly, even brutally, the connection made by Shaftesbury between beauty and virtue, claiming that:

The general application of this quality [i.e. beauty] to virtue, has a strong tendency to confound our ideas of things; and it has given rise to an infinite deal of whimsical theory; as the affixing the name of beauty to proportion, congruity and perfection, as well as to qualities of things yet more remote from our natural ideas of it, and from one another, has tended to confound our ideas of beauty, and left us no standard or rule to judge by, that was not even more uncertain and fallacious than our own fancies.[125]

Kant's *Beautiful and Sublime*, as its full title makes clear (though intriguingly he has put 'Beautiful' before 'Sublime') offers, instead of a universal perceiving subject, or indeed an educated or cultivated subject, the idea of differing responses according to temperament, sex and nationality. He begins by invoking the individual, and his or her 'disposition': 'The various feelings of enjoyment or of displeasure rest not so much upon the nature of the external things that arouse them, as upon each person's own disposition to be moved by these to pleasure or pain.'[126] Human beings are thus defined in terms of their difference from each other; certain things cause joy in some and aversion in others, and we are all prone to individual and irrational passions like love. Response to the sublime and beautiful can be defined in terms of the feelings evoked by particular kinds of objects; snowy peaks and Milton's Hell are sublime in giving enjoyment mixed with horror, while meadows and valleys evoke the beautiful. But individual preference for one or the other is derived from the varied temperaments of the beholders. Kant notes, poetically,

Temperaments that possess a feeling for the sublime are drawn gradually, by the quiet stillness of a summer evening as the shimmering light of the stars breaks through the brown shadows of night and the lonely moon rises into view, into high feelings of friendship, of disdain for the world, of eternity.[127]

If the sublime moves, the beautiful charms: 'Sublime attributes stimulate esteem but beautiful ones, love.' In human terms, 'The figure of persons who please by their outward appearance falls sometimes into

one, sometimes into the other sort of feeling', and 'dark colouring and black eyes are more closely related to the sublime, blue eyes and blond colouring to the beautiful'.

Kant first defines the individual subject morally and aesthetically, according to the four temperaments. Those with a feeling for the beauty and dignity of humanity are melancholic; the good-hearted and sensitive are sanguine; those with a sense of honour are choleric; while those deficient in finer sensation are phlegmatic (see illus. 14). But these temperaments can also dictate responses to the sublime and beautiful, so that the melancholy man has a particular feeling for the sublime, for he is aware of 'the deceiving charms of the beautiful'.[128] The sanguine man, on the contrary, has a feeling for the beautiful, for he reacts to changeable impressions and is sentimental. The choleric likes the sublime in its splendid form, for he is susceptible to propriety and superficial appearance, but has 'no feeling for the beauty or the worth of actions', but those of a phlegmatic humour are able to respond neither to the sublime nor the beautiful at all.

Kant then moves to the second division of discrimination, between the male and female subject. The male is predictably characterized as noble and sublime, and the female as beautiful. Kant reveals a crabby hostility to women, attacking bluestockings, denying the value of educating women and their ability to reason: 'her philosophy is not to reason but to sense',[129] for in her mind feelings dominate. In other words women are incapable of sublimity or of understanding duty, obligation or principles. Women in representing beauty have 'beautiful' faults like vanity. Behind these arguments is the traditional attribution of reasoning to the male and feeling to the female. Kant rationalizes this distinction by attributing the taste for beauty in a marriage to the wife, but by doing so he diminishes it: 'In matrimonial life the united pair should, as it were, constitute a single moral person, which is animated and governed by the understanding of the man and the taste of the wife.'[130] Though individual responses to the sublime and beautiful vary according to temperament, Kant argues that female beauty is universal to the European perceiver, on the grounds, probably derived from Buffon, that 'the Circassian and Georgian maidens have always been considered

extremely pretty by all Europeans who travel through their lands.'[131]

The fourth section discusses the response of different peoples to the sublime and beautiful broadly in the manner of Hume's *Of National Characters*. Kant's intention is not to portray the characters of peoples in detail, but 'only a few features that express the feeling of the sublime and beautiful which they show'.[132] This limited ambition leads him into a discussion that is more redolent of a crowd-pleasing lecture to the burghers of Königsberg than a great philosopher's study: the Italians and French have a feeling for the beautiful, the Germans, English and Spanish for the sublime, while the Dutch have no feeling for either. Italians are attracted to thoughtful beauty, the French to smiling beauty.[133] Those nations attracted to the sublime all choose a different type: the Spaniards the terrifying, the English the noble, and Germans the splendid. The French and the Italian have a genius for visual arts; tragedy is associated with England and comedy with France.

In the end, however, morality is the best test of attitudes towards the sublime and beautiful. The Spanish taste for the sublime is a function of their moral character, which is honest, noble and harsh. Because the beautiful predominates for Frenchmen, they are gracious, courteous and pleasing, but they can be frivolous, as Montesquieu and D'Alembert had already noted. The English, on the other hand, with their taste for the sublime, are cool and uncaring about what people think, and are steadfast, headstrong and principled.[134] Some peoples are mixed in their character, like the Germans, who as a mixture of the English and the French, incline more to the former. The Dutch, in their benighted phlegmatic state of tastelessness, are only concerned with the useful and so respond neither to the sublime nor the beautiful.

Kant claims to be concerned mainly with European countries, but he does also 'cast a fleeting glance over the other parts of the world', applying to them similarly vacuous generalizations: 'the Arab is the noblest man in the Orient'; 'Arabs are . . . the Spaniards of the Orient, just as the Persians are the French of Asia'. Other non-European peoples are dismissed with intolerance; the 'religion [of the Indians] consists of grotesqueries', and 'what trifling grotesqueries do the verbose and studied compliments of the Chinese contain!'[135] Africans

are characterized as irredeemably phlegmatic, the Dutch of the non-European world, just as the Dutch are, by the same token, the Africans of Europe. Africans are, like the Dutch, denied all aesthetic responses, and Kant cites in support Hume's notorious footnote in *Of National Characters*: 'The Negroes of Africa have by nature no feeling that rises above the trifling. Mr Hume challenges anyone to cite a single example in which a Negro has shown talents.'[136] Hume had argued that no 'Negro' has done anything great in arts or sciences, though Europeans sometimes rise to greatness from the common people. Kant, however, not only reinforces Hume's distinction, he makes it categorical:

> So fundamental is the difference between these two families (or races) of man (i.e. black and white [*Schwarze und Weisse*]), and it appears to be as great in regard to mental capacities as in colour. The religion of fetishes so widespread among them is perhaps a sort of idolatry that sinks as deep into the trifling as appears to be possible to human nature.[137]

The word that Kant uses to stand for black and white peoples is not the one he uses later, namely 'Rasse' or 'Race', but 'Menschengeschlechter', which can mean races, but could also be used to denote division into families. In this context it acts as an absolute distinction, opposing Europeans and Africans against each other on grounds of colour, mental capacity and the latter's fetishism, the worship of material things, traditionally attributed by travellers to those for whom the spiritual world was supposedly forever closed. Kant also tells, *en passant*, a notorious anecdote about an African carpenter that ends with a deplorable generalization: 'in short, this fellow was quite black from head to foot, a clear proof that what he said was stupid'.[138] If one were to defend Kant's expressions of prejudice it would have to be on the weak grounds that his correlation of skin colour and mental capacity follows not from considered reflection on human variety, but from a desire for rhetorical symmetry.[139]

If Africans were for Kant the antitype to civilized Europeans, his reading of Rousseau encouraged him to contrast favourably the qualities of Native Americans with the luxury of present-day Europeans: 'Among

all savages there is no nation that displays so sublime a mental character as those of North America.' They have a strong feeling of honour, and 'The Canadian savage, moreover, is truthful and honest.' Native Americans have the sense of freedom and lack of subservience of the early peoples of Greece: 'Lycurgus probably gave statutes to just such savages; and if a lawgiver arose among the Six Nations, one would see a Spartan republic rise in the New World.' Kant even claimed that 'Jason excels Attakakullakulla in nothing but the honour of a Greek name.'[140]

The exercise of taste and a feeling for the beautiful is, then, for Kant, in the 1760s at least, a decisive criterion of civilization, inextricably connected to finer feelings for social order and morality. Perhaps a reading of Winckelmann, whose *Gedanken über die Nachahmung der griechischen Werke* (Reflections on the imitation of Greek art) had been published in 1755, lies behind his claim that 'The ancient times of the Greeks and Romans showed clear indications of a real feeling for the beautiful as well as for the sublime, in poetry, sculpture, architecture, lawgiving, and even in morals;'[141] the Romans changed splendour into false glitter, and the barbarians introduced the perverted taste called the Gothic or the Grotesque. Even so, Kant argues that Europeans alone had the capacity to reconcile morality with sexual desire: 'The inhabitant of the Orient . . . has no concept of the morally beautiful which can be united with this impulse'; hence the harem is always a place of unrest, a kind of women's prison, and 'In the lands of the black, what better can one expect than what is found prevailing, namely the feminine sex in the deepest slavery?'[142]

For those at the bottom of their respective national categories, the Dutch and the Africans, no aesthetic responses are allowed, and therefore no moral ones. Though Kant allows some nations – even the German – to be made up of mixed characters, Englishness or Frenchness is made part of the very being of the inhabitants of England or France. But Kant does not use the concept of 'race' except in the loosest sense. There is no concern as yet to bring forward a universal theory of humanity, but the *Beautiful and Sublime*, slight though it is in many respects, is arguably the first book of aesthetics to incorporate modern ideas of human variety.

The Climate of the Soul

The four authors discussed in this section all published volumes in the 1760s and 1770s, in different fields of enquiry, but they were united by an interest in aesthetics and human variety, doing much to bring the issues they raised into the public realm throughout Europe. Johann Joachim Winckelmann's claim for the supremacy of Greek art was influential from the moment of the publication of *Gedanken uber die Nachahmung der griechischen Werke in der Mahlerey und Bild-hauerkunst* (Reflections on the imitation of Greek works in painting and sculpture) in 1755, and his influence was consolidated in *Geschichte der Kunst des Altertums* (History of the art of Antiquity) in 1763 (illus. 16).[1] Johann Caspar Lavater's *Physiognomische Fragmente*,[2] the first volume of which was published in 1773, was a voluminous if rather chaotic 'scientific' demonstration of how physiognomy might represent the innermost soul of a person. Johann Reinhold Forster and his son Georg had the extraordinary good fortune to accompany Captain Cook on the second voyage to the South Seas in 1773, and in writing their separate accounts of the voyage brought a philosophical background to the observation of 'new' peoples.[3] In brief, for Winck-elmann the question was how to account for the supremacy of Greek art and life against the claims of other ancient and also modern peoples; for Lavater how the connection between physiognomy and the 'soul' could be maintained in the light of the apparent inscrutabil-ity and variety of human appearance; and for the Forsters how an ideal climate might affect human typologies among previously unstudied peoples.

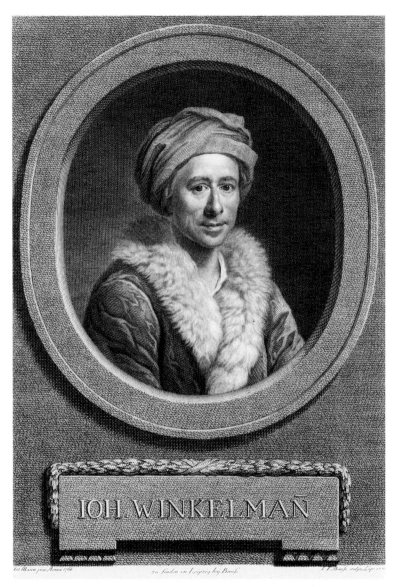

16 J. F. Bause, *Johann Joachim Winckelmann*, engraving of 1776 after a
painting of 1768 by Antoine Maron.

Johann Joachim Winckelmann's *Reflections* of 1755, and his more expansive *History* of 1764, made the ideal climatic conditions of Greece the principal determinant of the supremacy of Greek sculpture in its prime. The books argued that the Greek climate allowed the development of (male) physical perfection, and created the political and social conditions that enabled its transformation into material form as sculpture of the highest aesthetic quality. In effect, climatic and social conditions in one place (Athens), and at one brief period of time (fourth to fifth century BC), enabled the momentary collapse of the philosophically unbridgeable gap between the world of reality and the ideal world beyond experience. In this unrepeated, and perhaps unrepeatable, moment, the artist's guiding image of ideal and transcendent perfection, and the real human bodies he studied, were as one. The Aristotelian distinction between nature and the ideal, strongly maintained by all academic theorists of art, was, so Winckelmann claimed, transcended by the sheer perfection of Greek art and life at their apogee.

Can the ideal and the real ever be synonymous in this mundane world? As the poet Wieland noted, for Winckelmann's theory to be true, Greek statues would have had to be nothing more than imitations of nature rather than imaginative poetic creations.[4] Yet the ideal of human aesthetic perfection, that man had the power in the right political and social conditions to achieve and represent ideal physical form, was a potent one in the later eighteenth century, and was to remain so throughout the nineteenth and earlier part of the twentieth century. There is a tension, embodied in the very title of the *Reflections*, in the word *Nachahmung* (imitation), between the unrepeatability of the Greek moment and the belief that moderns might regain something of the Greek spirit by imitating them or their sculptures. In the *History*, a richer and more considered work than the youthful *Reflections*, the hope of revival was largely replaced by a poignant regret that such an age can never come again except in reverie.[5] The idea of constructive imitation is effectively pushed into the background by the full and subtle application of climatic theory. The *History* is, then, with Kant's

Beautiful and Sublime, written in 1764, one of the earliest aesthetic theories to have an anthropological framework, in Winckelmann's case based more on a reading of Buffon and Montesquieu. It would, however, be missing the point of Winckelmann's appeal to his contemporaries to treat the *History* as a work of philosophical rigour. His vision of an aesthetically grounded society was in itself deeply compelling, especially in Germany. The question of whether it might ever be attainable again dominated the thoughts of Goethe, Schiller and others, and contributed to the idea of the aesthetic life.[6]

Despite its affecting vision of a uniquely Greek moment, the *History*, as its title makes clear, is not a history of Greek art but of the art of antiquity; only the second of its two volumes is devoted to Greek art. The first, and less often studied, volume is about Egyptian, Phoenician and Etruscan art, and the art of other peoples, though all are considered in relation to the superior merits of Greek art. Already in the *Reflections* Winckelmann had set up the ancient Egyptians as an antitype to the Greeks. If for the Greeks daily life under blue skies was dominated by the display of beautiful, youthful bodies in natural attitudes, Egyptian artists were denied the sight of perfection because for them 'nature [was] hindered by rigid laws',[7] an argument developed more fully in the *History*.

Winckelmann makes the further claim that a temperate climate not only encourages artists, but also creates a natural good taste among the people in general, who become used to the sight of beautiful, barely clothed bodies. This in turn encourages harmonious and mutually respectful social relations between philosophers, poets and artists, as it did in the political context of the golden age of Athenian liberty following the expulsion of the tyrants: 'The high degree of perfection which art reached among the Greeks can be attributed to the happy influence of the climate, to an equally favourable constitution, to the Greek genius, to the esteem and favour enjoyed by artists, and the employment in different ways of art.'[8] The Greek climate achieved a mean between extremities of hot and cold; in winter and summer it was 'gay, sweet and agreeable'.[9] Plants flourished, as did human bodies; nature gave the body its maturity and perfection in accord with

82

the climate. Artists who lived in harmony with philosophers and were privileged by the state, were at liberty to celebrate the beauty around them, for they 'had the most beautiful forms constantly under their eyes'.[10] Art was channelled towards the well-being of the state, and artists' desire for glory and immortality was encouraged by prizes given for beauty and its representation. Bodily exercise was celebrated through competitive games, under the aegis of the greatest philosophers. A successful athlete might be honoured by a statue placed in a sacred place, where it could be seen and revered by all the people, as if he were a military victor or a God.

Winckelmann appears to have been the first in the eighteenth century to privilege the Greek climate over all others, though it is hinted at in some Classical texts. There was, however, nothing new in claiming the superiority of Greek sculpture. His choice of exemplary sculptures tends, at least in his earlier writings, to reinforce the Renaissance canon of antiquity, then mainly to be found in the Cortile Belvedere of the Vatican.[11] Buffon, as we have seen, placed the epicentre of the ideal climate somewhat east of Greece, in present-day Turkey, and perhaps only Thomas Blackwell, writing in the 1720s, had prefigured the connection between Greek culture and its climate.[12] For Winckelmann, climate was the principal, if not sole, cause of difference in the character and appearance of peoples: 'By the influence of climate we mean the effects that the diverse situation of the country, the variety of seasons, and the different forms of nutrition inevitably produce on the form of the body, particularly on the physiognomy, and ways of thinking of a people.'[13] He cites also the classical authority of Polybius, who claimed that climate 'forms the customs of nations, their figure and their colour'.[14]

Southern Italy was allowed to partake – to a lesser degree admittedly – of Greece's creative climate, but not the later more fashionable 'Caucasian' regions further east, less securely 'European', but nonetheless commended by Buffon and others for the beauty of their peoples: 'The features [of the southern Italians] are everywhere noble, spiritual, and well marked: the form of the face is normally large and full, and perfectly proportioned in all its parts.'[15] Even the common people of southern Italy may display true nobility:

Naples which rejoices in a sweet and temperate sky because it approaches the actual climate of Greece itself, produces in quantity forms and figures worthy of serving as models of ideal beauty, those who because of the harmony between their physiognomy, and the harmonious variety and expression of each part, appear to be made for masterpieces of sculpture.[16]

In Italy positive qualities become stronger the nearer one moves towards Greece and its ideal climate: 'The Neapolitans are more spiritual, more ingenious, more subtle and more wily than the Romans, and the Sicilians more than the Neapolitans; but the Greeks surpass even the Sicilians. The more the air is pure and thin, says Cicero, the more spiritual the minds.'[17]

Winckelmann makes the assumption that artists are bound to study most closely the human forms most familiar to them, and therefore reproduce in their figures the characteristic traits, physiognomy and constitution of their nation. Germans, Dutch and French, who have not travelled abroad, are, Winckelmann claims, as easy to distinguish in their figures as Chinese or Tartars, and the same must be true of pictures of them.[18] Because peoples exist in time as well as in a particular place they can and do change; foreign invasion, political upheaval and diet can all have an effect over centuries. Ancient Egyptians, living in a more agricultural society, were relatively slender; modern Egyptians, on the other hand, being now urban have become fat, as have modern Greeks for the same reason.[19]

It is freely admitted that the Greek body and Greek art were only at their apogee for a relatively brief period, for art, like man, has collectively and individually its infancy, maturity and decline. The Greeks, however, were and remain unique among peoples in having achieved a high period of moral and physical perfection, and their moment was also dependent on the unique nature of their government. Politically, the Athenian and the other Greek states were ruled by men who were not tyrants, but saw themselves as shepherds to their flock, or fathers to their people. Liberty inspired thinking that was grand, noble and

eloquent, by contrast with slave nations, whose enslavement was as much mental as physical. This ideal polity was based on early education, and there is in Winckelmann at times a didactic tone that recalls the instruction manuals of his contemporary Basedow.[20]

Winckelmann was certainly aware that his books on the ideal polity of Ancient Greece were likely to be read as an implied critique of modern Germany (they were, after all, written in German) and Europe. Indeed, a critique of contemporary materialism and philistinism lurks beneath the surface of the text of the *History* and sometimes breaks through: '[In Greece] the wisest man in a city was the most honoured and the best known; with us it is the richest.'[21] If artists in antiquity were esteemed like warriors and the wisest men of the nation made the important judgements, then the opposite was implicitly true of modern Europe. If art was used by the Greeks in their heyday for only the most noble, sacred and patriotic purposes, then the implied corollary was that the German aristocracy and bourgeoisie were correspondingly pleasure-seeking and frivolous.

If modern life is contrasted with the high point of Greek society, it is also hinted that modern society might be 'Egyptian' in its dismal values. If the aesthetic defines the ideal Greek polity, so it highlights Egypt's lack. Egyptian art is characterized by its bizarreness and concern with the extraordinary rather than the beautiful: 'it is in the imaginations that form the models of the bizarre figures of the Egyptians and the Persians, to unite in the same subject contrary natures and different sexes'.[22] Egyptian progress was thwarted by the habits of mind embodied in their religious and civil customs and laws. They left artists in poverty, and their bodies, distorted by custom, failed to raise ideas of beauty or sublimity in the imagination of their artists. The Egyptians were favoured less by nature, and were therefore less beautiful than the Greeks or even the Etruscans. They had an unhealthy preoccupation with death rather than life, as evidenced by the preservation of bodies as mummies. They were not born for joy and pleasure, but were naturally sombre and melancholy.[23]

Because the Egyptians remained with the first style, the stage of 'necessity' that preceded that of 'beauty', their art did not evolve to

reach the stage of true grandeur. Winckelmann gives several reasons for this. Innovation was forbidden to artists, with the result that statues remained unchanged in type for thousands of years, forcing artists to become servile imitators. There was no artistic education 'capable of raising up their souls to the idea of the great and the beautiful'.[24] Their figures were stiff and constrained, lacking knowledge of anatomy, for the Egyptians were too respectful of the dead to dissect corpses. In their sculpture physiognomy was similarly formalized. Eyes were always oblique and flat; they could not achieve the sweet profile of Greek heads, insisting instead upon copying gross nature with all its faults.

The Greeks and Egyptians represent the positive and negative poles of the art-making peoples of the ancient world, who existed, for Winckelmann, only on the shores of the Mediterranean. The Phoenicians were among the most accomplished after the Greeks in their heyday, and preceded them in achieving a level of civilization. They lived in a pleasant climate, with good health, claims to physical beauty, and a good reputation in the sciences and arts in the ages before the rise of the Greeks: 'The sciences flourished already among them, while the Greeks were still plunged in the shadows of ignorance'.[25] The Phoenicians were famed for their magnificence, and spread commerce across the world. Winckelmann claimed that they, and not the Egyptians, had a presence in ancient Greece, setting up temples there to Hercules. Regrettably, of their art only coins survive. Of all ancient peoples, the nearest in circumstance to the Greeks were the Etruscans. They had a benign form of government, which gave them sufficient liberty to allow them to raise themselves towards perfection. Their king was not a despot, and they were so anti-monarchical and jealous of liberty that they were unpopular with other peoples, especially the Romans. Their artists were admired and recompensed, but never achieved Greek perfection. Even in the best times their art exhibited 'a taste for excess'.[26] They were bilious in temperament and melancholy in their worship and religious customs. They were untouched by beauty and lacked 'sweet feelings', despite having gods in common with the Greeks. The first style of the Etruscans was the most remarkable; the second style really imitative of the Greeks. Winckelmann compares

them to a young man deprived of good education, at the mercy of his desires, by contrast with the Greeks, whose passions were governed by a good education that gave beautiful form to natural qualities.

Of what then does the beauty of the Greeks consist, that other nations have failed to achieve? Winckelmann is clear about the climatic and social causes of beauty, but less so about its nature. We can only deduce it imperfectly from his writing, but it is expressed in harmony between function and achievement, and the harmony of all parts among themselves, resulting in perfection of the whole. Beauty is an idea that raises us above the material world in all creation, approaching perfection as it approaches the thought that God invested in it. It unites contraries of variety and unity, and it involves for the artist an intense study of the human body.[27] Winckelmann's concept of beauty is strongly influenced by Shaftesbury, whom he is known to have read,[28] yet everything he writes about actual sculptures, like the *Apollo Belvedere* and the *Laocoon* (illus. 17 and 18), is filled with sensual and poetic emotion, as contemporaries recognized.[29] There is no suggestion in Winckelmann's thought of human beauty as a source of heterosexual attraction, and therefore as part of the imperative of reproduction. The ultimate source of beauty, in Winckelmann as in Shaftesbury, is God, but Winckelmann is equivocal over the question of whether Greek art represented an absolute standard of beauty or not. He accepts that there are different ideas of beauty, that they may even differ from one individual to another; but he also claims that in most 'civilized' countries, whether in Europe, Asia or Africa, there is a similar sentiment as to what constitutes beauty in general. Beauty is not arbitrary: 'Those who doubt the reality of beauty and who regard the idea of beauty as a chimera, assume that because physiognomy is different among the different nations, if they are compared one with the other they must have different ideas of beauty.'[30]

Winckelmann is, however, clear that Greek beauty was not associated with man's original state in a pre-lapsarian world. Greek sculpture represents a *developed* beauty, not one given by God to the first human beings and lost to later generations. Nor does he claim that Greek art represented the ideal of European beauty, and he was

17 *Apollo Belvedere*, marble. Vatican Museums, Rome.

18 *Laocoon*, marble. Vatican Museums, Rome.

probably aware that the ancient Greeks did not necessarily consider themselves European. On the other hand, he did find deformity in what he believed to be salient bodily characteristics of non-European peoples. The horizontal eyes of the Chinese are 'an offense against beauty', just as the squashed nose of Calmucks, Chinese and other peoples is 'an irregularity', incompatible with the unity of form of the body.[31] These 'deformities' may well be caused by climatic conditions, as in the case of Africans: 'The mouth swollen and raised, such as the Negroes have in common with the monkeys of their country, is a super-fluous excrescence, a swelling caused by the heat of the climate, as our lips are inflated by heat, or by an abundance of bitter humours; a swelling that anger can also produce.'[32] Such deformities were intensi-fied among peoples who live in places that suffer from extremes of climate: 'The more that Nature approaches the contrasting extremities

of hot and cold, the more she produces beings of an imperfect form.'[33] Yet he is prepared to allow that 'A negro could perhaps be beautiful, if his or her physiognomy is regular.'[34] He tells of a traveller who insisted that a daily conversation with a 'Negro' made him forget his colour, and allowed his traits of beauty to become visible.[35] Furthermore, though the 'vulgar' might associate blackness with the Devil, Winckelmann argues that, for instance, bronze or black basalt does not affect the beauty of antique heads when used as a medium like white marble. He cites the head of a woman in the Albani collection and a head of Scipio in the Palazzo Rospigliosi, claiming that they surpass in beauty three others in white marble.[36]

Winckelmann in the *History* is unusually sensitive in his descriptions of canonical Greek figures to the attitude of the whole body, and the way the parts unite in a coherent action. Even so, he emphasizes the importance of physiognomy and especially of the profile: 'The Greek profile is the first character of great beauty in the formation of the visage.'[37] He notes in the *Reflections* that famous women represented on Greek coins in profile were modelled after the ideal, and this ideal 'was as peculiar to the ancient Greeks as flat noses are to the Calmucks, and small eyes to the Chinese'. The profiles of known rulers on ancient coinage were the key evidence of date,[38] and stylistic comparison with the profiles of sculptures was a way of creating a chronology out of stylistic differences. The ideal profile, he argued in the *Reflections* initially, should be almost a straight line, and the indentation separating the nose from forehead should not be too deep. But this ideal could not be observed in real life, except presumably in the brief heyday of Greek art, for it transcended the common shapes of matter; 'Only with Gods and Goddesses did the forehead and nose make a straight line.'[39]

Martin Bernal has argued that Winckelmann sought to remove Greek culture from the 'taint' of a long-recognized and historically demonstrable African ancestry, by denying its derivation from the ancient Egyptians.[40] It is true that Winckelmann made slighting remarks on Egyptian physique and culture. He also denied, and he was far from alone in doing so, that Greek artists knew of Egyptian art, claiming that they were forbidden to go to Egypt, even though he

admits that early Greek sages voyaged to Egypt to acquaint themselves with customs and government. For good or ill, Winckelmann's claim is that the Greeks were closer to the Phoenicians, with whom they had trading connections, than they were to the Egyptians. But Winckelmann plainly does not equate the Egyptians with Africans, despite Herodotus' estimate that 240,000 Egyptians emigrated to Ethiopia, bringing with them their customs, that the Egyptians themselves were governed by a series of Ethiopian kings, and had some 'African' features: they were brown, dark or tanned, and had flat noses.[41] They also shared with Ethiopians the desire to preserve the traits of the dead, though Winckelmann claims that the Ethiopians probably learned the custom from them. This is, however, very different from claiming that Egyptians *were* 'Africans', even if they inhabited the same continent. Nor did Winckelmann claim that Egyptian art was inherently defective, but rather that it suffered from arrested development due to climatic and political reasons. These are quite different reasons from the traditional ones used to condemn African culture. The Egyptians, with their cold yet suffocatingly formal culture and their autocratic government, are portrayed as being more like the Papal government than anything else. They might even invoke Herder's 'bourgeois [German] people . . . the antipodes of humanity'. Whatever Winckelmann's Egyptians were, they were not 'savage'; indeed he implies that they would have benefited from an infusion of animal spirits. Similarly, Greek art did not come fully formed into ideal beauty. Ideal beauty, Winckelmann argues, is the culmination of several stages of development, one of which is the 'Egyptian' stage itself. As with all things, it then passes beyond its ideal stage into decadence.

Winckelmann's Greeks, furthermore, did not constitute a 'race', but a 'Nation',[42] without any of the implications of organic culture that Herder was to give the latter word. They were formed, as it were, by history and contingency, though Winckelmann does on occasions write of Greek 'genius', but such genius could flourish only in Greece, and perhaps southern Italy, because of climate, and only because social and political conditions made it possible at a particular time. Had the Greeks been exiled or obliged to work in a hotter or colder climate,

Winckelmann is clear that they could not have made works of ideal art. Yet the very idea of a Golden Age attached to a real place and real time, which offers a truly aesthetic society, in which all lives are lived as a work of art in harmony with others, was an irresistible vision for the future. If Winckelmann appears to have had little faith in the possibility of Germany becoming an aesthetic society, this did not stop others dreaming of detaching the great vision from the Greeks to apply it to their own peoples, or even to Europe in general.

THE PHYSIOGNOMY OF THE SOUL: LAVATER

The Physiognomic Idea

Johann Caspar Lavater's 'discovery' of physiognomy was in its own way just as influential in the 1770s as Winckelmann's histories, and perhaps even more enduring at a popular level (illus. 19). His thoughts on physiognomy were first published in a short volume, *Von der Physiognomik* (On physiognomy) in 1772, then in the sensationally successful *Physiognomische Fragmente, zur Beförderung der Menschenkenntnis und Menschenliebe* (Essays on physiognomy designed to promote the knowledge and love of mankind) (1775–8), produced initially with the active participation of the young Goethe.[43] It is a work in four very large volumes, containing over 800 fine plates by the best engravers after contemporary masters like Daniel Chodowiecki. It took over four years for all the volumes to appear, during which time Lavater was able to draw into the later volumes criticisms, some satirical or dismissive, of the earlier volumes, and long extracts from the works of other authors on allied topics, replying to them all. The volumes are not arranged methodically, but contain sections on a wide variety of applications of physiognomy, and extracts favourable to physiognomy ransacked from numerous sources. It is not held together, as was Winckelmann's *History*, by a strong chronological and stylistic framework. The French translation (1781–1803), the basis of the English translation, was enlarged and reorganized with Lavater's approval.

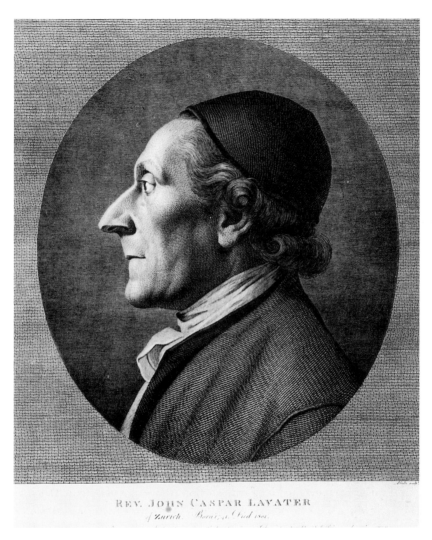

REV. JOHN CASPAR LAVATER
of Zurich. Born 1. Died 1801.

19 William Blake, *Revd John Caspar Lavater*, engraving of 1800 after an anonymous drawing of 1787.

The volumes are perhaps best seen as a kind of anthology of facial types and commentaries on physiognomy. In addition, Lavater's views on physiognomy were expressed in his own collection of prints and drawings, his 'Kunstkabinett', now mostly in the Österreichische Nationalbibliothek in Vienna, and only recently published.[44] This archive consists of approximately 22,000 images, largely portraits and mounted in his characteristic manner, with coloured borders, and there are further groups in other collections. Almost every image has a brief commentary in Lavater's own hand, identifying the kind of character to be deduced from the physiognomy, and they are usually meticulously dated to the day, a practice that went on long after the publication of the *Physiognomische Fragmente*. The Kunstkabinett may have started as a repertoire of images for the volumes, but after their publication Lavater continued to build up the collection until the end of his active life. They were mostly kept in book-shaped boxes, forming a kind of library, ordered like a collection of botanical or geological specimens.[45]

The Kunstkabinett contributed to Lavater's ambition to build the case for the 'science' of physiognomy as much by the systematic publication of data, as by deduction and argument. The gallery of faces in the *Physiognomische Fragmente* was intended to demonstrate the efficacy of the method, dealing with hard cases and answering doubts. Lavater's theory is essentially semiotic; the inward life is to be revealed by signs legible on the face, making up a kind of natural language.[46] This natural language preceded, and was to be understood as more eloquent than words. It could lay bare what was concealed by the signs of human status: 'Rank, condition, habit, estate, dress, all concur to the modification of Man, every one is a several veil spread over him.'[47] The human face was 'the most beautiful, eloquent of all languages, the natural speech of wisdom and virtue'.[48] If Winckelmann's premise was that a Golden Age had once existed in actuality, Lavater's was of a direct and accessible correlation between outward physical beauty and inner goodness, and between physical deformity and moral turpitude. Even those aware of the intellectual contradictions of these two authors were beguiled by the redemptive vision they offered: Winckelmann through poetic description and evocation, and Lavater through

incantatory insistence combined with conversational immediacy, in the 'Sturm und Drang' manner. The words from Genesis, '*Gott schuf den Menschen sich zum Bilde!*' (God created man in his own image), act as the epigraph for the work; they are repeated on the title-page of each volume, and many times in the introduction alone, giving a fashionably bardic tone to his utterances.

Lavater's project began with the support of rising intellectuals like the young Goethe,[49] but within two decades it had fallen from academic favour, living on in popular literature and in what Ernst Gombrich called the 'physiognomical fallacy'.[50] Physiognomy was defined later by Kant as 'the art of judging what lies within a man, whether in terms of his way of sensing or of his way of thinking, from his visible form and so from his exterior'.[51] But this definition does not convey the religious fervour that lay behind Lavater's project, what Henry Fuseli, in his introduction to the first English edition, calls the author's 'luminous zeal in his clerical capacity'.[52] For Lavater 'what lies within a man' was the soul; hence physiognomy could be a way of deducing from a person's appearance the depth of their moral character and spirituality. Lavater does allow for the possibility of other uses for physiognomy, on the assumption that the mind is made up of three faculties – the moral, the intellectual and the physical, each with its appropriate physiognomy: moral ('the disposition toward good and evil'), intellectual ('the faculties of human understanding'), and the external form.[53] The moral predominates throughout the four volumes.

The connection between the inner and outer was primarily aesthetic; a beautiful appearance was precisely indicative of a beautiful soul, and vice versa: 'The face's beauty and ugliness have a true and exact relationship to the beauty and ugliness of a person's moral condition. The better the morals, the more beautiful; the worse the morals, the uglier.'[54] Lavater thus took for granted the most extreme formulation of the ancient concept of *kalokagathia*, that physical beauty and moral goodness were synonymous, as were ugliness and vice. He probably derived the idea ultimately from Shaftesbury, though he admits to few intellectual forebears, especially those connected to the Enlightenment. He claimed not unjustly that much previous writing on the subject was

worthless: 'wretched things have been written on the interpretation of the face',[55] including in this condemnation virtually all previous treatises on physiognomy, including 'Aristotle', on the grounds that they compared human physiognomies to animal types, something he rejected. Indeed, it is at the heart of his enterprise to resist the human–animal comparison, which had a long tradition of representation in the visual arts from Leonardo to Stubbs in his own period, but which was associated with the further reaches of Enlightenment materialism, like La Mettrie's *L'homme machine*, published in 1748.[56] Human–animal comparison was, of course, a gift for caricaturists, and Thomas Rowlandson, in his caricature of Dr Gall the inventor of phrenology, turned the joke on those who sought to derive personality from the head's protuberances (illus. 20).

Lavater was essentially an intellectual scavenger, but the core of his thought was firmly Protestant and anti-Enlightenment. He was more of a professional preacher than either Herder or Winckelmann, who were also in holy orders. His list of 'Authorities', in which he cites earlier references to physiognomic principles, includes the Bible, especially Ecclesiastes; some classical authors; Leibniz, Wolff and von Haller, adding in the French edition an extract from a work by Herder (misinterpreted in this case).[57] He omits Locke, Hume or any trace of British empiricism, confining himself to overtly Christian authors among the moderns. Still, his fame and the hopes he raised in the mind of the young Goethe were surely owed to his vigorous claim that his method of physiognomy might reveal through rational enquiry God's purpose for man. The physiognomist in Lavater's conception was, in the highest form, a transcendent being, an intellectual and moral guide to the modern era, a scientist, a philosopher, and a theologian.[58] Lavater, however, does not claim such a level of accomplishment for himself: 'I am very far from being a Physiognomist. I am but a fragment of one; just as the work I present to the Public contains not a complete Treatise, but merely Fragments of Physiognomy.'[59]

Lavater, then, claimed that physiognomy was not only metaphysical but was a branch of natural philosophy like physics, medicine, theology, mathematics and aesthetics ('*schöne Wissenschaften*' in

20 Thomas Rowlandson, *Dr Gall with Fellow Phrenologists*, 1808, etching.

the German edition and 'Belles-Lettres' in the French and English editions), the last of which is 'comprehended under the department of literature, as it unfolds and determines the idea of the beautiful, the sublime, etc.'.[60] If the connection between the outward physiognomy and the moral worth of an individual were substantive, then science and religion would be mutually self-reinforcing. Virtue would reveal itself in the human face with scientific precision to those who had mastered the physiognomical method; vice could no longer hide behind an ingratiating or deceiving manner. At another level science would reveal itself as a servant and not a threat to religion, but – and this also was perhaps part of Lavater's attraction – science was not to be the dry accumulation of data, but was to involve vigorous human engagement. As he remarked with habitual vivacity, 'What is science where everything agreeable – taste, feeling or genius – has been left out? It would be a sorry state of affairs if science were to be such a thing!'[61]

There are indications of Lavater's desire to systematize and give numerical proportion to the differences between profiles. Ideally a head should have a perfect balance between breadth and height; long heads were a sign of obstinacy or weakness, while short heads signified inflexibility or sensuality, though Lavater gives no reasons why this should be so. He offers at one point a division of the profile into nine sections, the proportions of which can vary from person to person, but he does not follow the possibilities through, noting prophetically that such a project would need 'a Mathematical Physiognomist of the next age'.[62] Such a division of the profile also looks back to Dürer, who as an aid to drawing the head accurately, divided the profile into three: forehead to eyebrows; eyebrows to extremity of nose; and nose to point of chin.[63] Lavater believed that the forehead was especially susceptible to measurement; accordingly he invented a 'frontometer' for measuring foreheads, which is described and illustrated in detail in the fourth volume of the German edition. He omitted the illustration from the French and English editions, because he believed 'it is impossible either to describe or draw it with sufficient accuracy, to have it executed according to my idea'.[64]

Despite a concern with scientific procedures, the ideal physiognomist was to be possessed of 'physiognomic discernment', 'united to a sense of beauty and deformity, to a sentiment of perfection and imperfection'. It was 'a new form of knowledge [that] will awaken in the heart of Man a love of what is noble and beautiful . . . accustomed henceforth to the immediate contemplation and sentiment of the beauty of virtue, or the deformity of vice, a charm irresistibly sweet, varied, yet constant, will necessary attract us toward every thing which tends to the perfection of our nature'.[65] Lavater, with an unacknowledged look back to Shaftesbury, explicitly compares the physiognomist's skill in discerning human character to the art connoisseur; he is able to gain the same pleasure from looking at people in the street as the connoisseur does from a work of art. It is, however, a 'secret ecstasy', for 'He alone comprehends the most beautiful, the most eloquent, the least arbitrary, the most invariable and energetic of all languages, the natural language of the heart and mind, of wisdom and of virtue.'[66] The physiognomist must also be a connoisseur of works of art as well as people: he 'whose soul is not elevated by the sublimity of the Apollo, and who feels it not even after Winckelmann; he who is not affected, almost to the shedding of tears, in contemplating these ruins of the ancient ideal perfection of humanity . . . that Man, I say, will never become a tolerable Physiognomist'.[67]

The face of virtue could offer a gateway to Heaven, yet ultimately it could only be fully deciphered in Heaven. A full reading of a face was beyond normal human understanding and could be achieved only by a man of genius, if at all. In addition, this man of genius would have to possess not only special skills and the correct method, but also great beauty himself. (There is some irony in the fact that Lavater always assumed the physiognomist to be male, but in the nineteenth century physiognomy became a female pastime.) The absoluteness of the correlation between physical beauty and morality led Lavater to exclude ruthlessly those with physical disabilities from the possibility of ever being physiognomists. He notes that 'In other times, persons labouring under any bodily defect or blemish, the blind, the lame, one who had a flat nose, were all forbidden to approach the altar of the Lord. The

entrance of the Sanctuary of Physiognomy must, in like manner, be shut against all who appear before it with a perverse heart, squinting eyes, a misshapen forehead, a distorted mouth.'[68] This claim opened him to the acute and witty dissections of Georg Christoph Lichtenberg, who was a hunchback.[69]

There is a tension in Lavater's system between a desire to emphasize the metaphysical nature of the enquiry, and to make claims for its value in making judgements of people in social situations.[70] The theological basis of Lavater's thought was Pietistic; one might read God's word in nature. Physiognomy was therefore to him a kind of heavenly language that might transcend the imperfections of earthly language. This longing for a transcendent language was shared with Herder and Hamann, and suggests an analogy with (and even influence on) William Blake's idea of 'Visionary Forms Dramatic', a heightened form of discourse that would unite all the arts in transcendent communication.[71] Certainly Blake, who did four engravings for the English edition of the *Physiognomische Fragmente* and annotated his own copy of Fuseli's translation of Lavater's *Aphorisms*, adored him; on the title-page he touchingly enclosed his own name with Lavater's inside the outline of a heart.[72]

The physiognomist, then, embodied all the human qualities of mind, heart and body: perfect physique, observation, imagination, lively and discerning spirit, 'extensive acquaintance with, and superior skill in the Fine Arts', a 'soul, firm, yet gentle, innocent and calm', and a 'heart exempted from the dominion of the ruder passions'.[73] The one human being Lavater believed had something of the physical and mental perfection for the task was his assistant on the project, Goethe, for whom he showed a lifelong passion, probably not without an element of sexual longing. Goethe appears more than once as an ideal physical type in the *Fragmente* (illus. 21), and Lavater had a substantial collection of drawings and prints of the poet in his collection.[74] But Goethe's eventual rejection of Lavater must have caused pain, for the former no longer appears prominently in later editions and translations of the *Physiognomische Fragmente*.

21 Johann Heinrich Lips, *Medallion Portrait of Goethe*, engraving, from
Johann Caspar Lavater, *Physiognomische Fragmente* (Leipzig and Winterthur,
1775–78).

It follows from Lavater's insistence on the identity of beauty and virtue as a sign of God's wisdom that he should advocate uncompromisingly a universal or 'natural' standard of beauty. This standard was to be applied to all nations equally, overriding local standards and canons as created by 'the contradictory and often very extraordinary ideas which different nations have formed of the beauty of the human figure'.[75] All deviations are a form of parochialism against the universality of true beauty: 'as none except Negros admire a flat nose . . . it is evident that nothing but the tyranny of an ancient national and hereditary prejudice could have extinguished or altered . . . the natural sentiment of the beautiful'.[76]

With the exception of Raphael, '"ein apostolischer" Mann', Lavater was generally condescending towards artists, whom he saw essentially as imitators of nature. Even then it is Raphael's ability to draw out the moral character of the faces he depicts that gives him his distinctive qualities. On an outline engraving for the Kunstkabinett, probably by Johann Pfenninger after a *Madonna* assumed incorrectly to be by Raphael (illus. 22), Lavater notes in pen that it is a '*Madonna nach ein[em] Raphaelschen Original*', and lists the qualities revealed by the image: 'humility, piety, calmness, patience, worship, and love'.[77] Michelangelo, by contrast, has no presence at all in the *Fragmente*. Furthermore, Lavater expresses no sense of aesthetic pleasure in the human body apart from the physiognomy; human beauty being invested almost entirely in the head and specifically in the skull. Even the fleshly covering, which contains all the face's expressiveness, 'is only . . . the colouring which relieves the drawing'.[78]

Lavater frequently expressed admiration for Winckelmann, incorporating large chunks of text from the *History* throughout the volumes, but he also warns against notions of ideal beauty, the grand manner, the high style or antique taste.[79] On the grounds that 'my rule is Nature', Lavater denies that ancient artists had a 'poetical genius superior to moderns', but accepts Winckelmann's claim that they had before them 'models more perfect, a more beautiful Nature'. Lavater

22 Johannes Pfenninger (attributed), *'Raphael' Madonna*, engraving,
annotated and dated (25 September 1795) by Lavater. Private collection.

thus essentially denies to artists creative powers: 'Man cannot create . . . Imitation is all that is ever allowed to man; it is his life and disposition, his nature and his art.'[80] Man can no more create anything than he can create a language: 'no one can create a language; all language is imitation'.[81] All artists are therefore copyists of nature, but the man of genius produces a superior imitation by having a sense of 'one homogeneous whole', or unity of the parts.

The superiority of the art produced by the Ancients is then a function of the nature they had before them. Lavater freely accepted Winckelmann's notion that the Greeks were themselves more beautiful and morally whole than the moderns: 'The Greeks were not only more beautiful men – they were better men!'[82] It is inconceivable that beautiful nature could be made more beautiful;[83] art must forever exist on a lower plain than nature.[84] But the Greeks were of course pagans, so Lavater justifies their superior beauty by a conventional lament on the falling-off of the moderns from religious feeling: 'many Pagans of Antiquity followed the light of their reason with much greater integrity, than many of us Christians of the eighteenth century follow the light of our religion'.[85] But Lavater does not labour the superiority of the Ancients either in reality or in sculpted form, and antique heads have only an infrequent presence in the volumes.

If physiognomy was a more 'natural' form of communication than speech or gesture, both of which could be schooled in insincerity and polished by court life, then as a form of communication that went straight to the human soul, it was a valuable weapon for truth. How then could the physiognomist in practice penetrate the outward form of the face? Lavater's answer was that a person's physiognomy and its permanent character were primarily dependent on the form of the skull, which was shaped over time by the brain. The cavity of skull fits around the substance it contains, the brain, hence the form of skull is sufficient to determine with certainty 'the energy or the weakness of the character of the individual'.[86] The face was subject to the soul through a process by which repeated expressions affect and form first the soft parts of the face, and eventually and more permanently the hard parts: 'A graceful impression repeated a thousand times, engraves itself on the

face, and forms a trait at once beautiful and permanent – in like manner, a disagreeable impression, by frequent repetition, fixes at last on the countenance habitual marks of deformity', for 'every mental emotion produces a change in all the flexible parts of the face.'[87] The skull could not be altered by the act of expressing emotion, as were the soft parts of the face and body, for it took its shape from the way the brain itself changed shape as a person's character developed and solidified. These are fixed, permanent facial features, and Lavater distinguishes them from pathognomy, the study of the moving parts of the face that express feelings and passions.[88] This distinction between the hard and soft parts of the head privileges the skull as permanent and unaffected by transitory emotions, impervious to alteration except by the slow development of a person's inner character. This was taken by Lavater to imply that the skull had a superior value as knowledge, offering a deeper insight into the soul than the superficialities of outer appearance, though in reality Lavater's judgements are dependent on the 'soft' features, like the mouth.

Lavater's ideal human head is illuminatingly different from Winckelmann's Greek ideal, which was based on a strongly, if not absolutely, vertical profile, running continuously from forehead to nose. Lavater comments on the profile of a skull that it is 'too perpendicular, and bears upon it the indication of want of understanding and delicacy [on the part of the subject]'.[89] He praises the forehead of the Apollo for being 'neither too perpendicular, nor too sloping' (illus. 23),[90] but ridicules a series of Greek female profiles after Alexander Cozens, *Principles of Beauty Relative to the Human Head*, 1777–8 (illus. 24),[91] which have straight lines running from forehead to nose: 'But what monotony! what disgusting stiffness!'[92] Lavater reveals here an unexpected sympathy for Hogarth, whose *Analysis of Beauty* he could have read in one of two German translations of 1754, or learned of through many references in contemporary literature.[93] Lavater's remark that 'Nature delights in variety, and the straight line is the very essence of monotony', echoes Hogarth directly in its emphasis on the variety of nature, and he extends the principle to argue that 'Nature is the sworn and irreconcilable foe of perpendiculars', and to dismiss the Grecian

APOLLO.

23 Anker Smith, *Apollo Belvedere in Profile*, engraving from John Caspar
Lavater, *Essays on Physiognomy* (London, 1789–98 [i.e. 1788–99]).

24 *Three Ideal Heads in Profile*, engraving after Alexander Cozens from John
Caspar Lavater, *Essays on Physiognomy* (London, 1789–98 [i.e. 1788–99]).

straight profile: 'A straight profile, be it Greek or not, is then a mere chimera, and no where in reality exists.'[94]

Lavater, by contrast with Winckelmann, claims a prominent aquiline nose to be a sign of strength, and a receding forehead to be a sign of intelligence. Lavater's ideal head is best understood as that of Goethe himself, to whose physiognomy he devotes a whole 'Fragment' in the third volume, for 'what simplicity and grandeur there is in such a face!'[95] His forehead reveals 'true and rapid understanding',[96] his eyes 'traces of powerful genius',[97] and his nose 'expresses in full productivity, taste and love; in other words, poetry' (see illus. 21.).[98] Noses, for Lavater, could be not only poetic but also commanding, and this is the case with Goethe's equivalent in the world of affairs, Frederick II of Prussia. The poetic and the commanding nose have in common the fact that they form an almost continuous line with the slope of the forehead (illus. 25).

Men of achievement and rank from the Germanic lands predominate among the very many silhouettes, profiles and portraits in the *Physiognomische Fragmente*, and they are analysed according to the way visible traits reveal character. In the second volume, which appeared in 1776, Lavater does address the question of national varieties. He notes that members of nations have similar skulls to each other through the 'influence of climate, the power of imitation and of habit'.[99] His tone, however, is tentative here, and he suggests leaving the issue to the Dutch physiologist Pieter Camper, with whom he was evidently in touch at the time.[100] He still describes three different types of skull: the rounded skull of the Dutchman; the rude and coarse skull of the Calmuck, flattened on top, and the erect and stiff one of the Ethiopian, narrowed towards the top.[101] He also presents an engraved plate (illus. 26), containing four pairs of skulls seen from three angles, as follows:

1 The German: 'every thing about it bears the impress of a European head, and it sensibly differs from the three which follow'. It belonged to an individual of 'a character, cold, reflecting and active'.

25 Daniel Chodowiecki, *Frederick II of Prussia*, engraving by James Heath
from John Caspar Lavater, *Essays on Physiognomy* (London, 1789–98 [i.e.
1788–99]).

26 *Skulls Representing Different 'Nations'*, engraving from John Caspar Lavater, *Essays on Physiognomy* (London, 1789–98 [i.e. 1788–99]).

2 The Indian, with the crown of the head pointed: 'A scull thus conformed announces a person whose appetites are gross and sensual, and incapable of being affected by mental pleasure and delicacy of feeling.'

3 The African: 'bone of the nose is too short, and the sockets of the teeth advance too much; hence that little flat nose, and those thick lips, which are natural to all the nations of Africa'. There is also a disproportion between forehead and rest of profile. 'That excepted, the arch of the forehead considered by itself, bears not that character of stupidity which is manifest in the other parts of the head.'

4 The Nomad Tartar or Calmuck has a forehead like a monkey: 'A flat forehead and sunk eyes generally pass for signs of cowardice and rapacity.'

From these arbitrary examples Lavater drew an 'incontestable truth': 'That every remarkable concavity in the profile of the head, and conse-quently in its form, denotes weakness of mind: it seems as if this part were sinking in search of support, as a feeble constitution naturally seeks to prop itself by foreign aid.'[102]

As these examples reveal, Lavater's *Physiognomische Fragmente* does not deal methodically with questions of nationality or human vari-ety, nor does it attempt a human or racial hierarchy based on physiog-nomy. In fact the volumes contain relatively little reference to national or racial types, and Africans make very few appearances. It is possible that he regarded non-European heads as irrelevant to his enterprise, but inevitably, issues raised by them are present in the rich and uncon-trolled accumulation of ideas the volumes contain. The insistence that God created man in his own image makes the theologically orthodox basis of Lavater's views unequivocal. He at no point talks of 'race'; his classification, such as it is, is like Kant's in the *Observations* of 1764 based on a world made up of a wide variety of 'nations'. One plate in the *Frag-mente*, for example, has the title 'Compare a Negro and an Englishman, a native of Lapland and an Italian, a Frenchman and an inhabitant of

Terra del Fuego.'[103] His reading on peoples beyond Europe seems to have been confined largely to Buffon, though he does cite Montesquieu on occasions. He notes, following Buffon, the variety of Africans: 'There are as many varieties among the race of Negroes as among Whites', and that they vary enormously in appearance and attractiveness. Yet, as Judith Wechsler has pointed out, he also refers on occasions to the collective 'Negro' as if Africa were one people with common characteristics.[104]

Another and more unattractive picture of Lavater's views of non-Christian peoples emerges from a study of the Kunstkabinett. A drawing by Johann Rudolf Schellenberg of a group of assorted nations from regions remote from Europe, is captioned: 'each nation lacks any image of godliness'.[105] 'Mohren' or blacks are treated with coarse contempt and condescension. A young black boy in silhouette is captioned: 'Feed him – that will keep him happy',[106] and an outline engraving of a head, in three-quarter face, of a black with unusually prominent lips, is captioned 'animalistic humanity'.[107] That such private prejudices were not expressed in *Physiognomische Fragmente* is perhaps evidence of a new climate of support for the abolition of slavery in the 1770s. The volumes were in process of publication from 1775 to 1778, and it may be that abolition had become a sufficiently popular cause in the German lands to make offensive generalizations about Africans unacceptable in enlightened circles.[108] It is interesting in this connection that Lavater had already made a significant change between *Von der Physiognomik* published in 1772 and the first volume of the *Physiognomische Fragmente* published in 1775. In the former he makes the claim that the mind of a Newton could not exist in the head of a black, on the grounds that it was impossible to imagine that 'in the head of a Moor, with flattened nose, eyes protruding from the head, lips so fleshy and round that hardly reveal the teeth, the planets could be tracked and a beam of light split [into its components]'.[109] Criticism of this remark evidently led Lavater to change the comparison when he came to write the *Fragmente*, but only to change the object of contempt. Good sense is instead 'shocked at the idea of maintaining, that Newton or Leibnitz [*sic*] might resemble one born an idiot', and the head of a 'Mohr' has been

replaced by 'the head of a Labradorean who cannot count to six and calls everything beyond that number beyond measure'.[110]

Such stubborness is characteristic of Lavater's response to criticism. In response to Buffon's cogent objections to physiognomy, which he reprints in the second volume, Lavater asks rhetorically 'Must it be madness too to say, that one forehead announces more capacity than another, that the forehead of the Apollo indicates more wisdom, reflection, spirit, energy and sentiment than the flat nose of a Negro?'[111] Lavater's point is that 'savages', as indicated by physiognomy, lack the possibility of a transcendent mind: 'who could expect, on the promise of their physiognomies, from these Savages [from Terra del Fuego], a single page written with the elegance we admire in the numerous volumes of of Buffon?'[112] Even so, Lavater vigorously denies that man was ever 'in a state of pure nature', asking 'is not the necessity of the doctrine of the Gospel, demonstration sufficient of the nullity of a religion purely natural?' Hence even 'Among Savages, the new-born infant is man, and bears all the characters of his species. Compare him with the Orang-outang as he comes from his mother's womb – and you will admit, that the former will sooner rise to the dignity of angels, than the latter to the dignity of man.'[113]

Lavater on the Defensive

The nub of virtually all the attacks on, and satires of, Lavater was precisely the matter of the 'physiognomic fallacy'[114] directed against him, most notably by Buffon and Lichtenberg, both of whose critiques were published by Lavater in the fourth volume of *Physiognomische Fragmente* with further commentary. He complains that Buffon 'openly declares against Physiognomy!'[115] Buffon argues from the Cartesian premise that the soul or mind by definition has no material form anyway:

> It is [therefore] clearly evident that the pretended discoveries in Physiognomy can extend no farther than to a guess at the movements of the mind by those of the eyes, of the face,

and of the body; and that the form of the nose, of the mouth, and the other features, has no more connection with the form of the soul, with the dispositions of the person, than the length or the thickness of the limbs has a connection with thought.[116]

For this reason, 'A deformed body may contain a very exalted mind.'

Lichtenberg made a comparable point in an essay on the subject for the *Göttinger Taschenkalender* for the year 1778, in which he denied the scientific basis of Lavater's study.[117] Lavater actually reprinted Lichtenberg's article, *Remarks on a treatise on Physiognomics*,[118] in volume four of the *Physiognomische Fragmente*, with its response to Lavater's famous Newton question. Lichtenberg paraphrases Lavater's question as 'Newton's soul can sit within the head of a Negro? An angel's soul in a hideous body?',[119] to which his reply was simple and devastating: 'Why not? Why should Newton's soul not sit in the head of a black? Are you, wretch, the judge of God's works?'

Lichtenberg in the second edition, '*Über Physiognomik; wider die Physiognomen*' (On physiognomy, against the physiognomers) attributes deviant behaviour not to the 'soul' but to social circumstances. Physiognomy needs to be explained in terms of the beholder, the subject not the object of interpretation. Visual impressions can be affected by the accidental distortions caused, for instance, by pockmarks, gaps in teeth, and other deviations from the norm. Rather than privileging physiognomy, we should look at the things that people do unconsciously and therefore would not think to hide. For instance, an orderly room might suggest an orderly mind, and the colour and cut of clothes can be a more reliable than silhouettes or facial appearance, which can so easily deceive: 'We judge hourly from the face, and we err hourly.'[120]

The *locus classicus* of the debate over physiognomy, as Lavater realized, was the case of Socrates: how can Socrates' proverbial ugliness, his Silenus-like visage (illus. 27), be reconciled with his indisputably superior intellect and virtue? Lavater's response can be reduced to the following points, some of which are plainly self-contradictory:

Drawn by Sir Peter Paul Rubens Engraved by T. Trotter

27 Thomas Trotter, *Socrates*, engraving after Peter Paul Rubens from John
Caspar Lavater, *Essays on Physiognomy* (London, 1789–98 [i.e. 1788–99]).

1 Socrates was exceptional in every way and therefore not subject to any rule. The same could also be said of Dr Samuel Johnson, a man of notorious ugliness but of celebrated eloquence and virtue.

2 Socrates was not really ugly, or at least he only appeared ugly to those unable to discern true beauty: 'Socrates may have appeared very ugly to inexperienced eyes, while the play of his Physiognomy presented the features of a celestial beauty.' Besides, all the images of him show his strong forehead; his intellect was therefore visible on his face. A physiognomist of superior powers would be able to discern his beauty and the beauty of the skull beneath the flesh.

3 The images we have of him are too far from the original to be truly representative. The standard bust is copied from the twentieth or thirtieth copy, and is nothing more than 'a satire upon the original'. Artists in any case 'overcharge what is already harsh by nature'.

4 Socrates' face bears in his ugliness the marks of the vices of his youth, which he overcame in maturity.[121]

Lavater remarks approvingly on Holbein's hideously distorted image of Judas (illus. 28), as the complete antithesis to the same artist's face of Christ. Lichtenberg makes in response the cogent point that had Judas in reality looked like a Jewish beggar he would have had little success with the Apostles; a more subtle image was needed of a treacherous man who nonetheless must have possessed a plausible surface manner and appearance.[122] The English edition mentions the 'Jewishness' of Judas's physiognomy, and Lavater is not circumspect about identifying it in others in the Kunstkabinett. The much-admired philosopher Moses Mendelssohn was not only Jewish but had retained his ancestral faith. Lavater was eager to meet him, and described him as an 'affable radiant soul', but he was evidently distressed by Mendelssohn's loyalty to Judaism, at one point challenging him to

Had we never been told that this is the portrait of Judas Iſcariot after Holbein, had we never ſeen a face that bore the leaſt reſemblance to it, a primitive feeling would warn us at once to expect from it neither generoſity, nor tenderneſs, nor elevation of mind. The ſordid Jew would excite our averſion, though we were able neither to compare him with any other, nor to give him a name. Theſe are ſo many oracles of feeling.

JUDAS ISCARIOT.

He cared not for the Poor; He was a Thief, and had the Bag, and bare what was put therein. S.John. Ch.xii.v.6.

28 *Judas Iscariot*, engraving after Hans Holbein from John Caspar Lavater, *Essays on Physiognomy* (London, 1789–98 [i.e. 1788–99]).

either refute the argument of the Swiss scientist Bonnet for the truth of Christianity or convert.[123] Mendelssohn was understandably embarrassed and furious, and persuaded Lavater to withdraw, though the latter continued to express hopes for the former's conversion.[124] In the Kunstkabinett there are two images of Mendelssohn, which might have caused more discomfort to him and his loyal friends, like Lessing, had they become public. Commenting on a profile miniature by Chodowiecki (illus. 29), Lavater notes in 1787 the following indications of character from the subject's face: 'Refinement, cunning, intellect, taste and need for clarity; but no greatness of soul, no genius, no courage, no grandeur'.[125] Lavater thus denies Mendelssohn any but worldly virtues on the presumption that only Christians are privileged to reach transcendence. In an equally offensive comment of 1793 on a water-colour, ascribed to Johannes Pfenninger, of the overlapping profiles of Mendelssohn and Lessing (illus. 30), Lavater contrasts the effeminate character of the Jew with the manly attributes of the Christian author, not at all evident in the image – indeed Mendelssohn has the more forceful air of the two: 'Deeper, more delicate, cleverer, and more elegant, the Jew – manlier, sturdier, more cheerful, and more foursquare, livelier, Lessing'.[126]

Lavater's *Physiognomische Fragmente*, with its numerous translations and versions in French and English, represents the high-water mark of the idea of the unity of human visual beauty and virtue. Yet in giving physiognomy such a sensational form, Lavater exposed it and himself to a scrutiny that they could not easily withstand. Goethe, to Lavater's lifelong regret, effectively ran for cover in the face of the criticism, repudiating a man who had acted for a period as a mentor to him.[127] Herder was also initially captivated by Lavater, but broke with him in 1780 in an article entitled '*Studium des naturlichen Consensus der Formen im menschlichen Körper*' (the study of the natural consensus of the forms of the human body), rejecting physiognomic classification altogether, along with the four temperaments: 'that our temperaments and physiognomic features lead to nothing, everyone must clearly see'.[128]

By 1798, some twenty years after the publication of the *Physiognomische Fragmente*, Kant was able to assert that 'physiognomy, as the

29 Daniel Chodowiecki, *Moses Mendelssohn*, before 1787, miniature.

30 Johannes Pfenninger (attrib.), *Lessing and Mendelssohn*, before 1787, drawing. Österreichisches Nationalbibliotek, Vienna.

art of detecting someone's interior life by means of certain external signs involuntarily given, is no longer a subject of enquiry'.[129] He claimed that it was absurd to think of a correlation between the inner and outer man, or that judging someone as handsome or ugly could lead to wisdom. While we undeniably derive first impressions from someone's face, whether they are repugnant or attractive, this can never become a science, for human form can only be grasped intuitively and not conceptually. Kant has much to say on Greek profiles, which he saw as 'Urbilder' or prototypes for gods and heroes.[130] But he also found that the perpendicular profile lacked charm; in faces we consider beautiful the nose always deviates from a pure line. In any case, in real life exact conformity to rule results in ordinariness or lack of spirit. The mean of a large number of characteristic faces may be a necessary foundation of beauty, but it is not beauty itself, which requires the characteristic to be visible, a point that can also be found in the *Critique of Judgement*.[131] But the characteristic can be in a face that is not beautiful; in other words a face with faults can speak better for a person than conformity to an ideal without character. Deformity can be redeemed by good nature, and a face with defects can attract love. Like Lichtenberg, Kant looked in his last anthropological works to culturally determined ways of recognizing human beauty and defining character; human beauty was relative and could change with setting, for example, through the wearing of a wig or headdress, and character could be revealed through natural gestures like nodding or shaking the head.

Lavater's enterprise, despite its eventual rejection by most of the intellectual community of his time, survived in three distinct ways. In the first place, the idea of physiognomy entered into the common culture of Europe and the Americas. The *Physiognomische Fragmente* was reprinted in translated, abridged and juvenile editions in large numbers throughout the nineteenth century. It became a standby for caricaturists and humorous publications. Gillray responded to the English translation by a brilliant caricature of the opposition leaders, for the *Anti Jacobin Review*, published 1 November 1798, using as an epigraph Lavater's words 'If you would know Mens Hearts, look in their faces' (illus. 31). Gillray shows a series of heads contrasting the

Within the image:

DOUBLÛRES of Characters; – or – striking Resemblances in Phisiognomy. – "If you would know Mens Hearts, look in their Faces."

I. The Patron of Liberty. Doublûre, The Arch-Fiend. | II. A Friend to his Country. Doubl.: Judas selling his Master. | III. Character of High Birth. Doubl.: Silenus debauching. | IV. A Faithful Patriot. Doubl.: The lowest Spirit of Hell. | V. Arbiter Elegantiarum. Doubl.: Sixteen-string Jack. | VI. Strong Sense. Doubl.: A Baboon. | VII. A Pillar of the State. Doubl.: A Newmarket Jockey.

31 James Gillray, *Doublûres of Characters; – or – striking Resemblances in Phisiognomy*, 1798, etching.

opposition leaders' 'real' countenances with their moral being, as revealed by Lavater's method. The 'real' appearance is already a carica-ture; for instance, Charles James Fox is shown as a seedy, unshaven radical with cropped hair, but his 'Doublûre' or soul is a satanic head with a serpent, representing his deeper nature as 'The Arch-Fiend'. The same principle is applied to other heads. A more trivial example of the comic possibilities in Lavater is to be found in *The Gallery of Comi-calities*, a publication in newspaper format that claimed to be adorned by 'drawings' (in reality lithographs) by 'LAVATER THE SECOND'. It includes a series of dog images under the punning title of 'Canine Contrast, Or Lavater in Barkshire' (illus. 32).[132] Even in Lavater's time, the profusion of derivations and popularizations of the physiognomic method was recognized as a phenomenon. Lessing complained of the

121

CANINE CONTRAST,
OR LAVATER IN BARKSHIRE.

UGLINESS AND BEAUTY.

AN UGLY DOG.

Thou ancient Cur, with hideous grin,
 Whose merit is excelled by few,
If to be ugly is a sin,
 A very *shock*ing dog are you.

A HANDSOME DOG.

But here's a handsome dog, I vow,
 And few you'll find to equal this cur—
A real Newfoundland bow wow,
 With plenty of moustache and whisker.

32 'Lavater the Second', *Canine Contrast, Or Lavater in Barkshire: Ugliness and Beauty*, lithograph from *The Gallery of Comicalities* (London, 1834–5).

122

numbers of such volumes flooding into the Wolfenbüttel Library, 'What a mess!' (*Welch ein Wust!*)[133] Physiognomy by its omnipresence undoubtedly continued to colour the way in which people evaluated each other, and perhaps still has some potency in terms of the expectations we derive from facial appearance.

Secondly, Lavater provided valuable descriptive possibilities for novelists and playwrights, those who were concerned to reveal inward motives from external actions; this has often been noted by literary scholars.[134] Finally, Lavater had an afterlife in scientific circles, not because many believed that physiognomy reflected the soul, but because it opened up the possibility of measuring less ineffable things, like the level of socialization, 'civilization' or criminality. Lavater reinforced and gave direction to at least two ideas that were to become extremely influential in the nineteenth and the first half of the twentieth centuries: that the skull and face can indicate hidden psychological tendencies, and that they can be measured with indicative results.[135] Lavater in fact had relatively little to say about the varieties of humanity, but it is arguable that he anticipated more than anyone in the eighteenth century, the nexus of racial and visual typology and cranial measurability that was to become racial science.

'THE COLOUR OF THE GLASS': THE FORSTERS MEET 'NEW' PEOPLES

By the mid-1770s the expeditions of Bougainville and Captain Cook had created a major shift in European perceptions of humanity beyond its borders. Their travels revealed or confirmed the existence of lands and peoples new to, or scarcely visited by, Europeans. For governments, the discoveries in the South Seas were a matter of imperial strategy or exploitation; for the *Gelehrten* of Europe they raised in novel forms questions of human origin, savagery and civility, and of the relationship between appearance and moral character among peoples 'uncontaminated' by outside influences. Bougainville's *Voyage autour du Monde*, published in Paris in 1771, painted an Arcadian vision of the South Seas, particularly Tahiti, which he christened

'Nouvelle Cythère', invoking the pastoral and poetic world of Arcadia, and the prelapsarian Eden. The name Cythère recalls idylls painted by Watteau, especially his famous *Pilgrimage on the Island of Cythera* (Paris, Louvre), an elegaic vision of perfect love. Bougainville's vision of Tahiti in the retrospect of his return to France is a strikingly pictorial one, guided by the paintings of François Boucher and others, as he himself recognized. Describing a serenade by a young Tahitian man playing a nose flute, Bougainville notes 'he sang to us slowly a song, of an anacreontic kind, a charming scene, worthy of the pencil of Boucher'.[136] A Tahitian woman appears like a nymph surprised, a familiar subject from classicizing French sculpture of the period: on dropping her covering 'she appeared to the eyes of all, as Venus appeared to the Phrygian shepherd. Her form was celestial.' Tahitian women are described as 'nymphes', and for the sailors it was as if they were in 'the country where the freedom of the golden age reigned once more',[137] when the women offered themselves freely to them. As Bougainville sums it up: 'Venus is here the goddess of hospitality.' He pictures the interior of the island as a pastoral landscape in the manner of the seventeenth-century French painters Gaspard Dughet and Claude Lorrain: 'I believed myself to be transported to the Garden of Eden . . . We found groups of men and women seated in the shade of trees; everyone greeted us with friendship . . .; everywhere we saw reigning hospitality, peace, sweet joy and all the appearances of well-being.'[138] Even when he notes that 'The people of Taiti [sic] are composed of two very different races of men', he describes the premier race as like both classical gods and Europeans: 'to paint Hercules and Mars one could never have found such beautiful models. Nothing distinguishes their features from Europeans.'[139] The other 'race' is described as like mulattos, a lower order of humanity.

Bougainville's account held the field briefly before those from the three Cook expeditions, which began to appear from the mid-1770s onwards. The German naturalists Johann Reinhold and Georg Forster, father and son (illus. 35), were included on Captain Cook's second voyage to the South Seas and Antarctica in the years 1772–5, and in their descriptions of the voyage each in his own way took a 'philosoph-

ical' view of the human life they observed, consciously different from Bougainville's account, which Reinhold had himself translated into English and published in 1772.[140] The Forsters sought to frame their observations within current debates on the history of mankind, and were conversant with some of the texts considered so far, travelling with a copy of Buffon in hand,[141] and in the company of an 'apostle' of Linnaeus, Andreas Sparrman. Reinhold even described himself as 'a kind of Linnaean being'.[142]

Reinhold Forster was a German pastor of English descent, who became a naturalist and wide-ranging scholar of distinction and some fame while acting as pastor in the small Polish village of Nassenhuben near Danzig (Gdansk).[143] He had emigrated to England to teach at the Dissenting Academy in Warrington in the late 1760s, where his son Georg became a pupil, and he was able to develop good contacts in London scientific circles, despite a notoriously difficult personality. The opportunity which made their reputations came about when the great botanist and traveller Sir Joseph Banks (1743–1820) refused at almost the last minute to go on Cook's second voyage to the South Seas, because of problems with the accommodation on board one of the ships. Reinhold Forster was contacted as a replacement, and within a few weeks father and son, the latter barely eighteen and employed on the voyage as a draughtsman, were on their way south, remaining on board ship for over three years.[144] When they returned in 1775 they were frozen out by the Admiralty from the official publication of the voyage, which was eventually published under Cook's name. Both Reinhold and Georg published unofficial accounts of the voyage in 1778,[145] Reinhold's under the title *Observations made during a Voyage Round the World, on Physical Geography, Natural History, and Ethic Philosophy*,[146] and Georg's *A Voyage round the World*.

The titles indicate the complementary nature of the volumes. Reinhold claimed in an advertisement for his volume to have contemplated the South Seas with 'a philosophical eye' and to have looked 'upon mankind in general, as one large family, and described the various tribes of the South-Sea ... by adverting to their different degrees of civilization'.[147] In language that hints at the way that he antagonized

his fellow voyagers, he claims to have been neither a traveller who was not a philosopher, nor a philosopher of the kind who 'study mankind only in their cabinets'. The volume is arranged according to topic, beginning with the environment and its geology and vegetation, and finally with 'The History of Mankind . . . considered as one large body', based on observing the various stages from the 'most wretched savages, removed but in the first degree from absolute animality, to the more polished and civilized inhabitants of the Friendly and Society Isles'.[148] This emphasis on the unity of humanity is a repudiation of Bougainville, but it also implies that the South Sea islanders are not to be displaced to the realm of the 'Other' or the exotic, but can be considered within the same natural history as Europeans, or indeed any of the world's inhabitants. They may not have attained a European level of civilization, but their way of life might cast light on the nature of human development in general.

Reinhold Forster's observations of humanity go beyond the descriptive, to attempt to classify the peoples of the South Seas in a broadly Linnaean manner, but not according to Linnaeus' own human taxonomy. In the longest section of the book, 'On the Varieties of the Human Species', he organizes the peoples of the South Seas into two 'varieties' or 'races', placing them on a scale according to their level of 'civilization' and 'animality'. The primary criterion is aesthetic, based on a correlation between the relative beauty of each people and 'their different degrees of civilization'. On the highest level of the first 'race' are Tahitians: 'O-Taheitee, and the adjacent Society-Isles, no doubt contain the most beautiful variety of the first race.' In Tahitian men 'The features of the face are generally, regular, soft and beautiful,' while the women have an 'open chearful countenance . . . uncommon symmetry . . . heightened and improved by a smile, which beggars all description . . . The arms, hands, and fingers of some are so exquisitely delicate and beautiful, that they would do honour to a Venus of Medicis'; unfortunately, he adds prosaically, their legs were wrecked by walking barefoot.[149] Furthermore, their 'character is as amiable as that of any nation, that ever came unimproved out of the hands of nature'. Next in beauty are the inhabitants of the Marquesas, then the Friendly Isles, and then

Easter Island, whose men are middle sized with 'not the most pleasing features', and the women 'are not quite disagreeable', as well as being 'much addicted to thieving'.[150] New Zealanders are on the fifth level, and so a degree less beautiful, but still of the first race.

The second race is characterized as being of inferior beauty to the first race. After the relatively well-favoured inhabitants of New Caledonia come those of Tanna, where the women are 'ill favoured, nay, some are very ugly'. But in Mallicolo things are even worse. Here we come close to the 'most wretched savages, removed but in the first degree from absolute animality', who represent the opposite pole from 'the more polished and civilized inhabitants of the Friendly and Society Isles'.[151] Reinhold Forster remarks of the inhabitants of Mallicolo, 'of all men I ever saw, border the nearest upon the tribe of monkeys', while the 'women are ugly and deformed', partly from doing all the drudgery for the men.[152] Realizing that such remarks might suggest a continuum between animal and human, he insists nonetheless on the human identity of the Mallicolese, inserting a telling denial that orang-utans, traditionally thought to be the animals closest to human beings, were of the human species.

This denial reveals the way that aesthetic and the taxonomic enquiry could challenge the monogeneticism which one would expect a clergyman to uphold without question. If the Mallicolese appear to come uncomfortably close to the animal, the beautiful peoples of the South Seas can also be problematic. The maidens of Tahiti may evoke comparisons with classical nymphs, but they may not challenge in beauty 'Britannia's fair daughters', who occupy, so Forster assures us (perhaps thinking of his audience), a higher degree of perfection, nearer to the angelic or godlike. Behind these intellectual contortions to reconcile the gradualism of Buffon with a Linnaean taxonomy, lay the worry that an hierarchical and aesthetic ordering of mankind would reanimate the Great Chain of Being, in a way that would call into question the uniqueness, and ultimately the position of man in the divine order.

According to Georg Forster's preface to *A Voyage round the World*, the Admiralty had 'expected a philosophical history of the

voyage, free from prejudice and vulgar error, where human nature should be represented without any adherence to fallacious systems, and upon the principles of general philanthropy'.[153] Both Reinhold and Georg took these instructions to mean going beyond the identification of unknown plants and animals, towards an assessment of the human conditions in the places visited, and the way of life and prospects of the native peoples. Georg claimed that his own task (as distinct from Reinhold's) was 'to throw more light upon the nature of the human mind, and to lift the soul into that exalted station, from whence the extensive view must "justify the ways of God to man"'.[154] This is a conventional post-Milton and post-Newton justification of scientific enquiry – one that would have caused no problem to any churchman, whether Anglican or nonconformist, for it only reaffirmed that the extension of knowledge revealed God's great design for humanity. The quotation from Milton implies a certain moral urgency to the quest, and can be read as a reproof to the idea that knowledge endows the perceiving subject with the certainty of authority. If Reinhold emphasized his 'philosophical' credentials, then Georg revealed his debt to Protestant and dissenting traditions by emphasizing his own subjectivity: 'I have sometimes obeyed the powerful dictates of my heart, and given voice to my feelings; for as I do not pretend to be free from the weaknesses common to my fellow-creatures, it was necessary for every reader to know the colour of the glass through which I looked.'[155] This beautiful phrase, invoking both St Paul and the 'Claude glass' used by landscape painters, dissociates knowledge from *a priori* assumptions and the claim of scientific objectivity, resting its authority instead on a process of increasing experience and the open-ended pursuit of knowledge. Georg, in reaffirming the authority of the observer, distanced himself from the armchair anthropologists of the day like Buffon, though he would have recognized the latter's assiduity in interpreting travellers' accounts in the light of climatic theory, and a recognition of his subjectivity.

Georg's experiences and awareness of his own position enabled him to keep an open mind in relation to Buffon, and indeed to his own father. His theological background also made him sensitive to the

Adamic origins of humanity and the original state of unity before its dispersal, though later he was to cast doubt on monogeneticism. His account of the 1772–5 Cook voyage was a narrative one; his reflections are not ordered systematically but arise according to the situations he observes. On one occasion he speculates that a folk memory of the original state of humanity might remain with the peoples he encounters, when in New Zealand a group of natives offered a white flag as a sign of peace; this association of whiteness with peace perhaps 'has its origin anterior to the universal dispersion of the human species'.[156]

A certain scepticism towards Buffon is also evident in his recognition of the occasional inadequacy of climatic theory in accounting for the relationships between peoples and their environment. Climatic theory did not cope easily with change and development, as Hume had observed, and Georg highlights the change caused by the rapid and usually baleful effects of contact with Europeans. He frequently notes the way that political circumstances affect the relationship with the environment, and the fact that communities were often in perpetual flux. Early in the volume he blames the misery of the Cape Verde islands on Portuguese domination, arguing that the islands could become prosperous 'in the hands of an active, enterprising, or commercial nation . . . under the benign influence of a free and equal government, like that under which we have the happiness to live in this country [i.e. Britain]'.[157] Islands and nations are thus subject to external political factors. His attitude towards the value of European visits was not, however, completely consistent, nor indeed was Reinhold's.[158] He commends the efforts of Cook's sailors to teach the native peoples simple technology and methods of building, while expressing a Rousseauian pessimism about the decadence of Europe and its values. He is painfully aware of specific ways in which damage could be done by introducing materialism to those previously innocent of money: 'It is unhappy enough that the unavoidable consequence of all our voyages of discovery, has always been the loss of a number of innocent lives; but this heavy injury done to the little uncivilized communities which Europeans have visited, is trifling when compared to the irretrievable harm entailed upon them by corrupting their morals.'[159] In reflecting

on his visit to Tahiti he wrote:

> It were indeed sincerely to be wished, that the intercourse which has lately subsisted between Europeans and the natives of the South Sea islands may be broken off in time, before the corruption of manners which unhappily characterises civilized regions, may reach that innocent race of men, who live here fortunate in their ignorance and simplicity. But it is a melancholy truth, that the dictates of philanthropy do not harmonise with the political systems of Europe.[160]

European contact destabilized communities by creating new wants; contentment was lost in striving and competition, as it had been in Europe, yet Europe, it is assumed, had much to teach the South Sea islanders.

It was implicit in climatic theory that those who live in benign environments that cater to all physical needs, uncorrupted by European mores, had no reason to go to war or to steal. Yet, as Georg noted, the beautiful islands around Tahiti had a history of warring with each other over dominance: 'We cannot sufficiently wonder that a family so secluded from all the rest of the world, in a spacious bay, where they have a superfluity of food, and of all the necessaries of life, the fewness of their wants considered, should still have a thought of warring with their fellow-creatures, when they might live peacably and happily in their retirement.'[161] He later complains of Society Islanders who went to war when 'their native island was as fertile and desirable as these of which they had taken possession; therefore nothing but a spirit of ambition could have stimulated them to contention'.[162] He was eventually to despair of attempts to set up the native peoples with metal tools and simple methods of building and planting, but on the outward voyage, stopping in New Zealand before reaching Tahiti and the other islands, he had marvelled at the progress made in clearing a plot using European tools and methods. It was then evidence that 'Already the polite arts began to flourish in this new settlement . . . In a word, all around us we perceived the rise of arts, and the dawn of science, in a country

which had hitherto lain plunged in one long night of ignorance and barbarism!'[163] Yet he was forced to admit that land that had been cleared by Captain Cook's men a few years before, had now returned to its original state of infertility.[164]

If the Forsters rejected Bougainville's Arcadian view of Tahiti, it still appeared to them to be a place of prosperity, beauty and contentment. But Georg notes intimations of decline in the indolence of the chiefs, expressed in a loss of the harmony between beauty of physique and serene contentment, exacerbated by European temptations. The chiefs' indolence would induce them to make the lowest class work harder, who would then fall into poverty and physical ruin. 'The pampered race, on the contrary, will preserve all the advantages of an extraordinary size, of a superior elegance of form and features, and of a purer colour, by indulging a voracious appetite, and living in absolute idleness.' Such a division will eventually lead to insupportable grievances and revolution: 'This is the natural circle of human affairs; . . . how much the introduction of foreign luxuries may hasten that fatal period, cannot be too frequently repeated to Europeans.'[165]

Georg's descriptions of the Tahitians are warm and admiring, but they are not claimed to be ideal either in physique or way of life: 'The people around us had mild features, and a pleasing countenance; they were about our size, of a pale mahogany brown, had fine black hair and eyes, and wore a piece of cloth round their middle . . . Among them were several females, pretty enough to attract the attention of Europeans, who had not seen their own country-women for twelve long months past' – faint praise in the circumstances. Their clothing may be superior to the European, but it is not perfect: 'If this dress had not entirely that perfect form, so justly admired in the draperies of the ancient Greek statues, it was however infinitely superior to our expectations, and much more advantageous to the human figure, than any modern fashion we had hitherto seen.'[166]

Tahiti, however, was not the high-point of Georg Forster's experience of the South Seas, and in that he differs sharply from Reinhold. In fact, Tahiti occupies roughly a mid-point on Forster's scale of esteem, between New Zealand, where, like Reinhold, he finds the natives phys-

ically unattractive and alien to European values, and the island of Eua, in the Friendly Isles near Tonga, whose natives – not coincidentally in Georg's view – had never seen Europeans before Cook's second voyage arrived: 'Nothing was therefore more conspicuous in their whole behaviour than an open, generous disposition, free from any mean distrust. This was confirmed by the appearance of a great number of women in the croud, covered from the waist downwards, whose looks and smiles welcomed us to the shore.'[167] Forster claims that the inhabitants were of more industrious disposition than those of Tahiti, and 'Their attention to separate their property seemed to argue a higher degree of civilization than we had expected. Their arts, manufactures, and music were all more cultivated, complicated, and elegant than at the Society Islands. But in return, the opulence, or rather luxury, of the Taheitians seemed to be much greater.'[168] The gifts of nature were less plentiful, but distributed with more equality. Here there was no difference in dress or relative corpulence between nobility and people; the chief dressed in the same way as the people.

In Georg's account the unique polity created by the natives of Eua bears some resemblance to Winckelmann's ancient Greece, though, of course, they did not produce anything like Greek sculpture. Still, they did cultivate the arts, their government was not despotic, and they lived in freedom and relative equality. Georg might have come across Winckelmann's *Reflections* in Henry Fuseli's English translation of 1765, though it is unlikely he knew the *History* until he returned to Germany. He is quite clear that even the natives of Eua were not to be compared too literally with the ancient Greeks, though he well understood that such a comparison would have been as irresistible to the London literati as it had been to Bougainville's Parisian audience. Hence his complaint that the engraving after William Hodges's painting of the landing on the island, made for Cook's publication of the voyage, had Grecianized the natives in defiance of reality (illus. 33):

> The engraving does not convey any adequate idea of the natives of Eaoowhe or of Tonga Tabbo. The plates which

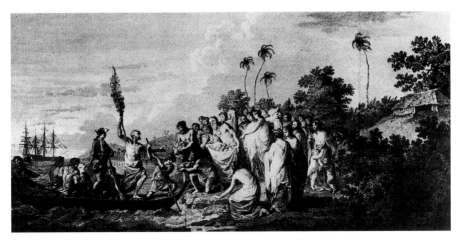

33 John Keyse Sherwin, after William Hodges *The Landing at Middleburgh (Eua)*, 1777, engraving.

ornamented the history of captain Cook's former voyage, have been justly criticised, because they exhibited to our eyes the pleasing forms of antique figures and draperies, instead of those Indians of which we wished to form some idea . . . The connoisseur will find Greek contours and features in this picture, which have never existed in the South Sea. He will admire an elegant flowing robe which involves the whole head and body, in an island where the women very rarely cover the shoulders and breast; and he will be struck with awe and delight by the figure of a divine old man, with a long white beard, though all the people of Ea-oowhe shave themselves with muscle-shells.[169]

Hodges's original drawings are either missing or mutilated, so we do not know how far it was he or the engraver Sherwin who altered the original drawing, if indeed it was altered. For Bernard Smith this engraving was the key example of the imposition of European classical idealism upon a piece of ostensible reportage of the South Seas.[170] For Forster it was a betrayal of observational principles to reinforce the

banal pastoralism sought by fashionable London society; Hodges or Sherwin, or the two together, were guilty of reinforcing popular fantasy, rather than presenting accurate observations.

The judgement, however, is seriously unfair to Hodges at least. It is, in my view, quite wrong to see his South Seas paintings and drawings as nothing more than Arcadian images. Unlike the Forsters, who went back to Germany, Hodges was thrust back into fashionable London, the only marketplace at the time. Even so, the paintings, all of which probably date from after his return to London in 1775, suggest a reflective artist attuned to 'philosophical' issues, some probably aired by the Forsters in his company on the voyage. Hodges is not an articulate presence in accounts of the voyage, but his later career, especially his late paintings of *Peace* and *War* (both lost), exhibited in 1794 with an accompanying pamphlet, suggests an artist who had high ambitions for landscape painting of 'moral purpose'.[171]

Arcadianism is often attributed to Hodges's famous large painting *Oaitepeha Bay*, also known tellingly as *Tahiti Revisited*, dated 1776 (illus. 36), probably the second version of a painting exhibited at the Royal Academy the same year. The figures are indeed bathed in the golden light of an unattainable world, and the atmosphere is both erotic and exotic. A naked female luxuriates uninhibitedly in the warm waters, while two others look on languorously. The exotic is represented by a carved wooden figure and the fetchingly tattooed bottom of the incompletely draped 'nymph' with her back to us. This suggests Tahiti as a female domain under the reign of Venus, a paradise of sexual display and availability reminiscent of Boucher's paintings, with classical echoes. The painting was a conspicuous success at the Royal Academy, even persuading Matthew Boulton to make mechanical copies of it. But it is only a partial vision of Tahiti, and is incomplete without its companion painting. The first version of *Oaitepeha Bay* was paired originally with a version of *A View of Matavai Bay in the Island of Otaheite* [Tahiti], also of 1776 (illus. 37). This presents Tahiti not as a place of erotic indolence but of productive work, a Georgic vision of man as the improver and organizer of nature. Cook's two ships, the *Resolution* and the *Adventure*, are incorporated into a busy harbour

scene, in which Tahitian males work harmoniously, their poses expressive of constructive if unhurried labour. The most prominent elements in the painting are not the visiting ships, but the local sailboats in the foreground. Hodges has meticulously detailed the irregular branches or tree trunks that act as masts to hold the equally irregular sails. These boats contrast with the regularity of the British ships, but their prominence suggests a tribute to native ingenuity and desire for improvement. An elegant and classical figure on the boat on the far left is engaged in conversation with a seated figure, the former perhaps suggesting some form of technical improvement to the boat.

These Tahitians are not European, but neither are they 'savage'. If we look at them in the light of the four-stage theory of human development, and there is no reason why Hodges would not have been familiar with it, they are far removed from being hunter-gatherers, but they have not yet reached – perhaps fortunately – the commercial stage represented by the European ships. They are capable of being active, ingenious and independent, yet they also have the temptations of indolence, though it is perhaps significant that it is only the women who appear to give way to it. Tahitians evidently enjoy a climate that allows them to be indolent, but also encourages them to use their ingenuity, and thus progress to a higher level of civility. If we cannot easily read from the paintings Hodges's precise view of the Tahitians, they leave us with sufficient evidence of his own 'philosophical' bent.

Whatever the stage of humanity occupied by the Tahitians, it is higher than that of the peoples deemed by Reinhold Forster to belong to the 'ugly' race of South Sea islanders. The male inhabitants of Mallicolo, it seems, walked around with their private parts exposed, and Cook described them as 'the most ugly, ill-proportioned people I ever saw'. They are represented in a small and freely painted oil sketch by Hodges of *The Landing at Mallicolo* (illus. 38). The Mallicolans are not depicted as conspicuously ugly – the painting is too sketchy to allow for such detail. Their 'savagery' is represented by their incoherence as a group, contrasting with the elegant British officers who inhabit spaces of their own, yet are rhythmically interconnected to each other and to the British sailors who form a compact and orderly group. In a similar

oil sketch of *The Landing at Erramanga* (illus. 39), the hostile natives are shown as an unruly mass of humanity torn between attacking the boat and each other. Hodges's rhetoric is, however, as Joppien and Smith pointed out,[172] completely subverted by the engraving (illus. 40), which gives the hostile figures a form and grace not suggested in the painting. They are no longer differentiated from the 'beautiful' Tahitians, whom they now join as generic noble savages.

Many of Hodges's drawings of representative South Sea islanders survive in various stages, from life drawings through to their adaptations by London engravers for publication. The drawings do not appear to follow Reinhold's aesthetic hierarchy, nor are they Arcadian in tendency. A drawing by Hodges of *A Man of the Island of Mallicolo* (illus. 43) shows a hangdog figure, not as 'ugly' as Reinhold Forster had suggested, but undoubtedly 'savage' in the display of nose plugs and a bow and arrows. In the final state of the engraving his skin has been lightened, his bow and arrows have been removed, and his naked upper body is now fully draped (illus. 44). Georg Forster complained that the original portrait was 'very characteristic of the nation; but we must lament, that a defect in the drawing, has made it necessary to infringe the *costume*, and to throw a drapery over the shoulder, though these people have no kind of clothing'. There is no sign of any 'defect in the drawing', a remark that might have been meant sarcastically. The rejection was more likely to be due to prudery, and a desire to play down the savagery of South Sea islanders in favour of romance.

Georg Forster's deliberate distancing from the urban-Arcadian view of the South Seas is also evident in his opinions on its most famous exemplar, Omai, the Tahitian who became a sensation in society, shown off by Sir Thomas Banks, and painted by Sir Joshua Reynolds (illus. 45) as a commandingly exotic presence. Forster accompanied Omai part of the way back to England, where he was assumed to be a native prince, and a figure of romance. Forster, on the other hand, thought him to be bogus; a man of low birth but shrewd and calculating, who agreed to come to England to acquire arms and support for warlike purposes, coolly adopting the role of noble savage. We should not be surprised to find that Hodges's painting of Omai (illus. 46) should be entirely

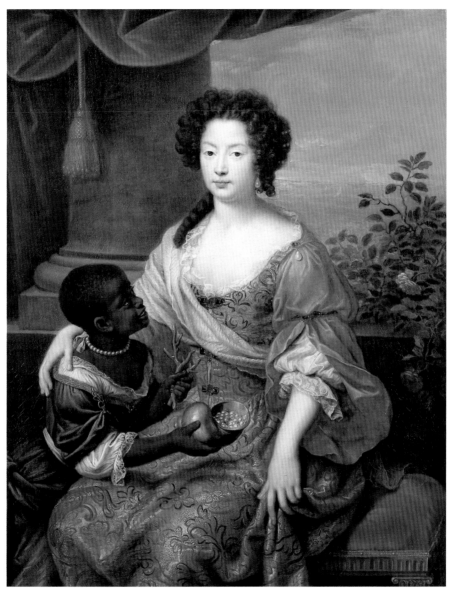

34 Pierre Mignard, *Portrait of the Duchess of Portsmouth*, 1682, oil on canvas.
National Portrait Gallery, London.

35 John Francis Rigaud, *Johann Reinhold Forster and Georg Forster in Tahiti*,
1780, oil on canvas.

36 William Hodges, *Oaitepeha Bay ('Tahiti Revisited')*, oil on canvas, 1776.

37 William Hodges, *A View of Matavai Bay in the Island of Otaheite* [Tahiti], 1776, oil on canvas.

38 William Hodges, *The Landing at Mallicolo*, *c.* 1776, oil on panel. Illustrations 36–9 are all National Maritime Museum, London.

39 William Hodges, *The Landing at Erramanga [Eromanga]*, *c.* 1776, oil on panel.

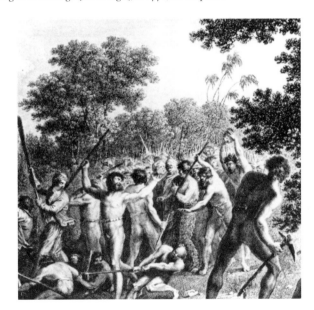

40 Detail from John Keyse Sherwin, *The Landing at Erramanga*, 1777, engraving after William Hodges.

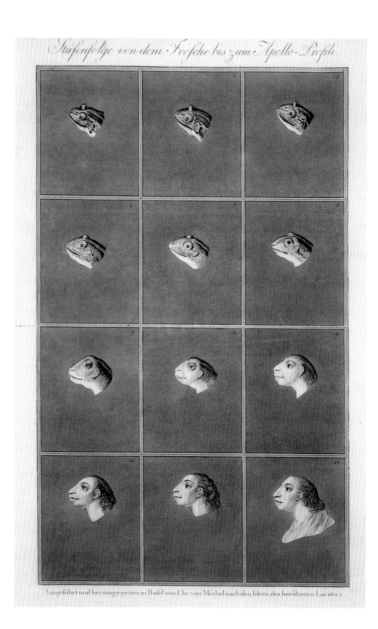

Ausgeführt und herausgegeben in Basel von Chr. von Mechel nach den Ideen des berühmten Lavater's.

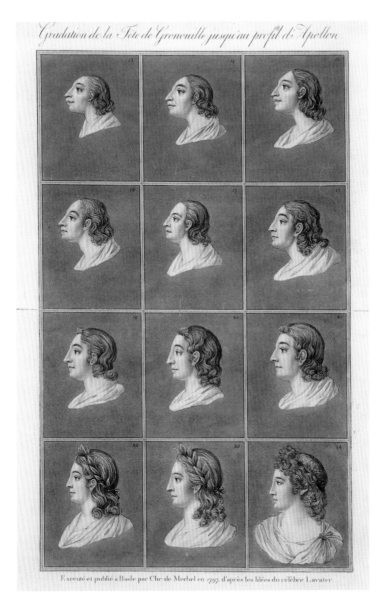

Gradation de la Tête de Grenouille jusqu'au profil d'Apollon

Exécuté et publié à Basle par Chr. de Mechel en 1797 d'après les idées du célèbre Lavater

41 Christian von Mechel, *Successive Stages from the Frog to the Profile of Apollo*, hand-coloured engravings after Johann Caspar Lavater. Wellcome Foundation, London.

42 Anonymous after Johann Caspar Lavater, *Successive Stages from the Frog to Apollo, c.* 1795, the four concluding watercolour drawings from a sequence of 24.

43 William Hodges, *A Man of the Island of Mallicolo*, 1774, red and black
chalk drawing. British Museum, London.

44 James Caldwall, *Man of the Island of Mallicolo*, 1777, engraving after
William Hodges.

45 Sir Joshua Reynolds, *Omai*, exhibited at the Royal Academy in 1776, oil on canvas. Formerly Castle Howard, Yorkshire.

compatible with Forster's view of him, and barely recognizable as the same person depicted by Reynolds.

Forster, after observing him on the voyage to London and in London society, described him as follows:

> [O-Maï] has for some time engrossed the attention of the curious. He seemed [on the voyage] to be one of the common people at that time, as he did not aspire to the captain's company, but preferred that of the armourer and the common seamen. But when he reached the Cape of Good Hope, where the captain dressed him in his own clothes, and introduced him in the best companies, he declared he was not a towtow, which is the denomination of the lowest class, and assumed the character of a hoa, or attendant upon the king. The world hath been amused at times with different fabulous accounts concerning this man, among which we need only mention the ridiculous story of his being a 'Priest of the Sun'; a character which has never existed in the islands from whence he came. His features did not convey an idea of that beauty which characterizes the men at O-Taheitee; on the contrary, we do him no injustice to assert that, among all the inhabitants of Taheitee and the Society Isles, we have seen few individuals so ill-favoured as himself. His colour was likewise the darkest hue of the common class of people, and corresponded by no means with the rank he afterwards assumed. It was certainly unfortunate that such a man should be selected as a specimen of a people who have been justly extolled by all navigators, as remarkably well featured and coloured, considering the climate in which they live [but] he was warm in his affections, grateful, and humane; he was polite, intelligent, lively, and volatile.[173]

Forster here argues implicitly that only someone who had experienced Tahiti could accurately judge Omai's true nature and rank. Romance was the product of indolence; experience was its solvent. Experience made things complex and unstable, challenging the formulae of climate

46 William Hodges, *Omai*, between August 1775 and June 1776, oil on panel.
The Royal College of Surgeons, London.

and social life that had dominated views of the 'savage' world. The beguiling beauty of the inhabitants and the landscape were, in the discourse of Arcadia, a threat to the distinction between the real and ideal; but the Forsters were aware not so much of the shortcomings of paradise, as of its fragility and its organic nature, its tendency to follow the cycles of humanity. As Reinhold Forster put it: 'Mankind is therefore to be considered in various situations, comparable with the various ages of man from infancy to manhood; with this difference only, that men in their collective capacity ripen but slowly from animality, through the stages of savages and barbarians into a civilized society, which has again an infinite variety of situations and degrees of perfection.'[174] While a kind of paradise might exist, it was not clear that it could last for more than a brief period, and then only if it were not disrupted by alien intrusion. One might have said the same of Winckelmann's Athens.

Defining and Denying Race

Debates over human variety were transformed by the European expeditions to the South Seas in the 1770s, and by the issue of slavery, which raised questions across religious, scientific and political discourses. There were political issues in the background of the South Sea expeditions, but the campaign against slave trading directly affected the entrenched power of the plantation owners, and those in the slave-trading nations who profited indirectly. It goes without saying that the debate was more heated in Britain and France, the two nations who dominated the slave trade, than in Germany, which had only a minimal involvement. Even so, the issue was alive in Germany, and virtually everyone who wrote on issues of human variety made their opposition to slavery clear; in the European republic of letters it was an offence against humanity.

The philosophical arguments deployed against slavery were invariably based on the universality of humanity, or brotherhood of man, which in turn rested on the implicit moral difference between man and animal. Bishop Warburton, in a sermon to the Society for the Propagation of the Gospel in 1766, accused the West Indian slave owners of claiming as property, like cattle, 'rational creatures . . . endued with all our faculties, possessing all our qualities but that of colour, our brethren both by nature and grace'. Slaves should be encouraged to seek their freedom because 'Nature created man free, and grace invites him to assert his freedom.'[1]

Such arguments were challenged by Edward Long in his three-volume *History of Jamaica*, 1774, which offers a philosophical defence of slavery on behalf of the Jamaican plantation owners, also based on current debates on human variety, enlisting Buffon, Montesquieu, and

Hume. Long makes the unbiblical claim for polygenesis, on the grounds that 'the White and the Negroe are two distinct species . . . this idea enables us to account for those diversities of feature, skin, and intellect, observeable among mankind'.[2] He praises the plantation owners, making the highly improbable claim that 'There are no people in the world that exceed the gentlemen of this island in a noble and disinterested munificence.' As a 'gentleman', the slave owner's role is that of an ancient patriarch, who acts towards his slaves like 'their common friend and father'.[3] The slave owner possesses a fully developed moral and aesthetic sense; 'Negroes', on the other hand, Long argues, following Hume, are 'void of genius, and seem almost incapable of making any progress in civility or science. They have no plan or system of morality among them . . . they have no moral sensations; no taste but for women . . . no wish but to be idle.' Equally they have no aesthetic comprehension of nature: 'They conceive no pleasure from the most beautiful parts of their country, preferring the more sterile.' Though they have been acquainted with Europeans for hundreds of years 'they have, in all this series of time, manifested so little taste for arts, or a genius either inventive or imitative'.[4] Africa is defined as essentially unvarying: 'a general uniformity runs through all these various regions of people . . . all people on the globe have some good as well as ill qualities, except the Africans'. Africans are allowed no hope of improvement, for 'they are now every where degenerated into a brutish, ignorant, idle, crafty, treacherous, bloody, thievish, mistrustful, and superstitious people, even in those states where we might expect to find them more polished, humane, docile, and industrious'.[5]

In asserting the difference between Europeans and Africans in such absolute terms, Long invokes the Great Chain of Being to emphasize the relative positions of black and white in the hierarchy of living creatures: 'how vast is the distance between inert matter, and matter endued with thought and reason!' This then becomes an argument for the closeness of apes to blacks, especially the orang-utan: 'Has the Hottentot . . . a more manly figure than the oran-outang? . . . That the oran-outang and some races of black men are very nearly allied, is, I think, more probable', for 'Mr Buffon supports his deductions, tending

to the contrary, by no decisive proofs.'[6] At the same time he raises the question of whether or not blacks and whites are 'different species of the same Genus', casting doubt on Christian monogenesis.

Long was, of course, an amateur, if a widely read one, but Wolf Lepenies has noted the emergence in the 1770s of a new class of professional scientist, of a different stamp from self-consciously universal thinkers like Buffon, Herder and Goethe.[7] The decade saw attempts at the ordering of humanity by Reinhold Forster (already discussed), Immanuel Kant, Johann Friedrich Blumenbach (1752–1840) and Pieter Camper (1722–89), who all held posts at universities or places of learning. Their work of classification made possible theories of human categories based on deductions drawn from carefully considered evidence, at least by the standards of the time.

Two of the most fruitful, yet disparate, attempts to categorize human variety appeared in 1775: Kant's *Von den verschiedenen Racen der Menschen* (Of the different races of mankind),[8] and Blumenbach's Latin thesis *De generis humani varietate nativa* (Of the origins of human variety).[9] Both authors were to return to the subject later: Kant in two treatises,[10] and Blumenbach in substantial reworkings of his thesis, both discussed later in this section. Kant's writings on race and anthropology have been neglected by modern Kant scholars, but, given the philosopher's enormous prestige, they were probably known to most German writers on human variety in the period. In fact, they were challenged at some length by Georg Forster, and also by Kant's former student Johann Gottfried Herder. Furthermore, the text of Kant's 1775 pamphlet was partly reprinted as a very lengthy footnote to volume four of Lavater's *Physiognomische Fragmente*,[11] which would have ensured a wide currency.

Blumenbach, by contrast with Kant's isolation in Königsberg in East Prussia, had excellent contacts abroad and many followers, and was recognized in the nineteenth century as a (if not *the*) founding father of modern anthropology.[12] He was in close touch with, among others, Sir Joseph Banks in London, keeping up with South Seas discoveries and participating in an exchange network to acquire human skulls and other materials for his work at Göttingen, where he was a

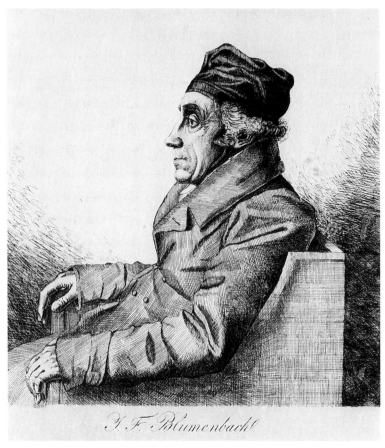

47 Ludwig Emil Grimm, *Johann Friedrich Blumenbach*, *c.* 1820, etching.

revered figure well into the nineteenth century (illus. 47).[13] He also knew Georg Forster, Lichtenberg and Christoph Meiners, all of whom had appointments at Göttingen,[14] and he corresponded with Pieter Camper.

The First Definition

Kant's 1775 treatise, *Of the Different Races of Mankind*, offers, possibly for the first time since François Bernier in 1684, the association of the word 'race' with a taxonomic division of mankind. Though *Different Races* belongs to Kant's 'pre-Critical' work, it dates from the period of gestation of the three great Critiques that began to be published from 1781 to 1790. Kant's disclaimer that *Different Races* was to be 'as much a useful entertainment as a demanding piece of work',[15] may have been intended to encourage the citizens of Königsberg to take it as part of the pioneering course on anthropology he had taught from early in the decade. It has also been suggested that Kant intended the pamphlet to be a 'Schuleinteilung', a classifying system or the basis of a chart from which the varieties of humanity could be memorized by schoolchildren or those seeking instruction.[16] The final version of his anthropology course was first printed (with only a cursory discussion of race) as late as 1798, as *Anthropologie in pragmatischer Hinsicht* (Anthropology from a pragmatic point of view). However, it is clear that the *Different Races* pamphlet was important to him, for he returned to the issue of race more than once in his later career.

The 1775 essay may have been intended as a response to Herder's *Auch eine Philosophie der Geschichte zur Bildung der Menschheit* (Another philosophy of the history of the development of mankind) of the previous year,[17] but in broader terms it can be understood as part of the shift in Kant's areas of interest in the 1770s, under the influence of Rousseau, from cosmology and metaphysics to morality and anthropology.[18] By then, as the pamphlet makes clear, he had absorbed Linnaeus and Buffon on human variety, and had evidently read much travel literature. Kant's interest in the material world by then was based on an adoption of a Newtonian view of the universe. 'Scientific knowledge' (*wissenschaftliche Erkenntnis*) was to be found primarily not in experi-

ence, but in the laws that governed the universe, the search for which depended upon the constructive abilities of the mind. The Newtonian model was of a scientist whose insights gained through mathematics and speculative thought could be verified in the material world, but were not derived from its study or contemplation.

A Newtonian approach to human variety would seek to elucidate the universal laws and the conditions that made human beings different from each other and from animals, and it would be satisfied with minimal certainties rather than wide-ranging speculations based on the painstaking gathering of data. For Kant the question was not: what objectively constitutes human variety and how might it come about? But how can we reconcile the observable phenomenon of human variety, which must itself be providential, with the assumption, necessary both to religion and philosophy, that mankind was once a single undivided people with a common ancestry?

Hence Kant used Linnaeus' categories as a starting-point, seeking to base his 'solution' on an all-encompassing taxonomy of humanity. His concept of 'race' is universal, in the sense that it encompassed the whole known world, but it also employs a set of broad data that are visible and tangible, and lack the nuances inevitable in categories like nationality. In *Different Races* Kant broadly follows Linnaeus in dividing mankind into four quarters living in four discrete continents, but he also gives an important role to climate. According to Kant all human beings belong to the same genus or species, because they are all notionally able to breed children between them, whatever their physical differences. All come from a single original stock (*Stamme*), the original human tribe before its dispersal, while 'races' are deviations or degeneracies (*Abartungen*) of the original stock, transplanted to the four continents. There they have been able to maintain themselves over many generations, interbreeding with those with the same deviations.[19] The constitution of soil and type of food available introduced characteristics appropriate to the region settled, but these characteristics became resistant to change over many generations, and then became permanent. Blacks (*Neger*) in the continent of Africa, and whites (*Weissen*) in the continent of Europe, have, therefore, a common ancestry in the

156

original stock, but conditions in their respective continents formed them differently over an immense amount of time, so that their different characteristics became fixed and impervious to transplantation. Blacks and whites belong to the same genus or species, because they have the physical potential to mate and produce hybrid children (*Blendlinge*), but they are, in Kant's terms, of different races, as are the inhabitants of the other two continents, America and Asia.[20]

Kant's theory of common humanity and racial difference presupposes two types of basic element found in all organic bodies and which derive from the original stock: germs (*Keime*) and predispositions (*Anlagen*). The germs are permanent characteristics, but the predispositions exist latently, and may or may not be activated according to the environment. All creatures have the possibility of growing different attributes for their self-protection, and will use and develop them in order to survive in different climatic conditions. Kant gives the example of how birds living in a cold climate have a disposition that allows them to grow an additional layer of feathers, while those living in a hot climate will not need to do so.[21]

Kant's theory of *Keime* and *Anlagen* is, as he makes clear, one of preformation; it assumes that all organic forms exist in embryo, and have existed since creation, before they come into their full and repeatable form. Preformation was essentially revived in the 1760s and 1770s by the Swiss natural scientist Charles Bonnet (a friend of, and much admired by, Lavater) and the German scientist Albrecht von Haller, because it tied the form of human beings to an originating act of divine will. God in creating man in his own image in effect plants a germ or seed or embryo, which already contains within itself the fully developed form of the individual man or woman.[22] This 'sleeping' embryo is brought to life during conception by the irritation caused by semen, and then undergoes a process of growth into a full human being. As J. F. Blumenbach, who was eventually to refute the theory, wrote with a certain sarcasm: 'According to this theory we, and indeed all the children of Adam, were at one time *ipso facto*, pent up in the two ovaria of our common mother Eve. There we lay, as it were asleep; though astonishingly little creatures we were yet completely organised bodies, and

perfect miniatures of the forms we have since assumed.'[23]

Kant's deductive method, beginning with first principles that can nonetheless notionally be verified, is embodied in the four Linnaean divisions of humanity, to which he now expressly applies the German word 'Rasse' or 'Race'. Divisions within each race, like nationalities within Europe or separate tribes, do not imply permanent difference, so these are called 'varieties', a distinction made neither by Bernier, nor by Reinhold Forster, who differentiated the peoples of the South Seas under the heading 'race or varieties'.

This is the first time that the word 'race' is specifically distinguished from the word 'variety', though this distinction did not become current before the nineteenth century. Georg Forster, in a review of Kant's writings on race, discussed at length below,[24] agrees that the genus or species of humanity is permanent and inextinguishable, and that varieties can merge into one another, but he concludes that there is no need for a concept of race. Why should race be any different from variety, 'that I take … to mean the same as *race*, the latter having only been seldom [separately] defined until now?' Forster claims that the word 'race' is borrowed from the French, and related to *racine* and *radix*, meaning descent and root. This meaning, however, is unspecific in its definition; one might talk of 'the race of Caesar' but also of the race of dogs or of horses. The word 'race' was used (as indeed he uses it himself) in descriptive accounts of the South Seas when 'variety' seemed inadequate to denote the differences of one people from their neighbours. The Papuans are called a different 'race' from peoples of Malay descent, because they are a people of distinctive character and unknown origin.[25] However, none of these linguistic usages, Forster insists, necessarily imply permanent characteristics.

Kant's division of the world into four races is defined according to '*Stammgattungen*' (root categories), but not predominantly according to colour, as follows:

1 The white race (*die Race der Weissen*).

2 The black race (*die Negerrace*).

3 The Hunnish, Mongol or Calmuck race (*die hunnische, mungalische oder kalmuckische Race*).

4 The Hindu race (*die hinduische oder hindistanische Race*).

Kant includes among the white race, though it has 'its chief seat' in Europe, Moors (i.e. Mauritanians), Arabs, Turks, and those from Asia not in other divisions. This is not a particularly unusual grouping for the time, for it incorporates the 'beautiful' peoples of the Caucasian regions within the white race. It also retains a division between the peoples of North Africa, and those of the rest of the African continent. Kant notes that that travellers have observed many mixed or incipient races, but he insists that they must derive from the four races identified. He does, however, in a later article entertain the belief, based on the Forsters' observation of two distinct races in the South Seas, that there might be five races altogether.[26]

Following Buffon, Kant sees air and sun as the permanent agents of formation of the different races, making the familiar polar contrast between Greenlanders and Africans. The former's low stature is correlated with their adaptation to the cold, which makes their blood circulate faster, increasing the pulse and hence the warmth of their blood. It also creates a distinctive Calmuck facial formation, flattened to make protuberant parts less vulnerable to the cold, and half-closed eyes caused by squinting against snowy glare. All such changes assume the transmission of acquired characteristics over many generations. Similarly the 'typical' thick lips and stub nose of the African are a consequence of a hot, moist climate, and it is the iron content of the blood that 'causes the blackness that shines through the superficial skin'. Kant concludes with the conventional view that 'in short, the Negro is produced well suited to his climate; that is, strong, fleshy, supple, but in the midst of the bountiful provision of his motherland, lazy, soft and dawdling',[27] yet he also argues opaquely that people of the original stock before dispersal would have been white in skin colour and have dark hair. This would make the white and blond race of northern Europe, which had benefited from a climate of damp cold, nearer to the original people of the earth, thus perpetuating the

beauty of the first creation. The argument was dropped from his subsequent pieces on race.[28]

Blumenbach in 1775

In the introduction to the first full translation of Blumenbach's works into English in 1865, the editor Thomas Bendyshe claims him to have been the 'first who founded his classification in great part on those presented by the general conformation of the head',[29] though Camper had previously lectured on the subject.[30] Blumenbach's thesis of 1775, *De generis humani varietate nativa* (Of the varieties of the human species), written for Göttingen University, emphasizes the distinctiveness of man, on two grounds: man has speech, and that is true of even the fiercest nations like Californians or those from the Cape of Good Hope, and man is bipedal, while even the orang-utan, the most 'human' of apes, is a quadruped.[31] Man's upright walk and verticality, and his use of two hands, puts an unbridgeable gap between him and the beast. The vehemence of his denial of the possibility of fruitful copulation between man and ape may have been a response to Edward Long's suggestion that such things might have taken place in Africa.[32]

Blumenbach's 1775 thesis explicitly dismisses the idea of the plurality of 'races' on the grounds that it was favoured by those hostile to Scripture, by whom he meant not Kant, but polygeneticists who denied mankind's origin in the same parents.[33] He followed Buffon in claiming that 'one variety of mankind does so sensibly pass into the other, that you cannot mark out the limits between them'.[34] and that climate causes diversity of habit, and varied modes of life and upbringing. Blumenbach only occasionally uses the word 'race', preferring to talk of 'varieties' or *geschlechte* (generation), or 'classes of inhabitants' (of the earth). Thus he notes that Linnaeus populated the world with four classes of inhabitants, and Goldsmith with six. In the 1775 edition he allowed for four varieties, but defined them by different geographical bounds from Linnaeus:

1 Europe

2 Asia, this side of Ganges, north of Amoor, and part of North America

3 Asia beyond Ganges, below Amoor, South Sea islands

4 Africa; and the rest of America,[35] adding a fifth race in later writings when he had absorbed the lessons of the South Sea expeditions.

Blumenbach's enquiry into human variety is based on the constitution of the whole body, stature and colour, which he attributes almost entirely to climate. In hot countries bodies are dry and heavy, in cold countries juicy and spongy. Height is affected by heat or cold, and the same is true of plants and animals. He notes great differences in colour between Ethiopians, white Europeans and red Americans, attributing this to a Malpighian analysis of the skin, locating the middle layer, the reticulum, as the seat of colour. Climate is most important in creating blackness of skin, but he also noted 'an almost insensible and indefinable transition from the pure white skin of the German lady through the yellow, the red, and the dark nations, to the Ethiopian of the very deepest black'.[36] Furthermore, colour variations are as wide within Europe as outside, if one compares, for instance, a working man with a delicate and well-bred female. White men in the lower classes are made brown by hard life, while men of the south may become whiter if they keep out of the sun.

Blumenbach's methodical study of the human skull had been anticipated, in spirit at least, by Lavater, who had noted the living skull's potential to grow and be affected by internal conditions, emphasizing its permanence in relation to moral character. Blumenbach drew the quite different and more cogent conclusion that the skull's very malleability makes it difficult to make general judgements of character or stage of civilization, because of the difficulty in putting together representative samples. As he notes with a Calmuck skull: 'it is ugly and nearly approaches a square in shape, and in many ways testifies to barbarism. But it shows how unfair it is to draw conclusions as to the

conformation of a whole race from one or two specimens.' He sets against this 'ugly' skull evidence of the beauty of some Calmucks: 'For Pallas describes the Calmucks as men of a symmetrical, beautiful, and even round appearance, so that he says their girls would find admirers in cultivated Europe.'[37] He notes further that the skulls of some peoples are distorted artificially. In general he takes a sceptical view of differences between skull types. Even the advent of the peoples of the South Seas makes little difference, though he notes that according to Georg Forster, the inhabitants of Mallicolo differ from other peoples in the shape of their heads. Nor are the skulls of African nations to be differentiated absolutely either from each other or from others: 'it is ... clear that almost all the diversity of the form of the head in different nations is to be attributed to the mode of life and to art: although ... with the progress of time art may degenerate into second nature'.[38]

When discussing physiognomy Blumenbach observes that some 'nations' have more settled features than others, mentioning the observations of Sydney Parkinson, Captain Cook and Lavater. He notes from Parkinson's plates distinctions between the fierce New Hollanders and New Zealanders and the mild Tahitians. 'Almost all the nations of Africa are sufficiently distinguished by persistent and peculiar lineaments of face',[39] but ancient Egyptians and southern Africans differ from the rest of Africans and mankind. Nonetheless Blumenbach emphasizes similarity rather than difference. He observes that black hair and dark eyes are usual in torrid zones, and light hair and blue eyes in colder parts, but Ethiopians' black woolly hair is 'no more congenital with them than the colour of their skin, but both have been contracted ... by the progress of time and the heat of the sun'.[40] The Ethiopian foetus has down scarcely different from the European, and some Ethiopians have black straight hair anyway.

If Kant was concerned with the laws we can legitimately apply to human variety, then Blumenbach was to prove more open to the inductive methods of the Forsters, seeking to open up new fields of study and accumulate data, with an awareness of the provisional nature of any conclusions.

Kant versus Herder

Kant's second article on race, *Bestimmung des Begriffs einer Menschen-race* (Determination of the concept of a human race), which appeared in 1785 in the *Berliner Monatsschrift*,[41] was probably written in response to Herder's *Ideen zur Philosophie der Geschichte der Menschheit* (Ideas towards a philosophy of the history of mankind), the first volume of which came out in 1784. Kant's article provoked a long reply from Georg Forster, which appeared in the *Teutsche Merkur* for October and November 1786.[42] Kant then replied to Forster (and also to Herder), making further comments on race in *Über den Gebrauch teleologischer Principien in der Philosophie* (On the use of teleological principles in philosophy), 1788.[43] We have, then, a three-way conversation on the matter of human variety and race, and I will here focus as far as possible on the role of aesthetic ideas in the debate.

The oblique exchanges between Herder and Kant over human variety can be seen as episodes in an extended, and by turns affectionate and rancorous interchange over 40 years. They were united by a lifelong mission to vindicate religion through science, but became intellectually and temperamentally at odds, and increasingly took profoundly different positions on human variety and history. Herder summed up his opposition to his teacher's later views by complaining of the 'the cold, empty ice-heaven'[44] of an autonomous reason distinct from experience, history and language. Herder, like Hume, was acutely aware of reason's limitations, speaking up strongly for the claims of the 'life-world', on the grounds that reason was not separate from, or impervious to, the world beyond its abstractions. Therefore reason must not cut itself off from the plurality of world views and cultures, individual sensibilities, and the contingencies of history.[45] If Kant's mission was one of separation and ordering, Herder argued always for unity, the unity of all creation under God, through an 'organic energy' (*organische Kraft*) which runs through all living

things, 'the single organic principle of nature, ... sometimes forming, sometimes driving, sometimes receptive, sometimes modelling'.[46] Mankind represents the highest form of life, but it is joined to all other forms of life, however humble. Herder's vision is essentially teleological; everything contributes to the improvement of the world and humanity, and the inner life of man is connected to God's construction of the world: 'The world's structure secures therefore the core of my being, my inner life, towards eternity.'[47] To Kant's particular disapproval, Herder based his view of human history on argument by analogy. Historical time is defined by analogy with the 'Lebensalter', or stages of life, from bold youth to decay in old age. Nations and cultures, like the human body, must pass through the same cycle: 'the life history of the individual and the life history of a culture have the same structure and follow the same laws'.[48]

Philosophy of History begins with an account, partly written in collaboration with Goethe, of the earth's position as a 'middle planet', then considers the earth as divided between mountains and water and between the warm southern and cold northern hemispheres. Organic energy is traced through the infinite variety of the natural world, finally reaching man, who is a *Mittelgeschöpf* (intermediate creation) between angel and beast.[49] This might recall the Great Chain of Being, and Herder occasionally uses it as an image of progression, but he is profoundly concerned to emphasize the separation of man from beast: 'no beast has speech, tradition, religion, laws or justice, nor clothing, homes, or the arts. Beasts can neither aspire to perfectibility nor fall into corruption.'[50] Physically, man is alone in the uprightness of his form, but in the last resort is set off from the rest of the animal kingdom by his beauty, which is also the mark of his divinity: God's 'Masterwork [is] the beauty of mankind'.[51]

Herder can claim the unusual distinction in the eighteenth century of rejecting all systems of classifying human variety. This is because, as Nisbet notes, he was opposed to systems of classification on principle, and was anti-Linnaean.[52] Though he did accept differences among human beings, in *Philosophy of History* he specifically denies racial differences, or the idea of race as a categorical division of

humanity. This may well have been in response to Kant's *Different Races*, or to Blumenbach, though neither name is mentioned: 'Some for instance have thought fit, to employ the term of races for four or five divisions, originally made in consequence of country or complexion: but I see no reason for this appellation. Race refers to a difference of origin, which in this case does not exist.' He argues instead for nationality as a category that more fairly reflects the range of influences on human character:

> every nation is one people, having its own national form, as well as its own language: the climate, it is true, stamps on each its mark ... but not sufficient[ly] to destroy the original national character ... In short, there are neither four or five races, nor exclusive varieties, on this Earth. Complexions run into each other: forms follow the genetic character: and upon the whole, all are last but shades of the same great picture, extending through all ages, and over all parts of the Earth.[53]

Herder nonetheless agrees that the original and ideal form of man was dispersed to the different quarters of the earth, but he makes the distinctive claim that the special character of peoples was created by the environment in the period of their first settlement, 'when all the elements were in their primitive rude force'. Africans became black and Mongols took on their distinctive physique early in human history, because, Herder argues, the earth acted more powerfully upon the peoples of the earth in the period after their dispersal than it did in later times.[54] Hence the characteristics of peoples became fixed in their earliest existence, though skin colour might change over a period of time.

In the sixth book of *Philosophy of History* Herder offers a brief survey of the peoples of the earth, like Buffon before him, judging the beauty or ugliness of non-European peoples, and classifying them accordingly, insisting that ugliness does not thereby make them less human. Describing a typical inhabitant of the North Pole, he notes that 'His head is large in proportion to his body; his face broad and flat: for Nature, who produces beauty only when acting with temper-

ance, and in a mean between extremes, could not ... allow the ornament of the face, ... the nose, to project.' In them 'no mind beams from the eye', nor is the 'hand of the organizing creator' visible. But Herder insists on a cautionary remark: 'Yet everywhere he still continues [to be] man.'[55]

Herder takes the conventional view that Africa was the antipode to the frozen north, and that the ideal climate and therefore the most beautiful people were to be found 'Near the Black Sea and the Caspian, on mounts Caucasus and Ural, consequently in the most temperate climate in some measure in the World ... Thus the nearer we come to the regions where Nature is most profuse of life, the more exquisite and better proportioned is the organization of man.'[56] He locates man's origin on the 'Asiatic ridge', but we should not necessarily seek there people of primeval beauty: 'As ... the first abode of the human species was on this ridge of the Earth, we might be inclined to seek on it the most beautiful race of men. But how greatly should we be deceived in our expectation!'[57] For the way of life of the inhabitants has now changed, and with it their beauty. There is, however, a group of nations where some memory of humanity's original beauty remains. This 'Region of well formed Nations' includes Kashmir, for 'The Cashmirians are deemed the most witty and ingenious people of India, equally capable of excelling in poetry and science, in arts and manufactures; the men finely formed, and the women often models of beauty.'[58] Like Persia, it is not far from 'Circassia, the parent of beauty', and 'Fortunately for us, Europe lay at no great distance from this centre of beautiful forms; and many nations, that peopled this quarter of the Globe, either inhabited or slowly traversed the regions between the Caspian and Euxine seas. At least we are thus no antipodes to the land of beauty.'[59] Herder thus helps to consolidate the idea that the Caucasus and the regions around it was the epicentre of a region of benign climate and human beauty that stretches from India at one end and Europe at the other.

Herder begins his account of Africa with a lengthy and ringing declaration against prejudice:

It is but just, when we proceed to the country of the blacks, that we lay aside our proud prejudices, and consider the organization of this quarter of the Globe with as much impartiality, as if there were no other. Since whiteness is a mark of degeneracy in many animals near the pole, the negro has as much right to term his savage robbers albinoes and white devils, degenerated through the weakness of nature, as we have to deem him the emblem of evil, and a descendent of Ham, branded by his father's curse. I, might he say, I, the black, am the original man. I have taken the deepest draughts from the source of life, the Sun ... fertility and richness of environment. Here each element swarms with life, and I am the centre of this vital action.[60]

Herder's recognition of the humanity of Africans is tempered by a clear desire to differentiate them from Europeans, based on the standard physiognomic typology attributed to the former: 'the thick lips and flat noses of the negro form ... spread far down through innumerable varieties of little nations', until it reaches 'the hottentots and caffres [who] are retrogradations from the negro form';[61] their noses are less flat and lips less prominent. On the one hand Herder strongly attacks travellers' tales, and their 'too tyrannical indifference, to investigate the variation of national form in wretched black slaves', with the exception of those with 'the penetration of Forster, the patience of Sparmann, and the science of both'. But he also argues, using the recent work of Soemmerring, for the sensual and unintellectual qualities of the 'Negro', in effect placing 'him' in an intermediate place between the non-human and the European, as a sensual rather than an intellectual being:

Nature, agreeably to the simple principle of her plastic art, must have conferred on these people, to whom she was obliged to deny nobler gifts, an ampler measure of sensual enjoyment ... According to the rules of physiognomy, thick lips are held to indicate a sensual disposition; as thin lips [i e. of the European], displaying a slender rosy line, are deemed symptoms of a chaste and delicate taste.[62]

167

The African's prominent lips, breasts and private parts are signs of 'sensual animal enjoyment' that is reflected in his whole body, but they do not make him less human. It is true, Herder affirms, that from certain points of view 'the face would have at a distance the resemblance of that of an ape', but this is only an illusion and perhaps a way of helping the African to camouflage himself in the wild. The African is thus by providence within the human race, but very clearly distinguished from those who live in temperate climes:

> That finer intellect, which the creature, whose breast swells with boiling passions beneath the burning sun, must necessarily be refused, was countervailed by a structure altogether incompatible with it. Since then a nobler boon could not be conferred on the negro in such a climate, let us pity, but not despise him; and honour that parent, who knows how to compensate, while she deprives.

Native Americans, by contrast, are admirable for 'that proud savage love of liberty and war, which their mode of life and domestic economy, their education and government, their customs and occupations both in peace and war, equally tend to promote'.[63] The 'uniformity of their primitive character [that] has been variously modified, yet never lost' is all the more remarkable in a climate that might seem to create extremes of human behaviour. They are, then, an argument for the ultimate superiority of 'generation' or heredity over climate in the formation of national character: 'there is nothing to prevent this branchy stock of mankind, with all its numerous ramifications, from having arisen from one single root, and consequently displaying an uniformity in its produce'. The 'leading or common character' they exhibit is of 'goodness of heart, and infantile innocence: a character, which their ancient establishments, their habits, their few arts, and above all their conduct towards the Europeans, confirm'. This character has developed in isolation, for they are 'sprung from a savage land, and unsupported by any assistance from the civilized world, all the progress they made was their own; and in their feeble beginnings of cultivation they exhibit a very instructive picture of man'.

Herder does not survey the continent of Europe, though he does have chapters on the individual nations. He devotes book thirteen of *Philosophy of History* to the Greeks, whom he contrasts favourably with the 'infantile culture of the Egyptians'. His ecstatic view of Greece in its heyday clearly owes much to Winckelmann, but there are characteristic differences of emphasis. For Herder, the determining art is that of Homer, and he speculates at one point on whether the South Seas might produce a Homer of their own: 'the Fates alone can tell, whether a second Homer will be given to the new Grecian archipelago, the Friendly islands, who will lead them to an equal height with that, to which his elder brother led Greece'.[64]

Herder gives a central place to Greek religion, rather than to physique: 'it was a fortunate circumstance, that the Greeks ... were beautifully formed; though this form must not be extended to every individual Greek, as a model of ideal beauty'. But sculptors were exercised by the demand for images of gods, and the presence of deity in the reverence for ancestors. Though the climate allowed for the display of bodies, the Greek figure depended more on descent. Like Winckelmann, he did not believe that modern nations could themselves become 'Greek'. But 'If then we cannot be Greeks ourselves, let at least rejoice, that there were once Greeks.'[65]

Herder's idea of the aesthetic subject, like his views on Africans, led him towards a Eurocentrism that is at odds with his protestations of universality. For Herder the act of aesthetic contemplation is tied to an aspiration towards an ideal aesthetic life, one that avoids either the cold, reflective and unemotional life of the person of reason, or that of the 'uncultivated man (who) is merely coarse sensuousness craving animal life'. The 'aesthetic man' occupies a middle ground between the two: 'his sensuousness consists in a refined sensibility that makes man fit for a moral life'. This life of sensibility is different not only from that lived by the rational person and the savage; it is also different from that of 'our bourgeois (German) people ... [who are] the antipodes of humanity'.[66]

Kant's *Concept of Race*, 1785,[67] is a restatement of the position taken in *Different Races*, but the insistence on the absolute separation of the

races, the continuity of certain racial features through the generations, and a vigorous denial of environmental and climatic effects on skin colour, suggest a determination to differentiate his position not only from Herder, but also from Blumenbach and the Forsters. Kant now makes skin colour the only permanent sign of racial difference. The issue of the number of races had been complicated by the South Sea voyages, but Kant is cautious towards the notion of a fifth race on the grounds of lack of evidence so far that the 'new' peoples are anything other than hybrids of the existing four races. But his central point, clearly directed against all those writing on human history in the period, is that it is 'crucial to define the concept that one is trying to explain by observation before consulting one's experience'.[68]

Kant argues that the 'experience' gained by empirical observers like the Forsters and accepted by Herder is valueless if one begins with a concept that requires such confirmation. One cannot simply assume that apparent similarities between different peoples are an argument for climatic influence. If the four races of humanity were, after the dispersal, initially dependent on climatic conditions, then at some undefined period in the past there is reason to think that they became independent of such factors. We need then to consider skin colour outside its native habitat, in order to eliminate the present effects of climate and observe its 'real' colour. Someone burned by the sun may after all still be essentially white: 'If the Moor (Mauritian) is brought up in rooms and the Creole in Europe, they are indistinguishable from the inhabitants of our part of the world'. It follows that the only way to tell the true colour of Africans is to look at 'the colour of those [Negroes] who have been living in France for a long time, or even better those born in France, rather than in their own fatherland, so as to eliminate the effects of sun'. That way we will be left with 'that blackness alone which he has acquired by birth, which he passes on, and which alone can be used for determining a class difference'.[69]

Kant thus makes a distinction between skin colour contingent on circumstances and 'real' colour, implicitly suggesting that Herder has elided the two, thus blurring the essential differences between the races. In the case of South Sea islanders, described by travellers as light-brown

skinned, according to Kant's logic we would need not only to see a child fathered by a South Seas couple in Europe, but perhaps even follow the family through a life-cycle and look at several generations of their descendents. Skin colour is the determinant of race because Kant claims that it is the only thing that is passed on through the generations as part of the human genus as a whole. Other attributes may or not be transmitted down the generations, but he insists that colour always is; even in mixed mating it is visible in due proportion to the colour of the parents. Dark and light skin colour is inherited in all races, while diseases and deformities and other characteristics are not necessarily passed on.[70]

Even so, Kant does not deny that skin colour is qualified by the particular conditions of the place that each people has inhabited. If Africans are not made permanently black by the sun, then their dark skin colour must derive from other conditions in their habitat, just as something in the habitat is making Americans red, and so on. This led Kant into a series of odd and, as he admits himself, possibly misremembered observations derived from travellers. In a section on the 'peculiarities of the Negro race' he argues that as human blood turns black on being overloaded by 'phlogiston', then blacks must eliminate phlogiston from their blood through their skin as well as from their lungs. Why? Because they live in places where air is unusually phlogistonized, in dense forests and swampy undergrowth, so more than lungs are needed to clear the blood.[71] Similarly he suggests that the red colour of Americans is to do with iron in the blood, though he puts that suggestion forward more tentatively.

Kant's aim in 'defin(ing) precisely the concept of a race' was to bring human variety into an orderly relationship with a general idea of the unity of mankind. He gives in *The Concept of Race* a definition of race as 'the class difference of animals of the same stem, in so far as it is certainly hereditary',[72] but this could, and in a way was bound to be, a principle capable of verification by experiment. But Kant's theory of race had the advantage for him at least, of creating a clear *a priori* framework based on 'the lost unity of the genus', without which the study of human variety would be of 'little use to philosophy'.[73] In other

words, the idea of a universal human subject would have been lost, with consequences for his own transcendental argument. It also enabled him to give a plausible basis for rejecting the increasing common belief put forward tentatively by Georg Forster, though not by Herder, that mankind was descended from different first tribes.

Kant did not specifically mention Herder's *Philosophy of History* in the *Concept of Race*, but his two-part review (*Recensionen von J. G. Herders Ideen zur Philosophie der Geschichte der Menschheit*) of the book makes his clear his philosophical differences from Herder. Kant denies that a philosophy of history could be possible, or that history can be anything more than an empirical human practice; it is therefore a secondary study. Kant, as we have seen, particularly objects to Herder's use of argument by analogy, between the human and natural worlds, and between the human and the cultural. The idea that 'the life history of the individual and the life history of a culture have the same structure and follow the same laws' was, according to Kant, a false one.[74] He ridicules the idea that the shape of the head, because it is governed by the uprightness of the stance, can affect the nature of thought, and rejects Herder's notion of organic energy, and the idea that reason might be a function of a group or tradition, as well as of an individual.

Herder returned to the issue in the later 1790s, in one of the *Briefe zu Beförderung der Humanität* (Letters to promote humanity) of 1797, in a way that makes clear that, even in old age, Kant remained his touchstone for views on race. Herder reiterates his belief that 'a complete description of peoples (*Völker*) according to so-called races, varieties, mating habits, and other categories is not helpful'.[75] By categorizing another people in such ways it becomes easy to make a false judgement of them, opening the way to such injustices as the Catholic Church bestowing legitimacy on slave trading. Recalling a similarly pungent remark he made in *Philosophy of History*, he reaffirms the common humanity of all peoples: 'The Black has as much right to take the white for an aberration, for a disgusting albino, as the white has to call him a beast, or a black animal. So also does the American or the Mongol.'[76] He then returns to Kant's theory of 'Keime', advocating 'Not different

172

germs [*Keime*] (an empty and contradictory word to refer to the development of mankind), but different forces developed in different proportions.'[77] Though Europeans might be different in various ways from other peoples, no one nation can claim 'The model, the prototype of mankind, [which] does not lie in the territory of one nation.'[78]

Georg Forster's Challenge

Unlike Herder, Georg Forster published a direct and considered review of Kant's articles on race. He had returned to Germany in 1778, disappointed with the way his father's and his own contributions to the second Cook expedition had failed to be recognized in England. His intention was to set himself up in Germany as an author and academic, on the basis of the immense prestige of having been to the South Seas with Captain Cook. He moved around Germany and Lithuania, taking on academic posts, intensive reviewing and scientific writing for the rest of his short and intermittently dramatic life, before dying in Paris in 1794 as a representative of the Mainz Republic to the French Convention. In 1778, still only twenty-four, he took a post as Professor of Natural History at Kassel, where he became close to the renowned physiologist Samuel Thomas Soemmerring, engaged, as it happens, on his influential book on the physiology of the African.[79] He exchanged the Kassel post in November 1784 for a similar but better paid if more provincial, post at Vilna in Lithuania, then in the Kingdom of Poland, staying there only until June 1787. His response to Kant's *Concept of Race*, in the Berlin *Teutscher Merkur* for 1786, was, as he notes himself, that of someone far from the centre of things taking on the now celebrated author of the *Critique of Pure Reason* of 1781.[80]

Forster's attitude towards Kant and his intervention in the question of race is vividly expressed in a letter to Soemmerring of June 1786: 'It would be a good thing for the cobbler to stick to his last! Kant has a powerful mind, yet paradoxically, when the philosopher is commenting outside his own profession, he wants to mould nature according to his own logical distinctions.'[81] Forster's broad concern is to challenge what

he sees as Kant's desire for 'incontrovertible certainty' (*apodiktische Gewissheit*). He begins by countering Kant's warning that the capacity for abstraction could be disrupted by clinging too firmly to observation, by insisting on the importance of philosophers getting their facts right. Speculation and abstract certainty may be able to predict what observation will be obliged to recognize as true, but they must not ignore or override experience. Noting the Linnaean origins of Kant's theory of race, Forster argues that Linnaeus' principles were far from infallible, and indeed have not stood up fully through the rapid changes in natural history over the previous fifty years, mischievously adding that 'even speculative philosophy must be subject to this common destiny. Who can help thinking at this point of the critique of pure reason?'[82] He counters Kant's claim that 'we only find what we need in experience if we have previously established what we have to look for', by noting that we can find the wrong thing if we are not careful. The observer must be unbiased, and not 'seduced by a faulty principle into lending objects the colour of his own glasses'.[83]

Forster insists that it is the observer's duty to record what he sees, regardless of preconceptions: 'Who would not prefer the modest observations of a straightforward yet alert and reliable empiricist to the colourful inventions of a tendentious systematiser?'[84] Yet he argues against a sharp distinction between empiricism and theory, simply demanding that the data brought back by travellers should be assessed according to high standards of reliability, by those qualified to assess the premises on which they are based. These general points lead into a defence of his own position in the face of Kant's claim that 'One cannot reliably define the actual colour of the South Sea islanders on the basis of the descriptions so far.' Forster insists that the differences in colour were plainly evident to observers like himself. Furthermore, they are compatible with the uniform traits of most inhabitants of the South Seas, who have in common 'light brown skin colour, impressive stature, beautiful build, pleasant physiognomy etc'.[85] They also reveal kinship in their customs and language, which, of course, he and his father studied. But there are also, as his father noted, smaller, darker people with frizzy hair and uglier physiognomies, and different lifestyles, who live

in New Guinea and New Holland. Even the depth of the darkness of their skin differs quite markedly among them. Kant, on the other hand, had been led to question the relative skin colour of the South Sea islanders by misunderstanding a passage in Carteret's account, something, of course, that an observer would not have done: as Forster noted, 'many a hypothesis would be improved if one could argue away the ugly Blacks from the South Seas. But they are there, and that is that.'[86] There would be no point in following Kant's recommendation that a child of Tahitian parents should be fathered in Europe away from the Tahitian climate, because it is not known whether whites do, or do not, turn black in course of centuries, or vice versa, or if so how many generations it would take. Every creature is only what it is in the place for which nature destined it; one cannot postulate an existence for a creature outside its habitation.

Forster was also able to cite Linnaeus' view that the colours of animals and plants were coincidental or changeable, and therefore did not suffice for the differentiation of species. He notes that his friend Soemmerring, referring to his book *Über die Körperliche Verschiedenheit des Negers vom Europäer* (On the bodily difference of the Black from the European), also published in 1785, had argued for an anatomical distinction between blacks and Europeans, on the grounds that colour belonged to the less essential attributes of the body.[87] Forster cites Soemmerring's opinion that 'the Negro has more in common with the race of the ape than the white man, with regard to both outer and inner shape', but he is emphatic that this supposed resemblance does not mean that the ape played any part in the former's formation. This resemblance is nothing more than an indication of the physical closeness between man in general and ape, and of the common features of all living creatures; the most 'apelike' Negro is very closely related to the white human being, and though the difference between man and ape may sometimes appear very slight, it is an absolute one. Man and ape are two different genera, hence 'An apelike man is no ape'; it 'could not be otherwise, unless humanity should turn into ape, or the Negro cease to be a human being.'[88]

Forster's critique, then, is Herderian in emphasizing the interconnections between humanity and all living creatures, while drawing a

clear line between man and ape. Indeed, he quotes Herder's remark that 'Despite all the differences between living creatures of this earth, there seems to be a certain uniformity of structure as well as a distinctive form.'[89] Forster, however, takes a less absolute position than Herder by insisting that the whole question of the relationship between genus, variety and race cannot be answered on present knowledge: 'Whether Negro and white man differ from each other as genera or mere varieties is a different, may be an insoluble question.'[90] Forster argues that this question cannot be answered by a natural historian on the evidence that exists to date. If a genus is defined by the invariability of its characteristics, then it is impossible to know if its characteristics have been invariable from its origins in remote history. In the case of humanity this must leave open the possibility of polygenesis: 'who is so wise as to teach us whether organic powers stirred just once, in one place only, or at entirely different times in entirely separate parts of the world, where they emerged gradually from the ocean's embrace?'[91]

Forster finds it difficult to distinguish between genera and varieties based on contingency; some genera are more closely related to each other than others, and in any case their number is infinite. It follows then that 'race' must be as indefinite a term as 'variety', for nature, as Buffon had already made clear, has a multitude of different relationships. Is the Negro then a variety or genus of the human race? If one can no longer fall back on the certainty that all varieties of humanity descend from one original couple, then it is no longer necessary to assume that all peoples are genetically interchangeable with each other. Nor can one assume each 'race' to be a discrete or uniform entity, for there are colour differences within each; white men are darker in Africa, while 'the Negro is olive-coloured in the land of the Kaffirs'.[92] If the form of a 'Negro' head is in general different from that of a white man, then there are as many nuances in the form of an African head, as there are with whites. On the other hand there is a clear distinction in physiognomy between 'Negroes' and Arabs, for in the latter 'descent from whites radiates from the face'.[93]

Forster also finds problematic Kant's assertion that hybrid children inherit colour in equal proportions from both parents. Firstly,

colour is no more essential than any other difference; nor are children from the same tribe necessarily uniform in colour. To accept blacks and whites as races of the same species would imply that there were definable limits to the changeability of one or the other. Forster also questions Kant's suggestion that skin colour achieves permanence after a time; what would happen if the inhabitants of one continent were forced into a second transplantation; why would they not be able to adapt to that as they had the first time?[94]

Forster returns to the question of polygenesis at the end of the essay, considering the objection that if blacks are denied a common ancestry with Europeans, 'do we not thus cut through the last thread by which this abused people was connected to us and through which it at least found some shelter and mercy from European cruelty?'[95] Forster points out that the traditional belief that blacks had the same original parents, and thus were 'brothers', did nothing to mitigate slavery or the cruelty they endured from Europeans, who were in any case capable of being equally cruel to each other. The solution to such problems is not to be found in verbal definitions but in practical education in making human beings feel what they owe to each other. Forster ends his assault on Kant with a passionate invocation to the 'white man' to renounce his complacent belief, based on the spirit of order, and on science and on art, that 'the mind of the black man only reaches the first level of childhood and surrenders to ... [the white man's] wisdom'. On the contrary, he tells the 'white man', in a tone reminiscent of Herder, to be

> ashamed to abuse your power over the weak man, to cast him down to your animals, to annihilate all traces of his power of thought ... you should act as his father, and by developing the sacred spark of reason within him, complete the act of enoblement ... Through you he could, should become what you are or could be, a being happy in the use of all his powers ... [but] he will become so one day; for you too are just an instrument of the plan of creation![96]

In this emotional passage Forster moves from a forensic analysis of the idea of race into a hymn of praise for universal human perfectibility

based on the benevolent care of one people for another. This is not quite foreshadowed in the previous argument, but it does parallel a development in Forster's own broad position – one that was to lead him to Paris at the height of the Revolution.[97] Forster's argument inexorably places Kant among an older order, whose consciousness was formed before the new world of the South Seas was opened up by exploration. Forster accepts that his polygenetic, gradualist view might be for the moment heretical, but it is also a way out of a past dominated by sages like Kant, who, Forster jibes, had never seen a 'Negro' in his life.[98]

Georg Forster's assault on Kant's racial theory exposes the inadequacy, in terms of the science of the time, of making colour the central indicator of racial or varietal difference. Theories abound on skin colour in the eighteenth century, but it is arguable that by the mid-1780s, thanks to Lavater, Camper, Blumenbach and Soemmerring, it had lost its central place as a criterion of difference. If Kant was virtually alone in continuing through the 1780s to make skin colour the principal sign of race, Georg Forster was, in Kassel and later in Göttingen, in direct contact with Blumenbach and Soemmerring, who were working on anatomical and physiognomic similarities and differences between peoples.

It is indicative of the seriousness with which Kant took the issue of race that he came back to Forster's critique in *Über den Gebrauch teleologischer Principien in der Philosophie* (On the use of teleological principles in philosophy), 1788. Kant here argues that nature, the embodiment of everything that lives according to laws in the world, can be revealed to us in two ways: the theoretical and the teleological. Because the theoretical way cannot achieve complete knowledge, its aims have to be defined by practical reason, to complement the inadequacy of theory. A teleological approach depends upon the knowledge of how things contribute to the survival and well-being of the human species. Hence Kant's 'little essay on the human races',[99] as an invocation to teleology, lifts his response from a wrangle over the truth of travellers' tales, where he was in a weak position in relation to Georg Forster's direct experience, on to a philosophical plane where he can

hope to define the terms of the debate. If, as Kant admits, pure theory or reason cannot alone reveal nature, then a teleological method can interpret nature and the physical being of humanity, in terms of their purpose and ends. But a determination of aims or an appeal to usefulness cannot replace theory, for end causes do not necessarily give knowledge of working causes.

It is this distinction, 'the principle on which I based my argument', that Kant accuses Forster of misunderstanding, for the latter fails to 'posit a principle by which the natural scientist should let himself be guided in his search and observations';[100] 'empirical groping', as Kant puts it, is inadequate. In any case, he argues that Forster does have a guiding theory even if he does not state it clearly, for he follows Linnaeus in assuming the persistence of the characteristics of reproductive organs necessary for description of the vegetable kingdom. While Kant admits that *a priori* reasoning can be inadequate, that is not a reason not to use it, nor to admit using it. Kant also accuses Forster of confusing natural history (*Naturgeschichte*) and natural description (*Naturbeschreibung*), by in effect dismissing the former on the grounds that the beginnings of natural and human life are unknowable. But Kant argues that it is legitimate to trace back connections between current forms of nature and ancient causes, as in the natural history practised by responsible scientists like Linnaeus, and indeed as Forster does himself in his Soemmerring-influenced speculations on the differences between Africans and other representatives of humanity. The point for Kant is not that natural description is inferior to natural history, but that one must be clear which of the two one is doing. Natural description can lead to a scientific system of classification, while natural history must ever be made up of fragmentary and shifting hypotheses. This does not mean it is a misguided pursuit. Such disciplinary borders, he claims (a little smugly) in his own career to have demonstrated, are a source of insight.[101]

Kant's definition of race is now revealed as an attempt to solve a problem in natural history. He defines it on this occasion as 'the basic characteristic which suggests a common origin allowing for persistent hereditary features within the same tribe'.[102] Racial characteristics

develop first in procreation, and are varieties so determined and persistent that they can be differentiated as a class. The value of the concept of race for Kant is that it is an idea by which 'reason can reconcile the greatest diversity in human progeny with the greatest unity in origin'.[103] It enables a natural history that can start from a basis in monogenesis, but it also satisfies a philosophical need for the unity of mankind. Furthermore, the theory of race is in itself an illustration of the need for a guiding principle in order to observe nature constructively. The observer will need to look for features in nature that explain their origin, and therefore go beyond physical description, which can lead only to designation, and which cannot indicate whether affinities are real or merely nominal.

According to Kant, the fact that two different kinds of human being of any type can produce offspring allows one to assume that they belong to the same species. Individual variety was probably a feature of the original stock as part of nature's purpose to develop the greatest possible diversity, but racial difference was developed for different but equally essential ends. This took place in a later phase of humanity's development, for racial characteristics once developed can survive and resist external conditions. It is true, Kant admits, that nature may allow the mixing together of races through hybridity, but she does not encourage it; people of mixed race might be fit for more than one climate, but they do not necessarily thrive in any one.[104]

Because Forster agrees that the difference between Africans and others is 'great enough not to consider it a mere play of nature or effect of coincidence but demanding of predispositions in nature contained within the original stock',[105] Kant mischievously claims that the intellectual difference between himself and Forster is, in fact, minimal. Indeed all that separates them is Kant's desire to extend the principle of difference to Indians and Americans. Kant even suggests that Forster's proposal that there could be more than one original stock is not a real subject of contention between them, only that it is 'more appropriate for a philosophical way of explanation' to have only 'one original stock with originally implanted purposeful dispositions'.[106] Furthermore, he claims, they both accept that the origin of

organisms remains unfathomable to human reason.

From this Kant is able to claim that his disagreement with Forster is less a matter of principle than of interpretation of specific cases. He therefore challenges Forster's order of gradation of skin colour from brown to black according to climate, reiterating that the effect of sun confuses our apprehension of the true colour of skin. It is clear that some skin colours were no longer dependent on the sun even if they might have been conditioned by it in the early phase of the occupation of their land. Kant gives here the example of Gypsies, who, he claims, still have 'Indian' skin colour though they have been in Europe over twelve generations, and he insists that it would be no counter-argument to say that over another twelve generations northern air would have bleached out their colour.[107] He answers Forster's 'second transplantation' argument by claiming that predispositions in the original stock allowed them to thrive in particular climates, rather than that they chose locations according to special predispositions. Once the predispositions had developed in a particular climate this would discourage peoples from moving from their territories, and this can be demonstrated by the fact that the inhabitants of India and Africa have shown no tendency to wish to move in the direction of Europe. Though Kant does admit that that the formation of races has been a long process, sometimes facing peoples with conflicts that interrupted their assimilation, he insists that races did not spread sporadically but were always found, initially at least, in united groups within borders. 'Negroes' were found only between Senegal and Capo Negro, and America contained until modern times none of the races of the Old World (except possibly the Inuit). The presence of the dark Papuans in the South Seas could be explained by the fact that they were driven from their original habitat by revolution or other change.[108]

KANT: ANTHROPOLOGY, AESTHETICS AND RACE

Georg Forster's and Herder's differences with Kant raise the question of the linkage between aesthetics and race in Kant's *Critiques*. Forster and Herder both assumed that the varieties of humanity could be

ordered according to some kind of aesthetic hierarchy, though not necessarily a rigid one. Kant, on the other hand, had avoided such relative judgements since the *Beautiful and Sublime* volume in the mid-1760s; indeed, it is an essential aspect of his mature Critical theory that aesthetic judgement is autonomous and would be unable to evaluate the human body in such a way. In what follows I want to argue that Kant's mature aesthetic theory is nonetheless aware of limitations in the idea of aesthetic autonomy, and that connections can after all be made between his Critical aesthetics and his views on human variety, though, of course, they are not as intimately intertwined as they were in the *Beautiful and Sublime*.

Philosophers have traditionally ignored or played down Kant's anthropological works, and his writings on race especially, but attempts have been made to bring the former at least into a web of interconnections with his Critical theory. Frederick van de Pitte, in his book *Kant as Philosophical Anthropologist*,[109] has argued that Kant's whole philosophical project, including the three great Critiques, can itself be regarded as anthropological, for his larger enterprise was the creation of 'an anthropological system in the broad sense, i.e. a system which establishes on *a priori* principles a particular conception of the nature and destiny of man'.[110] If Kantian anthropology is both theoretical and practical, concerned with the moral law and man's practice of it, then, Van de Pitte argues, the 'theoretical' is essentially subsumed within the three great Critiques, while the 'practical' is expressed in his writings on natural history, including race, and especially in *Anthropology from a Pragmatic Point of View*, published in 1798.

Such a division is perhaps a little too pat, given that Kant does not elaborate on the distinction between theoretical and practical anthropology. It might seem obvious to place the tracts on race within the field of practical anthropology; *Different Races* was, after all, explicitly connected by Kant to the course of anthropology lectures he had recently begun. But in the published version of the course, *Anthropology from a Pragmatic Point of View*, there is almost nothing at all on race. The section on it is a mere page of text within the second part of the volume, within the frame of 'Anthropological Characterisation: On

how to know a man's interior from his exterior'.[111] This page is placed between a long account of 'The Character of Nations' and 'The Character of the Species', but the material content of the section on national character, like the exercise in the same vein in the *Beautiful and Sublime* volume, consists of confident anatomies of national character through representative individuals. In 'On the Character of Races', Kant simply assumes their existence and refers the reader to a work published by his student Girtanner, which he claims to have elucidated his principles. Instead, he raises the question of the differences that can be observed within one race, reiterating only the point that the tendency in nature is progressively to increase the difference between races and within each race. This is presumably a further response to Herder and others; he denies that 'characters ... develop constantly and progressively towards resembling each other',[112] but rather that Nature operates a principle of infinite diversity, so that all human beings are different from each other, a point made in the articles on race.

The reason for this summary passing over of race may be explained in a later work, the *Physical Geography* of 1802, where race is connected to environmental factors, and to the effect of soil forms on plants, animals and humanity. This suggests uncertainty about where to put race within the larger scheme as it has evolved in previous decades, and casts doubt on the role of practical anthropology, what constitutes it, and how seriously it was to be taken. Though van de Pitte argues that *Anthropology from a Pragmatic Point of View* has a coherent place within Kant's larger enterprise, it appears to be inconsistent in tone and purpose, veering from the light touch of his earlier pedagogical work to more intricate formulations; it was, after all, written at different times over a 30-year period, and not necessarily with publication in mind.

At no point in Kant's 1780s writings on race does he apply an explicit or normative aesthetic judgement to any of the four races that he identified, or discuss morality in relation to race.[113] Nor did he comment on the relative ability of different peoples to make aesthetic judgements, as he had done in the *Beautiful and Sublime* of 1764. There he had implicitly argued that the empirical was the only possible

approach to beautiful, rejecting Baumgarten's attempt to create a 'science of the beautiful' by 'bring[ing] the beautiful under rational principles'.[114] By 1790, following the pioneering work of Karl Philipp Moritz, Kant had distanced himself from empirical aesthetics, which carried with it the implied corollary that an aesthetic judgement that discriminates between one people and another, or is dependent on sexual attraction, is *ipso facto* an instrumental use of beauty, and therefore not purely aesthetic.[115] If aesthetic pleasure is by Kant's definition not stimulated by sexual attraction, concepts, understanding or familiarity, then human beings or their representation could no longer be perceived purely aesthetically.

If Kant limits the judgement of beauty to an immediate response to the object, detached from normal desires or interests, then it would seem to be impossible to sustain a connection between his Critical aesthetics, his anthropology and his writings on race. Kantian aesthetics would preclude anything that belonged to the world of affairs, like national or racial culture.[116] That Kant was aware of the problem, and the limitations he had placed on the scope of aesthetic autonomy, is clear from two brief sections, 16 and 17, in the third 'Moment' of the *Critique of Aesthetic Judgement* (the first part of the *Critique of Judgement*).[117] He raises there the question of objects that inevitably evoke emotions beyond the aesthetic as he has defined it: human bodies and flowers, figurative as well as ornamental sculpture, and orchestral music and opera as well as chamber music. Kant's solution to this problem is not at all easy to follow, but to make an attempt at understanding it we need to look closely at the argument in the *Critique of Aesthetic Judgement* devoted to the Analytic of the Beautiful, of the operation of aesthetic response before an object of beauty.

Kant's claim that aesthetic pleasure lies in its very detachment both from reason and from the senses, so it 'can never be comprehended from concepts, as necessarily bound up with the representation of an object',[118] is set against an equally strong tendency on the part of the perceiving subject to believe that an aesthetic judgement does have universal validity, even though it is by his definition made without rational thought or in consultation with others. This, then, is a contra-

diction, or an 'Antinomy'; aesthetic judgement 'like all empirical judgments, can declare no objective necessity and lay claim to no *a priori* validity', but 'the judgement of taste also claims, as every other empirical judgement does, to be valid for all men'. The 'feeling of pleasure . . . attributed to everyone' is to be found in the universal, though subjective, condition of reflective judgments, in 'the purposive harmony of an object (either nature or art) with the relations of imagination and understanding'.[119] Natural beauty is perceived as an apparent (as opposed to a real) purposiveness (*Zweckmässigkeit*), and is discerned through aesthetic pleasure. Real (as opposed to an apparent) purposiveness is, on the contrary, discerned by the understanding and reason, and is therefore the province not of aesthetics but of teleology, which, as we have seen, provided an intellectual framework for his theory of race.

These distinctions are developed in the *Critique of Judgement* in a series of 'Moments'. The first Moment, 'Of the Judgement of taste according to quality', defines taste as the faculty of judging the beautiful, but this judgement can only be subjective, for it involves pleasure or pain. This aesthetic pleasure is disinterested, and independent of sensual pleasure: 'when the question is if a thing is beautiful, we do not want to know whether anything depends or can depend on the existence of the thing . . . but how we judge it by mere observation'. This means that the beautiful is different from the pleasurable (*angenehm*) which pleases the senses, and from the good, both of which are bound up with interest: 'taste in the beautiful is alone a disinterested and free satisfaction; for no interest, either of sense or of reason, here forces our assent'. This is summed up in the 'Explanation': 'Taste is the faculty of judging an object or a method of representing it by an entirely disinterested satisfaction or dissatisfaction. The object of such satisfaction is called beautiful.'[120]

The second Moment argues that the person judging something to be beautiful presupposes that every other person will have the same response. In doing so, he or she will then assume that beauty is part of the object, and that the judgement is a logical one. It is therefore presumed to be of universal validity, an idea that Kant calls 'subjective universality'. The person making the judgement will further assume

the beautiful to be more than merely pleasing, and thus deny true aesthetic taste to those who do not see the object as beautiful. This claim to universal validity is integral to any judgement of taste. In reality, of course, judgements of taste are often disputed, but the point is that agreement is imputed universally in making the judgement: 'The beautiful is that which pleases universally without [requiring] a concept.'[121]

The third Moment argues that the beautiful involves a perception of 'purposiveness without purpose' (*Zweckmässigkeit ohne Zweck*). An actual purpose would carry with it an interest, so no such thing can lie at basis of a judgement of taste. It is the form of purposiveness that is the determining ground of a judgement of taste. A pure judgement of taste is determined only by purposiveness of form and not by charm or emotion, which would be recognized through an empirical judgement made by sense. Emotion is described as alien to beauty, but it can be part of the sublime, as is discussed in the second book of the *Critique*. Kant also argues that beauty is independent of perfection, and here he deliberately differentiates himself from Baumgarten, who defined beauty as perfection apprehended through the senses. Perfection is in the last resort quantitative, and therefore involves judgements outside the aesthetic.[122]

It is at this point in the argument, section 16 of the third Moment, that Kant raises the question of the rarified nature of the aesthetic he has created, for his definition of beauty appears to exclude the sculpture of the ancient Greeks, the very canon reinforced by Winckelmann, that was almost always taken to be the *locus classicus* of ideal beauty. It would clearly be absurd in terms of the beliefs of Kant's time either to deny the human implications of the canonical works of Greek sculpture, or to deny their beauty. He appears to accept that the highest form of visual pleasure is derived from the contemplation of classical statuary, though living in Königsberg he can have had little or no direct experience of actual works.[123] If, as is likely, he had read Winckelmann or the work of anyone writing on art in Germany in the period, he could not have avoided the assumption that aesthetic pleasure was inextricably tied to the representation of ideal humanity.

His attempted solution to the problem is, in effect, to divide

beauty into two categories. The first is the pure aesthetic he has advocated so far, which, as 'free beauty', assumes no concept of what the object ought to be; he cites flowers, decorative things and music without words as those objects that can be subject to a pure judgement of taste. But he now raises the idea of a 'dependent beauty', which allows for aesthetic objects that contain qualities excluded from pure aesthetic sensation,[124] of which, in Kant's terms, only an 'impure' aesthetic judgement is possible. Within dependent beauty can be included human beauty, and that of horses and buildings, all the things that engage ideas beyond reflective aesthetic judgement.

In section 17 of the third Moment, 'Of the Ideal of Beauty', Kant claims that it is impossible to establish 'a universal criterion of the beautiful' because 'this is itself a concept that is by definition impossible and self-contradictory'.[125] The reason for this is evidently that the ideal of beauty rests on presentation, not on a concept. But this ideal can be seen as a model or archetype of taste, which the person making a judgement must produce in himself in order to judge an object of taste and other people's taste. Kant then asks: is the ideal of beauty *a priori* or empirical? He answers that with ideal beauty the judgement of taste is partly an intellectual process, therefore concepts must lie behind it that can determine *a priori* the purpose on which it rests. In other words, a judgement of ideal beauty cannot be a purely aesthetic one, so the ideal cannot be attached to such natural objects as beautiful flowers or views, nor, on the other hand, to things with definite purposes, like houses or gardens. It can, however, be attached to man, though Kant's reasoning is hard to follow at this point. He argues that 'The only being which has the purpose of its existence in itself is man, who can determine his purposes by reason; or, where he must receive them from external perception, yet can compare them with essential and universal purposes and can judge their accordance aesthetically.'[126] Whatever that means, it is clear that Kant's concern is to avoid the absurdity of disallowing an aesthetic response to ideal representations of the human figure.

Kant then divides the ideal into two elements, the 'aesthetic normal idea' and the 'rational idea',[127] in which the purposes of humanity are revealed through judgement of the human figure. In the

discussion of the 'aesthetic normal idea', the idea of race enters in, for the only time in Kant's Critical writing on aesthetics. In arguing that the judgement of a figure of a man as belonging to a particular type must be taken from experience, he argues that an aesthetic judgement of the same man requires an awareness of the ideal form of his race.[128] This sense of an ideal racial form does not, however, depend on an ideal of racial beauty, but on a racial mean. The appearance of a race is not to be found in its ideal form, as the *Apollo Belvedere* might be perceived as the ideal form of the Greek people, but in the average form of all, or a sufficient number of, members of that race. This is explained in psychological terms: the human imagination has the ability to remember thousands of figures of the same type, and thus is able to create an idea of an average figure. We can achieve by normal observation as clear a sense of what constitutes the normal size of a member of a group or a race, as we would by carefully measuring thousands of people. Kant claims that this average, or 'normal', figure presents a different basis of perception for every country and for every race (he does not distinguish the two clearly here), but his examples are racial rather than national types: 'such a figure is at the basis of the normal idea in the country where the comparison is instituted. Thus a Negro must necessarily have a different normal idea of the beauty of the human figure from a white man, a Chinaman a different normal idea from a European, etc.'[129]

Each race's characteristic form 'is the image for the whole race, which floats among all the variously different intuitions of individuals, which nature takes as archetype in her productions of the same species, but which appears not to be fully reached in any individual case'. It does not follow, however, that this form of the race need be ideally beautiful, for 'it is only the form constituting the indispensable condition of all beauty, and thus merely correctness in the presentation of the race'.[130] No one person can ever embody that ideal, and it must avoid being so specific or individual as to violate the 'normal idea for the race'.

Kant then distinguishes the ideally beautiful from the 'normal idea' by arguing that it 'consists in the expression of the moral, without which the object would not please universally and thus positively,

rather than just being an accurate presentation'.[131] This seems to suggest that the visual expression of moral ideas requires the union of pure ideas of reason with imaginative power, not only in the artist but in the perceiving subject. But in any case this could not be a purely aesthetic judgement, for 'a judgement in accordance with an ideal of beauty is not a mere judgement of taste'.[132] Kant's two levels of the ideal bear a resemblance, perhaps not coincidentally, to academic aesthetic theories of his own time. The 'normal' ideal may be compared to Joshua Reynolds's 'Central Form', which is the ideal form of things reflected imperfectly in nature. Natural forms (the example he gives is of an oak tree) have their ideal correlative in the world of ideas,[133] but for Kant it appears that only the representation of man has that privilege. But the notion of averaging proposed by Kant here (and also by academic theorists), does not necessarily allow a transition to the ideal in the metaphysical or moral sense. To perceive such elevated qualities in a human figure or its representation requires from the observer a reflective engagement that goes beyond the immediate response prompted by 'free beauty'.

This brief passage in section 17 of the third Moment of the *Critique of Aesthetic Judgement* is a hint that he continued to believe in some essential idea of race, though tantalizingly he does not go further, and such matters were rigorously excluded from the rest of the Critical theory. The reason is surely that the questions he was addressing in the Critiques were of a different intellectual order from the broadly anthropological matter of race. In the writings of Kant from the 1760s to the 1780s in which he refers to race, there is a notion that anthropology and natural science can be considered within the same broad metaphysical framework as itself. The Critiques, on the other hand, deliberately distance themselves from questions of anthropology, history and mundane experience. They represent, in one sense, the fracturing of the universal culture of the *Gelehrten* into the disciplinary enclaves of modern academic life; they also take Kant out of the debate on human variety, and he is rarely mentioned subsequently as a contributor to it.

The Skull's Triumph

In this final section we return to the natural sciences to look at the work of Blumenbach and of Pieter Camper towards the end of the century, and their attempts to use the skull to provide firm data on the similarities and differences between peoples. The value for them of the skull, over and above any other aspect of the body, was its potential measurability, and that measurability, it is argued, is inextricably tied to aesthetics.

AESTHETIC SCIENCE: BLUMENBACH

The 1795 edition of Blumenbach's thesis, *Of the Varieties of the Human Species*, reflects his position by that date as a leading scientist with excellent international contacts. In the dedicatory letter to Sir Joseph Banks, Blumenbach notes that his work is no longer based on armchair study, but on the experience of skulls, many supplied by Banks himself. He remarks on the surprising neglect of the human aspect of natural history, praising 'the immortal Linnaeus', 'who [first] attempted to arrange mankind in certain varieties according to their external characters; and that with sufficient accuracy, considering that then only four parts of the terraqueous globe and its inhabitants were known'.[1] But he also observes that Cook's first expedition had been instrumental in destroying Linnaeus' classification of humanity. Blumenbach itemizes the anthropological materials he has used in his investigation, including 'skulls of different nations', giving each a provenance. He boasts that his collection of skulls is unique – better than Camper's or John Hunter's – and he also mentions a collection of foetuses, and of pictures and prints, singling out engravings after Hodges's views of the South

Seas as among the few of any value for scientific study.

The 1795 edition of Blumenbach's *Of the Varieties of the Human Species* was, then, unlike its first publication as a thesis, based on the work of an established university scientist, able to build up his research materials methodically by exchange. The edition also goes beyond the original thesis, in incorporating the important idea of epigenesis. Kant in *Different Races* had accepted the theory of preformation, that all living forms exist in embryo or germ from the moment of universal Creation.[2] The alternative theory of epigenesis, first published by Caspar Friedrich Wolff in *Theoria Generationis*, printed in Latin in 1759 and in German in 1764, was given wide currency by its adoption and publication by Blumenbach himself in his volume *Über den Bildungstrieb* of 1781. For the 1789 edition of this work, Blumenbach asked Chodowiecki to illustrate the universality of the process by showing a thick bush with a hen brooding over an egg (illus. 48).[3] Epigenesis was, in effect, a new theory of the creation of life, in which each living thing was now regarded not as having existed since the Creation, but as itself a new creation. This new creation derives from unorganized fluid material, from which organisms emerge and consolidate themselves. These organisms are regulated not by an embryonic form of themselves, but by the *vis essentialis*, or essential force, an idea not far removed from Herder's 'organic force', which drives it to achieve definite form. This formative drive, the *nisus formativus*, reveals itself in an organism's ability to repair itself after injury.[4]

Each organism begins to exist at the moment of conception, in the action of semen on the original nutrient that consolidates spontaneously. Though the denial of preformation implicitly challenged the biblical account of Creation, the theory reinforced a tendency among scientists to place first causes in the realms of the unknowable. In deriving the formative drive from nature, reproduction, growth and transformation could be seen as divine creation in action, rather than a re-enactment of a single originating act.[5] Creation could be observed in everything from the humble plant to the birth and growing-up of a child. We can trace, among many other works of art and literature, the origins of the nature mysticism of Philipp Otto Runge in epigenesis as

48 Daniel Chodowiecki, 'Veneri Caelesti Genetrici', etched title-page vignette for Johann Friedrich Blumenbach, *Über den Bildungstrieb* (Göttingen, 1789).

the daily renewal of Creation. His cycle of *The Times of Day* (*Die Tageszeiten*; illus. 49) pictures the processes of nature as a kind of divine analogy.[6]

Though Wolff defined, and Blumenbach elaborated, the concept of epigenesis, it had a precedent in Buffon's theory of *molecules organiques* and the *moule interieur*, and the interest in the 1740s in growth, nutrition and regeneration. Even those, like Albrecht von Haller, who resisted epigenesis, at least accepted some idea of vitalism. The English physiologist James Parsons had attacked mechanistic philosophy in 1752, and the separation of living from non-living matter

49 Philipp Otto Runge, 'Morning' (small version) from *The Times of Day* (*Die Tageszeiten*), *c*. 1805–10, oil on canvas. Kunsthalle, Hamburg.

had already been adumbrated by Stahl, with his concept of the *anima sensitiva*.[7] In a sense, epigenesis was a return to the Stoic belief in forces of nature, not structures, the *pneuma,* or the breath of the cosmos, as the activating principle.

It can also be argued that epigenesis represents a further turn towards the aesthetic. As Michael Hagner has noted, those studying nature in the late eighteenth century in effect redefined themselves as artists, their distinction as professionals resting on an ability to find beauty visible in every form and step of nature.[8] Epigenesis is arguably itself an aesthetic view of nature, requiring the scientist to go beyond observation, classification and measurement to achieve empathy with, and an inner feeling for, nature. The scientist has to be capable of finding the beauty and order in nature, on the understanding, encouraged by Kant, that the divine order in nature is in some sense available to aesthetic perceptions.

Blumenbach, on the basis of epigenesis, was thus able to claim that the beauty of humanity was internal in the physical sense as well as external, expressed in the constitution of the body and the way it works. The human is differentiated from the animal not only by the hidden workings of the mind or soul, but by its hidden physical workings. Man's outward appearance might suggest a natural grace or proportion that separates him from the animal, but so also does the inner structure of the body. Blumenbach notes from the broad and flat human pelvis that 'man is made wonderfully to differ', and such an aesthetic difference reinforces the difference between man and ape.[9] In an updated argument by design, God's goodness is expressed in the fitness and elegance of the human machine in the relation of its parts to each other. An erect human body thus achieves harmony naturally, but it is 'the result of art and discipline if any apes are ever seen to walk erect'.

Blumenbach's sense of the beauty of the human body is carried through even into the internal tissues, which he explores in appropriately heightened language. He writes of 'the peculiar tenderness and delicate softness of the human *tela mucosa*, or *cellulosa* [for] the softness of that envelope is to be counted amongst the chief prerogatives by which man excels the rest of the animals'. At every point, even to the

internal membranes, man exhibits a distinctive beauty that sets him apart from the animal:

> For as this membrane is on the one side diffused over all parts of the body from the corium to its inmost marrow, and is interwoven like a chain with all and every part of the whole machine . . . I am thoroughly persuaded that to the flexible softness of this mucous membrane in man is owing his power of accustoming himself more than every other mammal to every climate, and being able to live in every region under the sun . . . so in respect of habitation it has intended him to dwell in every country and climate: and so his body has been composed of a most delicate mucous composition, so that he may adapt and accommodate himself more easily to the multifarious effects of different climates.[10]

Implicit in such rapturous accounts of man's physical interior is the idea that the anatomist's 'artistry' enables him to observe the body's internal harmony and place it in a metaphysical and philosophical context. The anatomist's aesthetic competence gives him an ability to observe the body's organic formation as something that might grow, decay or alter in response to external stimuli. Neither the application of reason, nor the accumulation of data by experience and taxonomies could achieve true understanding of such processes.

How, then, can epigenesis be applied to human variety? In Section II of the 1795 edition *Of the Varieties of Human Species* Blumenbach looks at the natural diversity of what his mid-nineteenth-century translator calls 'races and nations'. In fact Blumenbach does not use the word 'race' at all here, but (translating literally from the German) 'peoples and various nations of humanity'.[11] He also explains the diversity of humanity not as the fulfilment of nature's purposes, as did Kant, but as a process of what the translator calls *degeneration*: the word Blumenbach uses is 'Abartung', which can simply mean 'variation' without pejorative implications. Blumenbach might have wished to imply that humanity after its dispersal fell away from its aboriginal

perfection, but he does not necessarily suggest that some peoples were more 'degenerate' than others. Blumenbach, like Herder, from whom he clearly learned much, tends to minimize rather than emphasize differences between the human varieties, on the grounds that distinguishing human variety is a subtle and complex process. He argues for the shape of skull as an indicator of difference, but for him the 'skull of the Ethiopian does not differ more from that of the European than that of the domestic sow from the osseous head of the boar'.[12] Furthermore, the *nisis formativus* requires stimulation, and different stimuli 'in time can impart to it a singular and anomalous direction', so that aberrations like monsters and hybrids can emerge. Over generations stimuli can divert the formative force from its path, 'which deflection is the most bountiful source of variation (*Abartung*), and the mother of varieties'. These stimuli can be climate, diet, mode of life, hybrid generation and hereditary disposition to disease. However, Blumenbach is not clear as to whether accidental deformities could be transmitted to subsequent generations.

In Section III 'On the causes and ways by which mankind has degenerated, as a species', Blumenbach does use the word 'degenerated' (*degenerirte*), though again probably not with pejorative intent. Beginning with skin colour, he notes its 'constancy', connecting it to other aspects of the human form, both external and internal, the colour of the hair and the iris, and even temperament. The cellular membrane 'affords as it were a foundation to the whole machine'. It surrounds and enfolds the body, collected into the corium, and is penetrated by nerves, veins and blood vessels. The corium is lined with mucus, the *reticulum Malpighii*, which sticks the epidermis to the corium.[13]

The colour of human skin can range from the snowy whiteness of the European girl to the deepest black of the Ethiopian woman of Senegambia. Blumenbach tentatively proposes five classes, but again he avoids the word race, using the heading 'The National Differences of Colour' (*Die Nationalverschiedenheiten der Farbe*). In practice they are not wholly different from Kant's categories, though a fifth is added in the light of the South Seas expeditions:

1 White, to include 'most European peoples'; redness of cheeks is peculiar to it.

2 Yellow, olive tinge, to include the Mongolian nations

3 Copper colour, 'peculiar almost to the Americans'.

4 Tawny Malay race (Blumenbach here uses the words 'malayis-chen Rasse').

5 Tawny-black to jet-black, characteristic of the 'Aethiopian peoples (*aethiopischen Völkerschaften*), but other peoples have tinges of black.[14]

The fifth 'race' had already appeared in a brief volume summarizing his biological theories, published in 1790, entitled *Beyträge zur Naturgeschichte* (Contributions to natural history), in which each of what he calls the 'five principal races' (*fünf Hauptrassen*) are illustrated by scenes of daily life by Chodowiecki (illus. 50). The tiny engraved plates are, however, captioned not as 'races' but as 'varieties of mankind' (*Menschen Varietaeten*). They are in a different order from the list above, with the Tahitians as the fifth, but they subtly indicate differ-ent stages of civilization. The Chinese are shown with highly decora-tive buildings, the Tahitians as agricultural, the Africans as fishermen, and the Americans as warriors, although domesticated. They are all depicted in a distinctively sentimental style, and though the images are more fantastic than documentary, they were certainly approved by Blumenbach.

Perhaps the most surprising is the first one, adorning the title-page, representing under the Caucasian race (*Die Caucasische Race*), those of 'a colour more or less white' (*farbe mehr oder weniger weiss*). This image, we are told, represents Europeans from the Lapps and Finns to Western Asia, to include those living by the Caspian Sea and the Ganges, and North Africans, 'the inhabitants of the world known to the old Greeks and Romans' (*die Bewohner der den alten Griechen und Römern bekannten Welt*). What Chodowiecki gives us is an amorous scene in a luxurious setting of a young 'Turkish' couple, he

198

50 Daniel Chodowiecki, *The Five Varieties of Humanity* ('*Menschen Varietæten*'), etchings from Johann Friedrich Blumenbach, *Beyträge zur Naturgeschichte* ([1790] 2nd edn, Göttingen, 1806–11).

turbaned and possibly a Sultan, she an adoring lover, stretched out on a couch, as a beautiful young servant girl brings in tea. The origin of the image is probably to be found in a reading of Lady Mary Wortley Montagu's letters, for which Chodowiecki had provided a title-page in 1781, but it is interesting that even in the last decades of the eighteenth century, such an exotic scene should be taken as representative of Europe, rather than a scene of Western European life or an evocation of the Greek ideal.

In Blumenbach's description of the second variety, 'the Mongolian', a Chinese gentleman is being served tea by a young Chinese girl,

like a scene from Chinoiserie porcelain. Though the description emphasizes the yellow colour, black hair, flat faces and slanting eyes, none of these are visible in the illustration. The third variety, 'the Aethiopian', is represented by a black family from The Gambia: a man stands holding a paddle with fishermen in the background, while a woman suckles a baby and a boy stirs a pot. This group wears the fewest clothes of the five, the man wearing nothing more than a penis pouch, suggesting an attempt to mirror the level of civilization by the amount of clothing worn at each stage. Blumenbach draws particular attention to the special form of the hut in the background by the water. It is certainly the most 'primitive' of the five dwellings represented, but it is not a hovel.

In the fourth variety, 'the Americans' are represented by a 'Brazilian Indian', whose broad, flat, yet strong, features as described in the text do not quite come through in the illustration. He is presented as an amiable and domesticated warrior, standing with bow and large arrow, with two small children near him. He is naked except for a large feathered loincloth, necklace and feather headdress. He has a large rectilinear hut behind him, which contrasts with that of the African. The fifth variety, 'the Malayan', is represented by inhabitants of the Friendly Islands in a graceful scene redolent of Bougainville's pastoralism. A beautiful young couple in loincloths look lovingly, if a little formally, at each other. A child is between them, chickens are at their feet, and a neat arbour suggests cultivation and husbandry.

All the human 'varieties' are differentiated according to colour in Blumenbach's text, but line engravings can do no more than suggest relative lightness or darkness. In general the designs, and this is true of Blumenbach's writings, emphasize not savagery but the possibilities of differentiated, but harmonious, ways of life among the world's peoples, and of improvement by the cultivation of nature. Perhaps the image of the Caucasians contains a suggestion of cultivated idleness and its dangers?

In considering human variety in the 1795 treatise, Blumenbach notes that 'Every different variety of mankind . . . has a national face,' and 'this difference of faces may be observed not only in Europeans but

also among barbarous nations.'[15] (Blumenbach uses the expression 'national face' *nationale Gesichtsbildung*; in the nineteenth-century English translation it becomes, inevitably, 'racial face'.) He also defines an ideal human visage, an aesthetic norm from which all others have 'degenerated', which is oval, straight, moderately marked, 'In general that kind of face, which, according to *our* [my italics] opinion of symmetry, we think becoming and beautiful.' Degeneration from this ideal can go towards the excessively wide and the narrow, distributed among the four other 'races': the Mongolian is wide and flat; the American wide but not flat; the African narrow but with prominent lips; the Malay and South Seas, less narrow, but somewhat prominent below. The omission of the white or European from the above four categories places it implicitly with the ideal type of oval face.[16] The aesthetic ideal is thus decided by Europeans, but also embodied in the European face.

Blumenbach represents, along with the Abbé Grégoire, the most 'liberal' position on non-Europeans in his own time. He resisted all attempts to place Africans on a lower scale of humanity, and he collected the works of black authors, vigorously defending their claims to literary merit.[17] Yet, in the end, Europeans and Caucasians are for Blumenbach simply the most *beautiful* peoples, and in their whiteness preserve a potential for moral purity and a memory of humanity before the Fall. By effectively removing the races of mankind from their association with different continents and reordering them into an aesthetic hierarchy, Blumenbach inadvertently provided a further argument for European superiority over the rest of mankind.

MEASURING THE SKULL: PIETER CAMPER

Pieter Camper was also fiercely opposed to claims of white supremacy based on skin colour or any other criteria, but he played an equally inadvertent, though even more decisive, part than Blumenbach in giving race the aura of an exact science. His most influential work was based on the understanding that the human skull was open to systems of measurement.[18] As a permanent feature of the body, the skull was only responsive to the slow evolution of the brain within; not to transi-

tory emotions or changes in climate, but to the broader movement of character. By contrast skin colour, though instantly recognizable, was harder to measure and classify.

The skull's primacy was, however, inhibited by religious and moral scruples, which meant that only towards the end of the century did non-European skulls become available from expeditions to the South Seas and elsewhere, in large enough numbers to allow for effective comparison. Even so, the only way a scientist could actually work from real skulls was to acquire them himself, with all the attendant problems of provenance, authenticity and size of sample.[19] Hence the force of Blumenbach's boast in the preface to the 1795 edition of his book on human variety, that he had a better collection of skulls than his rivals, even Camper himself.

The basis for Camper's work on skull types was in his training in comparative anatomy as a medical student at Leiden, under the famous practitioners Boerhaave and Albinus, the latter the author of *De Ossibus corporis humani* (1726), and also of a book on skin colour.[20] Camper's training was strongly empirical and observational, and he showed an unusual interest in art and the representation of the human body. He took painting lessons from Karel de Moor, and on his 1748 visit to London he met prominent doctors, including Richard Mead and Hans Sloane, but also attended drawing sessions with the model at the St Martin's Lane Academy.[21] He was made Fellow of the Royal Society in London in 1751, and stayed six months before going to Paris to meet Buffon. He held the chair of philosophy at Franecker University in 1749, in 1755 the chair of anatomy and surgery at Amsterdam, writing a noted book of descriptive anatomy, and becoming in 1763 professor at Groningen. He completed the first draft of his treatise on skulls in 1768, but it was not published in book form until 1786. In 1770 he delivered the text as lectures to the Amsterdam Academy of Art 'before a numerous and respectable audience'.[22] In 1779 he gave a talk on 'the facial line and analogy among men, quadrupeds, birds and fish' to a group at Göttingen University that included Blumenbach, Lichtenberg and Soemmerring, and Lavater and Herder showed an early interest in the theory.[23]

The diagrammatic charts of comparative skulls (illus. 50 and 52) published with the lectures created a compelling and endlessly copied image of a hierarchy of mankind from ape to Apollo, with the European placed next to the Greek god, and the African next to the ape. The chart seemed, even to those who opposed his conclusions, to be the first scientific attempt to associate the typology of an archetypal European skull with that of canonical antique sculptures. It places mankind on a scale ranging from animality to godliness, comparable to Herder's view of man's position between the animal and the angel.[24] The scientific basis for the scheme is the measurement of an angle derived from the profile line, in effect a line drawn from the forehead to the projection of the upper teeth. This is measured against a vertical line, the line of gravity, going through the aperture of the ear.[25] These lines were then projected on to a grid, with a small group of skulls representing 'two apes, a negro and a Calmuck', a European and the *Apollo Belvedere*. When lined up in a series they give persuasively differentiated figures on a scale. At the top end the ideal Greek head possesses a completely straight profile, the facial angle of which comes out, therefore, at 100 degrees. At the other end, the tailed ape has a facial angle of 42 degrees, the orang-utan 58 degrees, the 'negro' and Calmuck both 70 degrees, and the representative European 80 degrees. Any degree above 80 'is formed by the rules of art alone', while anything below 70 resembles 'some species of monkies'. However, Camper is at pains to point out that the 70 degrees angle of the Black and the Calmuck, and the 80 degrees of the European are minimum and maximum. The distinction between European and non-European would be, therefore, somewhere in a relatively narrow band, and could even be eliminated altogether in certain cases.[26]

In Camper's explanation, the physiognomy of Europeans and other humans is very close, and he does not suggest that Africans and Calmucks were simian, or significantly closer to the animal. In fact he had long been fervently opposed to categorical racial distinctions, and especially to the blurring of the distinction between man and animal. Despite an early espousal of Linnaeus, Camper turned against him in the 1760s, arguing that his taxonomies were nothing more than mental abstractions,[27] that nature was too various, and that Linnaean nomen-

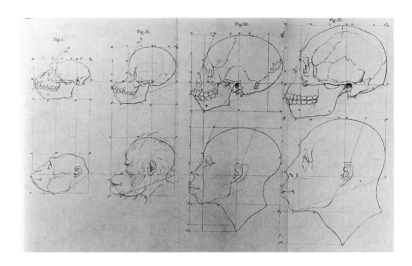

clature was only useful for memorizing. He also wrote one of the earliest and most uncompromising treatises against colour discrimination, probably influencing Herder and Blumenbach. In his *Redevoering over den oorsprung en de kleur der zwarten* (Oration on the origin and colour of the blacks) of 1764, he vigorously denied there was a difference between whites and blacks: 'In the beginning a single man had been created by God, to wit Adam, to whom all of us, whatever may be our figure or colour, owe our origin.'[28] He emphasized that blacks and whites had identical anatomy, rejecting the immutability of skin colour. 'The heat of the region we live in is the cause of the colour', but black colour is not immutable; blacks would become white if they lived long enough in the north, and whites would become black if they lived long enough in the south. Most unusually, he denied the normative whiteness of original man: 'Adam might have been white, brown or black.' Skin colour, in any case, was a matter of imperceptible gradation: 'we are white Moors'.[29] It hardly needs adding that Camper was fiercely opposed to slavery, ending the treatise with an exhortation that anticipates both Herder and Georg Forster: 'Unite yourself with the observations of the penetrating Le Cat [author of a treatise on skin colour], and you will no longer find it difficult to proffer with me a fraternal hand

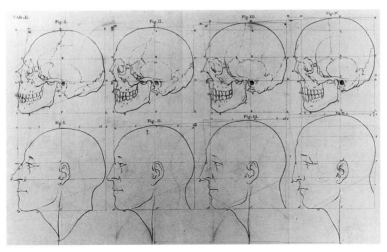

51 Thomas Kirk after Reiner Winkeles, 'Faces in profile from apes, ourangs, negroes, and other classes of people, up to the antique', from Pieter Camper, *The Works of the late Professor Camper, on The Connexion between the Science of Anatomy and The Arts of Drawing, Painting, Statuary . . .* (London, 1794).

to Negroes, and recognize them for veritable descendents of the first man, to whom we all look as our common father.'

In the text that accompanied the chart of comparative skulls, Camper warns off those who might draw incorrect conclusions from 'The striking resemblance between the race of Monkies and of Blacks, particularly upon a superficial view.' He claims, a little disingenuously, to have placed the African next to the ape precisely to highlight their difference,[30] and a consideration of the whole body will show 'the boundaries which the Creator has placed between the various classes of animals'. Camper, then, meant us in looking at his chart to draw a mental line between the profile of the 'Negro' and the ape, and, at the other end, between the ideal Grecian head and the European. There is, as he noted, a relatively small difference in degree between the African and European profile, but an absolute one between the African and ape at one end, and between the European and the Greek ideal at the other.[31] The problem is that the diagram conveys inescapably a hierar-

chy that appears to reinforce the Great Chain of Being; with hindsight misunderstanding seems inevitable.

The posthumously published volume in which the theory is presented in its final form, in Dutch (1791), French (1791), German (1792) and English (1794) editions, is presented as a work of instruction for artists, though it is also hoped that it would provide a useful method for anyone to make distinctions between different types of people. According to the full title of the French edition, it contained 'une nouvelle Méthode pour Dessiner toutes sortes de Têtes Humaines avec la plus Grande Sureté'. The English edition of 1794 was subtitled 'on The Connexion between the Science of Anatomy and the Arts of Drawing, Painting, Statuary, etc. etc.' (illus. 42.)[32] The translator of this edition claimed:

> The grand object [of the book] was to shew, that national differences may be reduced to rules; of which the different directions of the facial line form a fundamental norma or canon; – that these directions and inclinations are always accompanied by correspondent form, size and position of other parts of the cranium, the knowledge of which will prevent the Artist from blending the features of different nations in the same individual, and enable him to give that true character to national figures introduced into a composition.[33]

That Camper took the work seriously as an instruction book for artists is clear from his own introduction, where he claims an interest in differences between peoples going back to childhood. The seminal moment came when, at the age of eighteen, he was instructed by his painting teacher Karel de Moor to copy a 'Moor' in a painting: 'In his colour he was a Black; but his features were European. As I could neither please myself nor gain any proper directions, I desisted from the undertaking.'[34] He notes that other painters had failed to achieve the sense of difference necessary if a painter were to represent the actors accurately. Camper's interest in visual 'correctness' links the worlds of scientific observation and artistic practice. His introduction refers

THE

W O R K S

OF THE LATE

P R O F E S S O R C A M P E R,

ON

The Connexion between the Science of Anatomy

AND

The Arts of Drawing, Painting, Statuary,

&c. &c.

IN TWO BOOKS.

CONTAINING

A TREATISE ON THE NATURAL DIFFERENCE OF FEATURES IN PERSONS OF
DIFFERENT COUNTRIES AND PERIODS OF LIFE; AND ON BEAUTY,
AS EXHIBITED IN ANCIENT SCULPTURE;

*WITH A NEW METHOD OF SKETCHING HEADS, NATIONAL FEATURES,
AND PORTRAITS OF INDIVIDUALS, WITH ACCURACY, &c. &c.*

ILLUSTRATED WITH SEVENTEEN PLATES,
Explanatory of the Profeſſor's leading Principles.

———

TRANSLATED FROM THE DUTCH BY T. COGAN, M.D.

———

LONDON:
PRINTED FOR C. DILLY, IN THE POULTRY

———

1794.

52 Title-page of *The Works of the late Professor Camper, on The Connexion between the
Science of Anatomy and The Arts of Drawing, Painting, Statuary* ... (London, 1794).

frequently to Winckelmann, who plainly inspired the image and role of the head of the *Apollo Belvedere* in the series of comparative skulls. He reports in the introduction a conversation with Benjamin West, the President of the Royal Academy who succeeded Reynolds, with whom he discussed the correct way to represent Jews in biblical paintings.[35] He knew William Hunter, the Professor of Anatomy at the Royal Academy, and probably his brother John (see illus. 54), and he may have discussed comparative anatomy with George Stubbs, whom he undoubtedly influenced.[36] Camper's artistic intentions are, then, not only central to the formation of his system, but confirm the inseparability in the later eighteenth century of aesthetic discourses and ideas of human variety.

Camper's comparative method is based on real and identifiable skulls carefully positioned and represented in profile, a method he claimed to be derived from antiquity, from what Pliny called *imagines obliquas*,[37] but the most important archetype is surely ancient coins with the ruler represented in profile. Camper's use of the profile as evidence is almost certainly derived from Winckelmann's criteria for dating Greek statues, based on the assumption that coins would be datable to the reign of the ruler represented, and that the profiles would share a common style with statues of the same reign. Winckelmann, in making these comparisons, makes much of the relative curve of the eyebrow.[38] Camper clearly drank deep in Winckelmann's vision of the ideal, but he challenged its metaphysical premises: 'What this penetrating observer [i.e. Winckelmann] terms ideal, is in fact founded upon the rules of optics.'[39] The ideal for Camper is derived from a physiognomic formula, which happens to agree with Winckelmann's claim that in ideal Greek heads, forehead and nose form something close to a continuous line. Camper freely admitted that the ancient Greeks themselves, let alone the moderns, may well have fallen below this ideal: 'It is certain that such a form is never to be met with among moderns; and I doubt whether the ancient Greeks themselves had living models of the form.'[40]

It is tempting to conclude that the benign intention of Camper's scale was inadvertently travestied by its visual rhetoric, but in Foucault's terms Camper's scale is just as much a 'statement' as his

verbal denials, and is therefore as valid in terms of its discourse.[41] The scale 'states' that there is a hierarchy of humanity that privileges the European as the closest to the universal ideal, for Camper shared with Herder and Blumenbach the normal assumption of the period of European aesthetic superiority.

CROSSING THE LINE: RESPONSES TO THE SKULL

Camper's method rapidly became part of scientific orthodoxy, but it was not unchallenged in its own time. Blumenbach, writing in 1795, without questioning the importance of the skull made the following objections:

1 It only makes sense for nations whose jaws go in a different direction, but not for those with lateral differences.

2 The facial line may not be the most significant difference between skulls.

3 Skulls from same people may be generically similar, but have a markedly different facial line.

4 The profile in itself does not provide enough information.

Blumenbach thus questioned on empirical grounds the idea of a single comparative scale based on the profile, arguing for a consideration of the skull from above and behind, to take account of the shape of the face and its relative width and narrowness.[42] But behind Blumenbach's objections to Camper's scheme was the real worry that it denied the unity of the human species by suggesting a continuum between mankind and the whole animal kingdom, that it in effect brought back the Great Chain of Being by stealth. A similar worry seems to lie behind Lavater's response in the series of designs[43] entitled *Stufenfolge von dem Frosche bis zum Apollo-Profil* (Successive stages from the Frog to the Profile of Apollo),[44] known also as *Vom Frosch zum Dichter-Apoll* (From frog to poet Apollo). The series, in line engraving, appeared in

the fourth volume of the French edition of the *Physiognomische Fragmente*, only published in 1803,[45] well after the earlier volumes (illus. 53). It is in neither the first German edition, nor the English edition, which was translated from the earlier volumes of the French edition, but it exists also in at least two printed versions, and a superb series of unattributed watercolour drawings in Lavater's Kunstkabinett in the Österreichische Nationalbibliothek (illus. 41 and 53).[46] In the French edition of the *Physiognomische Fragmente*, Lavater singles out Camper for praise beyond his predecessors – Dürer, Winckelmann, Buffon, Soemmerring, Blumenbach, Gall: 'but nothing in this genre deserves to be read as much as a dissertation by Camper, full of depth and wisdom, on the natural difference of the lineaments of the face'.[47]

Lavater, by contrast with Camper, offers not a series of different species or races, but a frog that evolves by stages into an ideal human being, from 'not-man' to 'man'. In the published series of 24 line engravings, which correspond closely to the Vienna watercolour series, on which they must have been based, the frog's head gradually takes on human form, and around the mid-point (nos 12–13) metamorphoses into a recognizable human being. Lavater explains in the French edition of the *Physiognomische Fragmente* that the frog is the 'most ignoble and bestial' of creatures, and man, of course, is the highest. There is no clear line between the state of bestiality and humanity, but a transitional phase when the human features gradually prevail over the froglike. In no. 10 'begins the first degree of *non-brutality*'; with no. 12 we 'arrive on the first rung of a human nature', but with the facial angle not yet at 60 degrees 'it is nearer to the Ourang-outang than the negro'. Even at no. 14 we are still only at a mixture of imbecility and goodness, but in 15 we at last find all the attributes of a human figure, which corresponds to Camper's angle of 70 degrees, reaching a higher level of rationality in no. 21, which presumably corresponds to Camper's 80 degrees, or the highest level of humanity. This leaves the last three to aspire to the ideal, and they exhibit noble foreheads, and wear the laurel wreaths of the classical poet. However, even in the watercolour series there is no suggestion that no. 24 is a divinity separate from the others; indeed, he has conspicuously fleshy cheeks. Lavater, however, in his

commentary complains, as he often does about his artists, that the drawing is defective. He finds head no. 22 the most agreeable, but is reproachful that no. 24 is unsatisfactory because it 'does not accord with the character of the real Apollo'. This suggests that the final head was always meant to be Apollo, but that this was not understood by the anonymous artist.

The two-sheet engraved version commissioned by Lavater from the Basel engraver Christian von Mechel in 1795 and dated 1797 (illus. 53) might have been intended to replace the published engraving, though it was made before the published engraving actually appeared. A long delay in the publication of the French edition could well have been caused by Revolutionary turmoil in the last years of the century. There are, however, significant changes that seem to bring the series closer to Lavater's stated intentions. The first step on the ladder of humanity in no. 12 is indicated by the addition of shoulders covered by a drape, which remain attached to the human to the end of the series. Furthermore, no. 24, the apogee of humanity, is clearly differentiated from the others and is now unequivocally the *Apollo Belvedere*. Though the god is in profile like the lowlier stages of humanity, his shoulders are turned in a different direction, and he no longer has the earthly poet's wreath. Lavater's *Frog to Apollo* series is, then, a homage to Camper's scheme, but, unlike Camper's, it reaffirms visually the separation of man from the animal.

The danger that unsound conclusions might be drawn from the comparative analysis of skull types was evident not only to Blumenbach, but was publicly expressed in Britain even before Camper's book was published in English in 1794. Dr John Hunter (1728–93) lectured at the Royal Academy in the late 1780s on the gradation of skull types, almost certainly with knowledge of Camper's work, but, when quizzed on the matter by the English abolitionist James Ramsay,[48] he explicitly disclaimed any suggestion that they implied the existence of an 'inferior race'. We can get a hint of Hunter's lecture from his portrait by Joshua Reynolds (Royal College of Surgeons), which, because of its poor condition, can be better studied in the fine engraving by William Sharp of 1788 (illus. 54). In the detail (illus. 55) we can see an open volume in

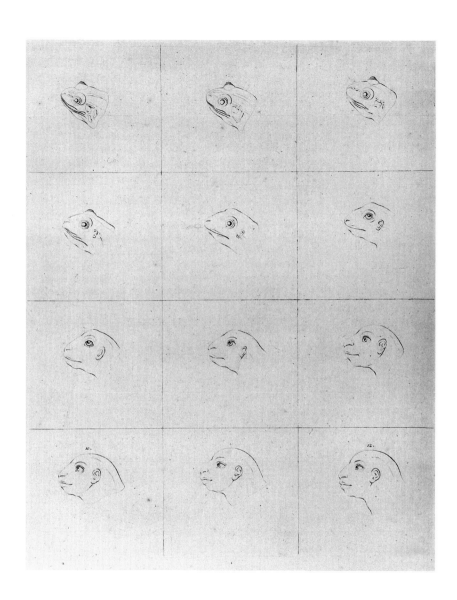

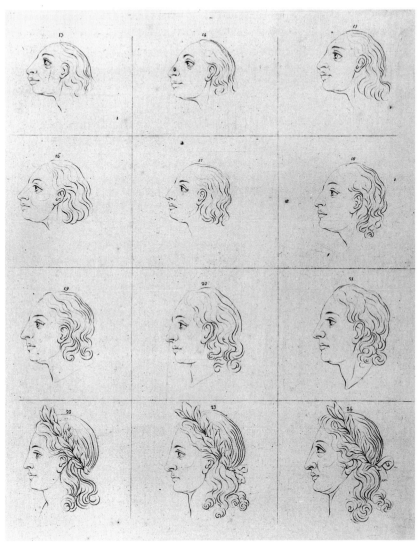

53 Anonymous engravings for Jean Caspar Lavater, *Essai sur la Physiognomonie* (The Hague, 1781–1803).

which a sequence of skulls is laid out in order. These skulls, ranging from one on the upper left with a strongly vertical profile, through two other human skulls to an ape, dog and alligator or crocodile, cross over the human–animal divide. This detail makes clear why an abolitionist like Ramsay might have needed some reassurance.

A version of the lecture was given by Hunter in Manchester, where it was attended by a local physician, Charles White. White noted that Hunter 'had a number of skulls, which he placed upon a table in a regular series, first shewing the human skull, with its varieties, in the European, the Asiatic, the American, the African; then proceeding to the skull of a monkey, and so on to that of a dog; in order to demonstrate the gradation both in the skulls, and in the upper and lower jaws'.[49] White's response was *An Account of the Regular Gradation in Man, and in Different Animals and Vegetables; and from the Former to the Latter*, read to the Literary and Philosophical Society of Manchester in 1795 and published in 1799. This book momentously shifted the notional barrier between human and ape in Camper's scheme, to place it between the 'African' and the 'European'. They now become the 'extremes of the human race', with the African approaching 'nearer to the brute creation than any other of the human species'.[50] White's theory was based on the idea of Gradation, in effect a rigorous application of the Great Chain of Being: 'Nature exhibits to our view an immense chain of beings, endued with various degrees of intelligence and active powers, suited to their stations in the general system.' In his visual scheme, which bears an obvious resemblance to Camper's, at the top end of the chain, White tells us, we have 'the perpendicular face of the human European' and at the bottom end 'the horizontal one of the woodcock' (illus. 56).[51] White shows how Gradation works throughout the human body, and the emphasis is firmly on the differences between 'white European' and 'Negro', though he follows Camper in leaving the 'Grecian Antique' in the pole position on his chart. In pursuit of these differences he carried out measurements to show that the arms of Africans are longer than Europeans', emphasizing their supposedly simian characteristics. He also claimed that there is 'a gradation from the European man to the brute, in respect to the bones', and he found

gradation in 'cartilege, muscles tendons, skin, hair, sweat, catamenia [menstruation], rank smell and heat of the body, duration of life, testes, scrotum, and fraenum praeputii, clitoris, nymphae and mammae, size of the brain, reason, speech and language, sense of feeling, parturition, diseases, and manner of walking'.[52] He notes also 'like wise that a gradation takes place in the senses of hearing, seeing, and smelling; in memory, and the powers of mastication', but that blacks have a larger penis than whites, as do apes, though, also like apes, their scrotum and testicles are smaller.

White, conscious of his 'philosophical' position in relation to his predecessors, even Camper, differentiates himself from the monogenetic belief that 'the whole human race [is] descended from a single pair, and that all the varieties were occasioned by climate, nutrition, air, &c'.[53] He claims that differences between black and white are as evident in the parts of the body hidden from the sun, noting that the African's scrotum is blacker than his face. He tentatively puts forward a polygenetic position, on the grounds that 'another race of mankind besides that descended from Adam, seems implied in the text [of the Bible]'. Even so, he uses the word 'species' more often than 'race', claiming that there could be four separate 'species' based on each of the four continents, with the possibility of there being more than one in Africa.

White, then, was in intellectual dialogue with Camper and probably Blumenbach, but intriguingly he discussed in person the difference between the African and European with G. C. Lichtenberg, presumably on one of the latter's visits to Britain. Lichtenberg recommended that he read Soemmerring's book on the anatomy of the African, published in 1785, and White duly printed in an appendix to his book extracts that supported his thesis of Gradation and difference.[54] White made a strong anti-slavery disclaimer in the advertisement to his volume, but the polarity he establishes between European and African is now presented as absolute as that between man and beast, and is made visible in aesthetic terms. If 'the African . . . seems to approach nearer to the brute creation than any other of the human species', then the white European is the 'most removed from the brute creation . . . the most beautiful of the human race'.

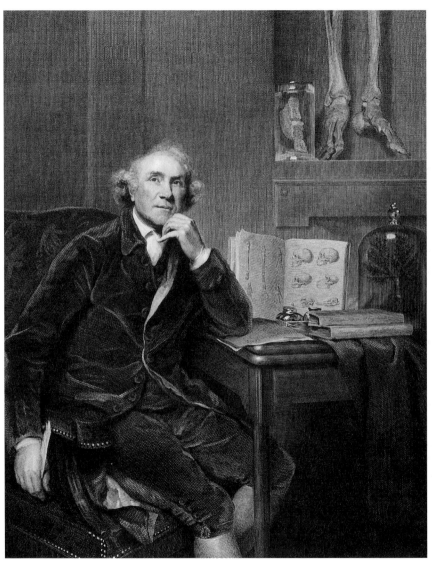

54 William Sharp, *John Hunter, FRS*, 1788, engraving (proof impression) after
Joshua Reynolds. Yale Center for British Art, New Haven, Connecticut.

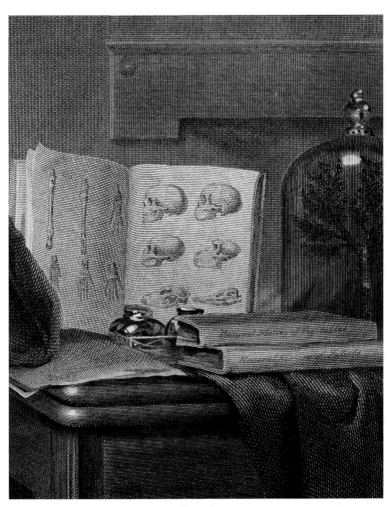

55 Detail from Sharp's *John Hunter* (illus. 54).

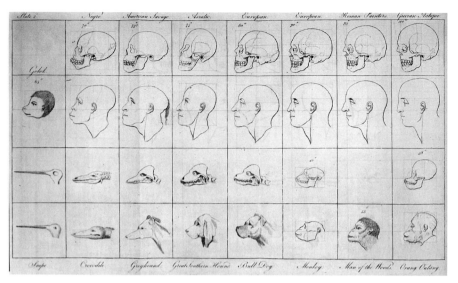

56 Anonymous engraving, from Charles White, *An Account of the Regular Gradation in Man, and in Different Animals and Vegetables; and from the Former to the Latter* (London, 1799).

White does not, like Edward Long, deny Africans souls, or suggest that they might even be animals, but he does end his book with an extraordinary invocation to the beauty of the European 'species': 'Where shall we find, unless in the European, that nobly arched head, containing such a quantity of brain . . . ? Where the perpendicular face, the prominent nose, and round projecting chin?'[55] The European male is, however, transcended in beauty not by the Greek gods but by the European female:

> In what other quarter of the globe shall we find the blush that overspreads the soft features of the beautiful women of Europe, that emblem of modesty, of delicate feelings, and of sense? Where that nice expression of the amiable and softer passions in the countenance; and that general elegance of features and complexion? Where, except on the bosom of

218

the European woman, two such plump and snowy white hemispheres, tipt with vermillion?

As Winthrop Jordan comments: 'Where indeed?'[56]

White extended the implications of Camper's scheme into a fervent Eurocentrism, but their, and Blumenbach's, dependence on the skull was challenged by the latter's colleague at the University of Göttingen, Christoph Meiners.[57] Meiners, who taught philosophy at Göttingen from 1772 until his death in 1810, in his 1785 volume *Grundriss der Geschichte der Menschheit* (Outline of the history of mankind) rejected a four- or fivefold division of humanity, arguing instead for a division into two completely different stems (*Stamme*) from the original tribe. Each of the two stems could, however, include several varieties and sub-divisions of peoples, though ironically for one who was regarded by Nazi racial theorists as a precursor, he did not always adhere to a strict division between races, at least as they were commonly understood at the time.[58] The two principal stems were the Caucasian and Mongolian, but 'the latter [were] not only much weaker in body and spirit, but also much more usually disposed to lack morals than the Caucasian'. The Caucasian stem was itself divided into two, the Celt and the Slav races, the first being on a higher level, richer in spirit and virtue. Within the Celts the Germans were the superior people and, in an article dated 1790,[59] he describes them in the Barbarian stage (the second of his four stages after the state of savagery) as 'taller, slimmer, stronger, and with more beautiful bodies than all the remaining peoples of the earth'. These early Germans possessed 'a dazzling white skin, blond curly hair, and blue eyes; courage and love of freedom, that never finds itself submissive to other nations, inexhaustible invention, and an unbounded talent for all arts and sciences, tender fellow feeling with the joys and sorrows of other men, and all the sentiments and instincts that spring from it, admiration for great and noble men, deeds and virtues, and rejection of all vices, especially bad habits, cowardice, falsity, harshness, grateful to benevolent, generous and merciful to enemies, striving for improvement'. On another occasion he argued that only northern Germans had such qualities, on the grounds that

only the northern races were truly creative.[60]

This Montesquieu-like elevation of the German barbarians, and the insistent binary categories, were once again dependent on aesthetic criteria. Meiners wrote in the 1785 *Outline of the History of Mankind*, that 'One of the most important signs of the stem from which peoples sprang is beauty or ugliness, either of the whole body or of the face',[61] but he argued against the privileging of the skull on the grounds that racial differences can be discerned in almost every feature of human existence. 'The differences in the formation of the body, and the dispositions of spirit and heart are a richer and better source for the study of man than a single or a small number of skulls of unknown origin.' Blumenbach, in the *Contributions to Natural History* of 1790, agrees that his method would be flawed if his skulls were of unknown origin, but he insists that they are not; in any case they provide a much less clear picture of human variety than Meiners would claim. In particular he disputes Meiners's contention that the body, and indeed every part of body, can be judged against a 'national body'.[62] For Meiners this is preferable to deductions based on the geographical distribution of skulls, for migrations can mean that a skull found in Turkey might not belong to an inhabitant of that region. Blumenbach argues, however, that there may be many different types of Turkish skull based on geography and social factors, and these may not be completely distinguishable from the skulls of other peoples. In other words, one should accept the imperceptible gradations between peoples and not seek to put up 'firm boundaries between these nuances'.[63]

Meiners's two-stem theory adopts a kind of Kantian essentialism towards race, but adapts it ingeniously to the service of a virulent German nationalism. The differentiation into beautiful and ugly races is fluid enough to allow for virtually any people to find a place in either. In Meiners's scheme, Jews, for instance, could become 'Asian' under the category of Mongolian peoples. They thus belong with Armenians, Arabs and Persians, and not with Europeans, or 'Caucasians', and so as a transplanted people they are detached from association with their own land. Meiners's characterization of the Jews may have been

directed against proposals for their emancipation and Joseph II's reforms, and the 'levelling' tendencies of his academic colleagues.

The concern of writers like White and Meiners to emphasize racial difference can be seen as part of the *rappel a l'ordre* that followed the French Revolution, when the ideals of human improvement and the Enlightenment itself were perceived by those in established positions to have destroyed the social order in France and endangered it in the rest of Europe. Even those who opposed slavery could come under suspicion, and it is significant that Meiners wrote a defence of it, *Über die Natur der afrikanischen Neger* (On the nature of the African negro) in 1790, the second year of the French Revolution.[64] Those who sought to shore up social hierarchies in the face of the revolutionary call for equality and brotherhood would have had an interest in reinforcing scientifically the difference between peoples as a specific challenge to 'democrats' and 'levellers'.

Ideal physiognomy, which had been unattainable on earth for those who believed in the brotherhood of man, became increasingly as the nineteenth century progressed a European or 'Caucasian' norm, to be contrasted with the inferior physiognomy, morality and 'intelligence' of other races. As Georges Cuvier put it in the *Règne Animal* of 1812, 'The Caucasian, to which we ourselves belong, is chiefly distinguished by the beautiful form of the head, which approximates to a perfect oval . . . From this variety have sprung the most civilized nations, and such as have most generally exercised dominion over the rest of mankind.'[65] The distinction made by Winckelmann and Camper between the ideal beauty of the ancient Greeks and the imperfect forms of modern Europeans has been lost in the post-Revolutionary theories of White and Cuvier, to be replaced by an assumption that the Greek ideal represented the generic typology of 'civilized' Europeans, and one that was susceptible to measurement. Camper had been careful not to take the step of relating the profile line to the size of the skull cavity, the skull cavity to the size of the brain, and the size of the brain to intellect and moral judgement, but his nineteenth-century followers had no such inhibitions.

Epilogue

I have taken some pains in this book to avoid imposing a modern teleology on eighteenth-century attitudes towards human variety, but I want to end by sketching out their legacy, albeit overlaid by new scientific theories and technologies. Race, for all its problems of definition and scope, established itself at the heart of anthropological and physiological studies in the nineteenth century, but, as Nancy Stepan has noted, as it became more 'scientific', it became more 'racist'.[1] Ideas of race were increasingly attached to nations as well as to continents, making the scope of the word looser than ever. Francis Galton, the founder of eugenics, for instance, writing in the 1860s, included in his idea of race, among others, 'the Negro', 'the European', the 'lowland Scot' and the 'North-country Englishman'.[2] Max Müller sought racial definition in language precisely because of the failure of anthropologists to reach a consensus on the number of races.[3]

Even so, by about 1850 a racial science based on a scale of relative intelligence and measurable skull type, with the European at the upper end and the African at the lower, had become well established in a number of European universities. In Britain it was argued by many scientists, including Robert Knox, author of *The Races of Man*, and Galton, that 'the Saxon race' was, or was about to be, the dominant race of mankind, and the latter was able to bring in the Darwinian principle of the survival of the fittest.[4] For Galton it was mental ability, or inherited 'intelligence' that distinguished one race from another, and enabled it to produce 'genius', which could be measured by the number of 'great men' each race could produce. On this evidence Galton perceived the ancient Greeks to be two stages higher in accomplishment than modern Englishmen, who were in turn two stages higher than 'Negroes'.[5]

If for the nineteenth century, as Knox put it 'race is everything, [and] civilization depends on it',[6] then the skull remained the key to its identification and characterization, but as much the seat of the intellect as of divine beauty. Of course, how the skull expressed intellectual attributes was not obvious, and there were many attempts in the nineteenth century by 'craniologists' to correlate the relationship of the skull to the size and weight of the brain, and those in turn with intelligence and moral proclivities, in the hope that criminal and other tendencies might be read from physiognomy.[7] The effect of the scientific concentration on the skull was to reinforce the definition of race in terms of representative or ideal typology, rather than in terms of the aggregation of people or peoples. Textbooks on human variety in the nineteenth century very often offer pictures of single individuals who stand for the essential physiognomies of their race or nation. Galton developed an ingenious technique to capture the common characteristics of families and groups of people, by photographing the series of subjects in precisely the same position, but underexposing the film so that common features would register more strongly than individual variants.[8] In addition to family groups, series of criminals, coins of Alexander and medals of Napoleon, Galton made a composite photograph of a series of 'young Jewish boys', and his pupil at University College London, Karl Pearson, believed that the method was particularly appropriate for highlighting racial physiognomies.[9] Galton was fully aware of the artistic implications of his new process and saw it as analogous to ideal art: 'A composite portrait represents the picture that would rise before the mind's eye of a man who had the gift of pictorial imagination in an exalted degree', yet it had the additional merit of scientific precision.[10]

If new technology could give a specious precision to ideas of race in the nineteenth century, then a vision of the past could act as a bridge between race and ideas of human beauty. The idea of 'racial health', as has often been noted, was almost always based on an ideal image of Greek life that can be traced back directly to Winckelmann.[11] But this image could be adapted to a racist teleology only by making the kind of connections between the ancient world and modern Europe that he

himself had been reluctant to make. Eighteenth-century climatic theory, by polarizing the warm south and the cold north, acted as an obstacle to the desire of those in northern countries to see themselves as the legitimate heirs to the intellectual, physical and moral strength, and even appearance, of the ancient Greeks. The absolute status given to the Greek sculptural canon and by extension to the gods represented by them, dominated questions of human aesthetics to the extent that real bodies were, as Sander Gilman has shown, surgically adapted to conform to Greek archetypes.[12]

Winckelmann's assumption that the Greek sculptors replicated the bodies of the people they saw around them, rather than idealized them, was popularized by Ernst Curtius, who wrote in the 1850s that 'Apollo and Hermes, Achilles and Theseus, whether they stand before our eyes in stone or in paint, are simply transfigured Greeks, and the noble harmonies of their limbs, the simple gentle lines of their faces, their large eyes, their short chins, their straight noses, their fine mouths, belong to, and were the marks of, the people themselves.'[13] That the 'Saxon race' might also partake of this ideal physiognomy emerged also in mid-century in Robert Knox's application to it of Camper's facial angle and the ideal embodied in the *Apollo Belvedere*. The physiognomic antitype to the Saxon race, however, was increasingly not the 'Negro' but the Jew.[14]

It is clear, then, that essential elements of nineteenth- and twentieth-century racial aesthetics were present in the eighteenth century, but these elements were usually separated from each other by a number of antitheses that were somehow resolved in the nineteenth century: race as opposed to nation; ideal as opposed to physical beauty; individual as opposed to collective beauty; and physical beauty as opposed to moral and intellectual prowess. Such antinomies find a kind of spurious resolution in the vulgar Neoclassicism of Nazi sculptural figures, but perhaps their fullest expression is to be found in the opening sequence of Leni Riefenstahl's film *Olympiad*, commemorating the 1936 Berlin Olympic Games. It shows the bringing of the Olympic torch, the 'sacred flame', from Mount Olympus to Berlin, a ritual invented for the 1936 Games and used ever since.[15]

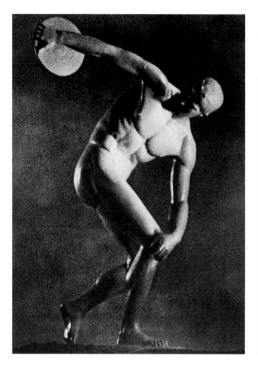 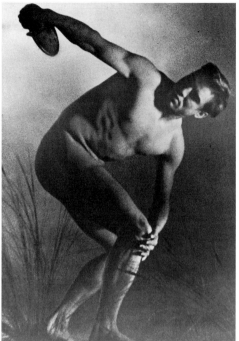

The sequence opens with dream-like shots of classical ruins, from which emerges an image of a Greek temple and the Parthenon. The camera then cuts to a series of close-ups of canonical Greek statues, reaching eventually a version of Myron's *Diskobolos*, which metamorphoses into a living discus-thrower in the form of the German athlete Erwin Huber (illus. 57). Winckelmann's vision of ancient Athens is given a living and present form, implying the resurrection of the spirit of ancient Greece in the modern German body, an idea reinforced by other athletes in sequence, who carry the sacred flame into the presence of the Führer in a swastika-dominated Germany. The idea that ancient Greece has found its present home in the north can be traced back to origins in the eighteenth and early nineteenth centuries, but in the opening sequence to *Olympiad* it is overlaid with a kind of pagan mysticism, a desire for total immersion in emotional

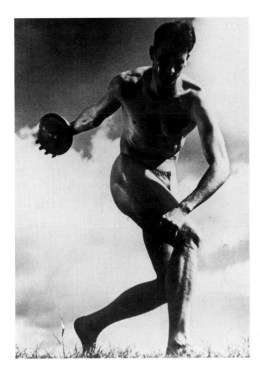

57 *Myron's Diskobolos fades into German discus thrower*, three stills from Leni Riefenstahl's film *Olympiad* (1936–8).

subjectivism that represented a fundamental rejection of the Enlightenment's hopes for the improvement of humanity through reason and sentiment.

References

INTRODUCTION

1 Michel Foucault, *The Archaeology of Knowledge*, trans. A. M. Sheridan Smith (London, 1972), p. 22. This concern to differentiate the eighteenth century from the nineteenth is also strongly expressed by Roxann Wheeler (see Reference 18 below).

2 Quoted by Henry Louis Gates in 'Writing "Race" and the Difference it Makes', in *Critical Inquiry*, xii/1 (Autumn 1985), p. 3.

3 Peter Hulme, *Colonial Encounters* (London, 1986), p. 50.

4 Ibid., p. 8.

5 Norman Hampson, *The Enlightenment* (London, 1990), p. 107; L. Poliakov, *The Aryan Myth* (New York, 1996), pp. 185–86

6 Nancy Stepan, *The Idea of Race in Science, 1800–1960* (London, 1982), p. xix.

7 Peter Fryer, *Staying Power: The History of Black People in Britain* (London and Sydney, 1984), p. 134.

8 In a lecture to the Anglo-American Conference of Historians, held in London 30 June – 2 July 1999.

9 John Hare, *St Edward's Ghost: or, Anti-Normanisme. Being a Patheticall Complaint and Motion in the behalfe of our English Nation against her grand (yet neglected) grievance, Normanisme*, 1647 (quoted in H. A. MacDougall, *Racial Myth in English History: Trojans, Teutons, and Anglo-Saxons*, Hanover, NH, 1982, p. 60).

10 Christopher L. Miller, *Blank Darkness: Africanist Discourse in French* (Chicago, 1985), p. 6.

11 Translated from *Dialektik der Aufklärung*, first published in 1947 in German, and in English in 1972.

12 Ibid., p. 6.

13 George L. Mosse, *Toward the Final Solution: A History of European Racism* (London, 1978).

14 Ibid., pp. 2–3.

15 Ibid., pp. 21–4.

16 See pp. 225–7.

17 Lorna Schiebinger, *Nature's Body: Gender in the Making of Modern Science* (Boston, 1993), p. 133.

18 Roxann Wheeler, *The Complexion of Race* (Philadelphia, 2000), p. 2f.

19 Sander L. Gilman, 'The Figure of the Black in the Aesthetic Theories of Eighteenth-century Germany', *Eighteenth-century Studies*, VIII (1975), pp. 373–91.

20 Sander L. Gilman, *On Blackness without Blacks: Essays on the Image of the Black in Germany* (Boston, 1982).

21 Ibid., pp. 25–9.

22 A. Potts, *Flesh and the Ideal: Winkelmann and the Origins of Art History* (New Haven and London, 1994), pp. 159–63

23 See p. 155.

24 See p. 158.

25 A seemingly modern use of the word that suggested that native Americans were of Jewish origin is found in the title of a seventeenth-century book: Thomas Thorowgood, *Jewes in America, or, probabilities that the Americans are of that race* (London, 1650).

26 I. Hannaford, *Race: The History of an Idea in the West* (Washington, DC, 1996), p. 191.

27 Philip Sloan in C. Fox, R. Porter and R. Wokler, eds, *Inventing Human Science: Eighteenth-century Domains* (Berkeley, CA, 1995), pp. 121–2.

28 Ibid., p. 123.

29 Ibid., pp. 124–6.

30 H. R. Schweizer, ed., *Alexander Gottlieb Baumgarten: Theoretische Ästhetik* (Hamburg, 1980), Prolegomena, §1, 3.

31 Terry Eagleton, *The Ideology of the Aesthetic* (Oxford, 1990), p. 13.

32 Susan L. Feagin and Patrick Maynard, ed., *Aesthetics* (Oxford, 1997), pp. 3–4.

33 I greatly regret that John H. Zammito's excellent book *Kant, Herder, and the Birth of Anthropology* (Chicago and London, 2002) only reached me when my book was already in proof. It deals in depth with some of the same texts by Kant and Herder that I discuss, and it is exactly the kind of historical study I hoped to find when I began this book, though, of course, its focus and method are very different.

ONE HUMAN VARIETY BEFORE RACE

1 Roger Smith, *The Fontana History of the Human Sciences* (London, 1997), p. 161.

2 Pim den Boer, 'Europe to 1914: The Making of an Idea', in K. Wilson and J. van der Dussen, eds., *The History of the Idea of Europe* (London, 1995), p. 45.

3 Ibid., pp. 34–6.

4 Ibid., p. 59.

5 Ibid., pp. 60–61.

6 Ibid., p. 60.

7 Ibid., pp. 16–17.

8 David Hume, *Essays and Treatises of Several Subjects* (new edn, 1822), vol. 1, Essay XXI 'Of National Characters', p. 184.

9 S. Alpers and M. Baxandall, *Tiepolo and the Pictorial Intelligence* (New Haven and London, 1994), p. 110.

10 Cesare Ripa, *Iconologia* (1604), and subsequent editions.

11 See Hugh Honour, *The New Golden Land* (New York, 1975), pp. 84–117.

12 John Locke, *Some Thoughts Concerning Education*, 1695 (quoted in Smith, *Human Sciences,* 1997, p. 169).

13 John Locke, *Two Treatises of Government* [1690], ed. P. Laslett (New York, 1965), p. 343; Ronald Meek, *Social Science and the Ignoble Savage* (Cambridge, 1976), pp. 37–67.

14 David Brion Davis, *The Problem of Slavery in Western Culture* (London, 1970), p. 139.

15 Ibid., pp. 137–8.

16 D. B. Kramer, *The Imperial Dryden* (Athens, GA, and London, 1994), p. 128.

17 Southerne's version was first performed in 1695.

18 Behn, *Oroonoko* [1688], in the 1886 reprint, p. 12.

19 Ibid., p. 9.

20 Ibid., pp. 14–15.

21 Ibid., pp. 16–17.

22 For Williams, see Peter Fryer, *Staying Power: The History of Black People in Britain* (London and Sydney, 1984), p. 421.

23 John Locke, *Essay on Human Understanding*, II, IX, 8. See also Hans Aarsleff in Vere Chappell, ed., *The Cambridge Companion to Locke* (Cambridge, 1994), pp. 266f.

24 E. Long, *The History of Jamaica* (1774), II, p. 476 (cited in Fryer, *Black People,* 1984, p. 421).

25 Ibid., II, p. 478.

26 Davies, *Problem of Slavery*, pp. 495–8.

27 Cited in Fryer, *Black People*, p. 421.

28 The discussion of *Robinson Crusoe* here is partly based on my article '"A Voluptuous Alliance between Africa and Europe": Hogarth's Africans', in Bernadette Fort and Angela Rosenthal, eds., *The Other Hogarth: Aesthetics of Difference* (Princeton, NJ, 2001), pp. 260–69. References to *Robinson Crusoe* below are to John Mullan's edition for Everyman's Library, London, 1992. For an extended account of the racial implications of *Robinson Crusoe*, see Peter Hulme, *Colonial Encounters* (London, 1986), pp. 175–224, and Wheeler,

Complexion of Race, pp. 50f.

29 Defoe, *Robinson Crusoe*, p. 30.

30 See Pat Rogers, *Robinson Crusoe* (London and Boston, 1979), p. 42.

31 Defoe, *Robinson Crusoe*, p. 112.

32 For Defoe's involvement with the Royal African Company, see T. Kiern, 'Daniel Defoe and the Royal African Company', *Historical Research*, 61 (1988), pp. 242–7.

33 Defoe, *Robinson Crusoe*, p. 18.

34 Hulme, *Colonial Encounters*, pp. 14–43.

35 Defoe, *Robinson Crusoe*, p. 171.

36 Ibid., p. 173.

37 The portrait was commissioned by the Corporation of Plympton, a port on the Devon coast, alongside a matching portrait of Captain (later Lord) Edgcumbe (National Maritime Museum), in which a ship in the background acts as a kind of visual counterpart to the figure of Jersey in the Ourry portrait (Nicholas Penny, *Reynolds,* exh. cat., Royal Academy of Arts, London, 1986, pp. 172–3).

38 D. Bindman, '"Am I not a man and a brother?": British Art and Slavery in the Eighteenth Century', *RES*, 26 (Autumn 1994), pp. 74–5.

39 For a full account of the paintings and the many prints derived from them see John G. Garratt, with Bruce Robertson, *The Four Indian Kings* (Ottawa, 1985).

40 *The Gentleman's Magazine* (19 February 1749), pp. 89–90.

41 Wylie Sypher, *Guinea's Captive Kings* (New York, 1969), p. 167.

42 There is an impression in the Dept of Prints and Drawings, British Museum, London.

43 Gretchen Gerzina, *Black London: Life before Emancipation* (New Brunswick, 1995), pp 10–11.

44 See Robert E. Norton, *The Beautiful Soul: Aesthetic Morality in the Eighteenth Century* (Ithaca, NY, and London, 1995).

45 L. E. Klein, *Shaftesbury and the Culture of Politeness* (Cambridge, 1994), p. 2.

46 *The Spectator*, no. 10 (12 March 1711).

47 Klein, *Shaftesbury*, pp. 7–8.

48 Dabney Townsend, *Hume's Aesthetic Theory* (London and New York, 2001), p. 30.

49 Anthony Ashley Cooper, 3rd Earl of Shaftesbury, *Characteristics of Men, Manners, Opinions, Times, etc,* ed. Tolus M. Robertson (London, 1900), II, p. 255.

50 Anthony Ashley Cooper, 3rd Earl of Shaftesbury, *Characteristics of Men, Manners, Opinions, Times*, ed. L. E. Klein (Cambridge, 1999), p. 63.

51 Ibid, II, p. 126.

52 Ibid., II, p. 132.

53 See Norton, *Beautiful Soul*, p. 49.

54 Townshend, *Hume*, p. 66.

55 Francis Hutcheson, *An Inquiry into the Original of our Ideas of Beauty and Virtue*, 2nd edn (London, 1726), p. xv; Norton, *Beautiful Soul*, p. 41.

56 Townshend, *Hume*, p. 71.

57 Hutcheson, *Beauty and Virtue* (1726), pp. 17, 38.

58 Gathered in D. F. Bond, ed., *Critical Essays from The Spectator* (Oxford, 1970).

59 Ibid., pp. 179–80.

60 Ibid., p. 182.

61 *Paradise Lost,* Book iv, l. 539.

62 Wilhelm Engelmann, *Daniel Chodowieckis sämmtliche Kupferstiche* (Leipzig, 1857), no. 319.

63 Norton, *Beautiful Soul*, p. 40f.

64 *Pompeo Batoni and his British Patrons*, exh. cat., Kenwood House (London, 1982).

65 See p. 47f.

66 Norton, *Beautiful Soul*, p. 31.

67 Shaftesbury, *Characteristics,* ii, p. 136.

68 For the problem of Socrates' 'ugliness', see pp. 114–16.

69 Shaftesbury, *Characteristics,* ii, p. 138.

70 Ibid., ii, p. 142.

71 *Kritischen Wälder*, in *Herders Sämmtliche Werke* (Berlin, 1878), iv, p. 175.

72 J. B. Du Bos, *Reflexions critiques sur la poesie et sur la peinture* [1719] (new edn, Utrecht, 1732), ii, p. 132.

73 Montesquieu, *De l'esprit des lois*, Book xvii, chap. iii (Montesquieu, *Oeuvres complètes*, Gallimard, Paris, 1951, ii, p. 524f.).

74 Ibid., p. 526.

75 See Meek, *Ignoble Savage*.

76 J. C. Lavater, *Physiognomische Fragmente, zur Beförderung der Menschenkenntnis und Menschenliebe* (Leipzig and Winterthur, 1775–8), iv, title-page engraving by J. H. Lips; copied by C. Grignion for the English edition.

77 Dedication 'to the King'.

78 Winthrop D. Jordan, *White over Black: American Attitudes toward the Negro, 1550–1812* (New York, 1977), p. 220.

79 Schiebinger, *Nature's Body*, p. 119.

80 Hannaford, *Race*, p. 204.

81 For Buffon's reputation see Wolf Lepenies, *Autoren und Wissenschaftler im 18. Jahrhundert* (Munich and Vienna, 1988), p. 63.

82 H. Le Guyader, 'Linné contre Buffon: une reformulation du débat structure-fonction', *Actes du Colloque international pour le bicentenaire de la mort de Buffon,* Paris, Montbard, Dijon (14–22 June 1988), p. 492.

83 'actuellement la botanique ell-même est plus aisée à apprendre que la nomenclature, qui n'en est que la langue' (quoted ibid., pp. 491–501). See also P. Sloan in Fox, Porter and Wokler, *Human Science*, pp. 128–9.

84 Hannaford, p. 204.

85 'L'homme a … cessé d'etre homme … l'homme enfin sans éducation, sans morale, réduit à mener une vie solitaire et sauvage, n'offre au lieu de sa haute nature, que celle d'un être dégradé –au-dessous de l'animal' (*Les Époques de la Nature*, 1778, quoted in C. Blanckaert, 'La valeur de l'homme: l'idée de nature humaine chez Buffon', *Mort de Buffon*, 1988, p. 588.

86 'sont encore, tant au moral qu'au physique, dans l'etat de pure nature; ni vetemens, ni religion, ni societé qu'entre quelques familles disposées a de grandes distances' (quoted in Blanckaert, *Mort de Buffon*, p. 589).

87 'race d'hommes de petite stature' (*Oeuvres complètes de Buffon,* Book III, *Variétés dans l'espèce humaine,* 1839, p. 301).

88 Ibid., p. 301.

89 'chez tous ces peuples les femmes sont aussi laides que les hommes, et leur ressemblent si fort, qu'on ne les distingue pas d'abord' (Buffon, *Variétés*, p. 302)'.

90 'les memes inclinations et les memes moeurs; ils sont tous egalement grossiers, superstitieux, stupides … la plupart sont idolatres, et tous sont tres-superstitieux; ils sont plus grossiers que sauvages, sans courage sans respect pour soi-meme, sans pudeur; ce peuple abject n'a de moeurs qu'assez pour etre meprise' (Buffon, *Variétés*, p. 302).

91 'il y a autant de varietés dans la race des noirs que dans celle des blancs' (Buffon, *Variétés*, p. 319).

92 'Il est donc necessaire de diviser les noires en differents races, et me semble qu'on peut les reduire, a deux principales, celle des Negres et celle des Cafres' (Buffon, *Variétés*, p. 319).

93 'Ensuite, en examinant en particulier les differens peuples qui composent chacune de ces races noires, nous y verrons autant de varietés que dans les races blanches, et nous y trouverons toutes les nuances du brun au noir, comme nous avons trouvé dans les races blanches toutes les nuances du brun au blanc' (Buffon, *Variétés*, p. 319).

94 'Ils ont aussi les memes idées que nous de la beauté; car ils veulent de beaux yeux, une petite bouche, des levres proportionnées et un nez bien fait' (Buffon, *Variétés*, p. 320).

95 'Lorsqu'on les nourrit bien et qu'on ne les maltraite pas, ils sont contens, joyeux, prets a tout faire, et la satisfaction de leur ame est peinte sur leur visage; mais, quand on les traite mal, ils prennent le chagrin fort a coeur, et perissent quelquefois de melancolie' (Buffon, *Variétés*, p. 323).

96 Ibid., p. 323.

97 'les plus laids et les plus difformes qui soient sous le ciel' (Buffon, *Variétés*, p. 303).

98 'perdu une partie de sa laideur, parce qu'ils se sont melés avec les Circassiens, les Moldaves et les autres peuples dont ils sont voisins' (Buffon, *Variétés*, p. 303).

99 'les hommes les plus beaux, les plus blancs et les mieux faits de toute la terre' (Buffon, *Variétés*, p. 315).

100 See pp. 188–9.

101 Lepenies, *Autoren*, p. 63f.

102 Le Guyader in *Mort de Buffon 88*, p. 492.

103 See p. 173–4.

104 See Reference 8 above.

105 Hume, *Essays*, pp. 184–5.

106 Ibid., p. 186.

107 Ibid., p. 188.

108 Ibid., p. 189.

109 Ibid., p. 199.

110 Ibid., p. 192.

111 Ibid., pp. 505–06.

112 Davis, *Problem of Slavery*, pp. 491–3.

113 Ibid., p. 492.

114 Kant, *Inquiry Concerning the Distinctness of the Principles of Natural Theology and Morality*, in. D. Walford, ed., *Immanuel Kant: Theoretical Philosophy, 1755–1770* (Cambridge, 1992), p. 259.

115 'Die Ausführung is bloss anthropologisch, und über die letzten Gründe des Schönen lernt man darin nichts' (quoted in Karl Vorländer, *Kant: Der Mann und das Werk*, Hamburg, 1977, p. 159). See Meg Armstrong, 'The Effects of Blackness: Gender, Race, and the Sublime in Aesthetic Theories of Burke and Kant', *Journal of Aesthetics and Art Criticism*, LIV/3 (1996), pp. 213–36.

116 See Brigitte Geonget, ed., *Emmanuel Kant, Remarques touchant les Observations sur le Sentiment du Beau et du Sublime* (Paris, 1994). For a full account of the circumstances and context of the volume see John H. Zammito, *Kant, Herder and the Birth of Anthropology* (Chicago and London, 2002), p. 103.

117 Judith Feyertag Hodgson, *Human Beauty in Eighteenth-century Aesthetics* (University Microfilms, Ann Arbor, 1973), passim.

118 S. H. Monk, *The Sublime* (Ann Arbor, 1960), pp. 56–7.

119 Ibid., p. 86f.

120 Edmund Burke, *A Philosophical Enquiry into the Origin of our Ideas of the Sublime and Beautiful* (7th edn, 1773), p. 1.

121 Ibid., p. 162.

122 Ibid., p. 15.
123 Ibid., p. 100.
124 Ibid., pp. 208–9.
125 Ibid., p. 208.
126 Immanuel Kant, *Observations on the Feeling of the Beautiful and Sublime*, trans. John T. Goldthwait (Berkeley, CA, 1991), p. 45.
127 Ibid., p. 47.
128 Ibid., p. 64.
129 Ibid., p. 79.
130 Ibid., p. 95.
131 Ibid., p. 89.
132 Ibid., p. 97.
133 Ibid., pp. 98–9.
134 Ibid., pp. 103–4.
135 Ibid., p. 110.
136 Ibid., pp. 110–11.
137 Ibid., p. 111.
138 Ibid., p. 113.
139 See p. 156.
140 Kant, *Beautiful and Sublime*, p. 112.
141 Ibid., p. 114.
142 Ibid., pp. 112–13.

TWO THE CLIMATE OF THE SOUL

1 The *Gedanken* is available in translation, with German text by Elfriede Heyer and Roger C. Norton, *J. J. Winckelmann: Reflections on the Imitation of Greek Works in Painting and Sculpture* (La Salle, IL, 1987). There is no easily accessible translation of the complete *Geschichte*.
2 See pp. 92–123.
3 See pp. 123–50.
4 *Uber die Ideale der Griechischen Künstler* [1777] (*Wielands sämmtliche Werke*, Berlin, 1984, 24, p. 139).
5 Whitney Davis, 'Winckelmann Divided: Mourning the Death of Art History', in D. Preziosi, ed., *The Art of Art History: A Critical Anthology* (Oxford, 1998), pp. 40–51.
6 For the aesthetic life, see E. M. Wilkinson and L. A. Willoughby, ed., *Friedrich Schiller: On the Aesthetic Education of Man* (Oxford, 1982).
7 *Winckelmann Reflections*, p. 11.
8 J. J. Winckelmann, *Geschichte der Kunst des Altertums,* Bibliothek Klassischer Texte (Darmstadt, 1993), p. 128.

9 Ibid., p. 129.

10 Ibid., 129.

11 For example, the set-piece descriptions of the *Laocoon* and the *Apollo Belvedere*. See Reference 29 below.

12 Thomas Blackwell, *An Enquiry into the Life and Writings of Homer*, 1735 edn, Scolar Press facsimile (London, 1972), p. 6: 'the temperate Regions, lying under the benign Influences of a genial Sky, have the best Chance for a fine Perception, and a proportioned Eloquence'.

13 Winckelmann, *Geschichte*, 1, p. 35.

14 Ibid., p. 35.

15 Ibid., p. 40.

16 Ibid., p. 39.

17 Ibid., p. 40.

18 Ibid., p. 41.

19 Ibid., p. 42.

20 Ibid., p. 135f.

21 Ibid., p. 134: 'Ein weiser Mann war der geehrteste, und dieser war in jeder Stadt, wie bei uns der reichste, bekannt'.

22 Ibid., pp. 41–2.

23 Ibid., p. 47.

24 Ibid., p. 48.

25 Ibid., p. 78.

26 Ibid., p. 88.

27 Ibid., pp. 306–8.

28 L. Curtius, *Johann Joachim Winckelmann, 1768–1968* (Bad Godesberg, 1968), p. 11.

29 For the *Laocoon* see Winckelmann, *Reflections*, pp. 33–7, and for the *Apollo Belvedere* see Winckelmann, 'Beschreibung des Torso im Belvedere zu Rom', *Bibliothek d. schönen Wissenschaften u. Künste*, 5 (1759), pp. 33–41.

30 Winckelmann, *Geschichte*, p. 148.

31 Ibid., p. 146.

32 Ibid., p. 147.

33 Ibid., p. 147.

34 Ibid., p. 148.

35 Ibid., p. 148.

36 Ibid., p. 148.

37 Ibid., p. 174.

38 Alex Potts, *Flesh and the Ideal: Winckelmann and the Origins of Art History* (New Haven and London, 1994), p. 84f.

39 Winckelmann, *Reflections*, p. 174.

40 Martin Bernal, *Black Athena*, vol. 1 (London, 1991), pp. 212–13.

41 Winckelmann, *Reflections*, p. 47.

42 Ibid., p. 2.

43 Nicholas Boyle, *Goethe: The Poet and the Age* (London, 1992), vol. 1, p. 181.

44 Gerda Mraz and Uwe Schögl, eds, *Das Kunstkabinett des Johann Caspar Lavater* (Vienna, 1999).

45 Ibid., p. 74f. Gudrun Swoboda, 'Die Sammlung Johann Caspar Lavater in Wien: Geschichte-Struktur-Funktion'.

46 Ellis Shookman, ed., *The Faces of Physiognomy: Interdisciplinary Approaches to Johann Caspar Lavater* (Dartmouth College, 1993), p. 6.

47 J. C. Lavater, *Physiognomische Fragmente, zur Beförderung der Memschenkenntnis und Menschenliebe* (Leipzig and Winterthur, 1775–78), p. 25. I have referred to the German edition, *Physiognomische Fragmente*, wherever appropriate, but where the English edition – J. C. Lavater, *Essay on Physiognomy*, 5 vols (London, 1789–98), itself translated from the French edition of 1781–1803 and containing alterations by Lavater himself – employs a particularly eloquent translation or new phrase, it has been used in preference to the German edition. Where the German text appears in a Reference, the English translation is my own.

48 'die schönste, beredeste aller Sprachen, die Natursprache der Weisheit und Tugend' (Lavater, *Physiognomische Fragmente*, 1, p. 96).

49 Boyle, *Goethe*, vol. 1, pp. 149-50.

50 E. H. Gombrich, *Meditations on a Hobby Horse* (London, 1963), p. 51. Gombrich's target is, of course, wider than Lavater; he is concerned to attack the notion of works of art as expressing the 'spirit of the age'. He notes that 'It is first exemplified by Winckelmann, who professed to divine the 'noble simplicity and quiet grandeur' of the Greek soul behind the impassive marble front of classical statues'.

51 Mary Gregor, ed., Kant, *Anthropology from a Pragmatic Point of View* (London, 1974), p. 160.

52 *Essays in Physiognomy*, Advertisement (n.p.).

53 Ibid., pp. 17–18.

54 'Die Schönheit und Hässlichkeit des Angesichts, hat ein richtiges und genaues Verhältnis zur Schönheit und Hässlichkeit der moralischen Beschaffenheit des Menschen: Je moralisch-besser; Desto schoner. Je moralisch-schlimmer; Desto hasslicher' (*Physiognomische Fragmente*, 1, p. 63).

55 'Man hat erbärmliche Dinge uber die Gesichtsdeutung geschrieben' (*Physiognomische Fragmente*, 1, p. 17).

56 Norbert Borrmann, *Kunst und Physiognomik: Menschendeutung und Menschendarstellung im Abendland* (Cologne, 1994), p. 119.

57 *Essays in Physiognomy*, 1, p. 42. In this extract, which is not in the German

edition, Herder emphasises pathognomy, i.e., the idea that the face is the seat of the soul's expression, of will and the active life. It is taken from *Plastik*, written 1768–70, but only published in 1778 (*Herders Werke in fünf Bänden*, Weimar, 1963, III, pp. 78–9).

58 *Essays in Physiognomy*, I, p. 119f.

59 Ibid., I, p. 127.

60 Ibid., I, pp. 62–3.

61 'Wo ist die Wissenschaft, wo alles bestimmbar-nichts dem Geschmacke, dem Gefühle, dem Genius übrig gelassen sey?–Wehe der Wissenschaft, wenn eine solche ware!' (*Physiognomische Fragmente*, I, p. 55).

62 *Essays in Physiognomy*, II, p. 201.

63 Ibid., III, part 2, p. 271.

64 Ibid., III, part 2, p. 336.

65 Ibid., I, p. 77.

66 Ibid., I, p. 77.

67 Ibid., I, p. 119.

68 Ibid., I, p. 117.

69 G. C. Lichtenberg, *Ammerkungen zu einer Abhandlung über Physiognomik, Göttinger Taschenkalender aufs Jahr 1778* (Göttingen, 1778).

70 *Essays in Physiognomy*, I, pp. 76–7.

71 See William Blake, *Jerusalem,* ed. M. D. Paley (London, 1991), p. 294 and M. D. Paley, *The Continuing City: William Blake's Jerusalem* (Oxford, 1983).

72 For the four engravings see R. N. Essick, *William Blake's Commercial Book Illustrations* (Oxford, 1991), pp. xix, 41–2, figs. 61–4. Blake's copy of Lavater's *Aphorisms on Man*, printed for J. Johnson, 1788, is in the Huntington Library, San Marino, California.

73 *Essays in Physiognomy*, I, p. 126.

74 Gerda Mraz and Uwe Schögl, eds, *Das Kunstkabinett des Johann Caspar Lavater* (Vienna, 1999), p. 308, no. 57, and *Physiognomisiche Fragmente*, III, p. 220f.

75 *Essays in Physiognomy*, I, p. 131.

76 Ibid., I, p. 131.

77 'Dehmuth, Frömmigkeit, Ruhe, Geduld, und anbethung und Liebe'.

78 *Essays in Physiognomy*, II, p. 145.

79 Ibid, II, p. 326.

80 'Ganz erschaffen kann der Mensch überall nichts . . . Nachahmen ist des Menschen ewiges Thun und Lassen; sein Leben und Weben; seine Natur und seine Kunst' (*Physiognomische Fragmente*, III, p. 40).

81 'Kein Mensch erschafft sich eine Sprache. Alle Sprache ist Nachahmung' (*Physiognomische Fragmente*, III, p. 40).

82 'Also waren die Griechen schönere Menschen-bessere Menschen!' (*Physiognomische Fragmente*, III, p. 45).

83 'die schöne Natur verschönern' (*Physiognomische Fragmente*, III, p. 44).

84 'Ewig unternaturlich ist und bleibt alle Kunst' (*Physiognomische Fragmente*, III, p. 43).

85 *Essays in Physiognomy*, II, part 2, p. 370.

86 Ibid., II, p. 145.

87 Ibid., I, p. 134.

88 Ibid., I, p. 23.

89 Ibid., II, p. 169.

90 Ibid., II, p. 376.

91 Ibid., II, p. 380. This rare work has 19 plates after Cozens engraved by Bartolozzi. It was issued with a French translation, no doubt for Continental distribution.

92 Ibid., II, p. 380.

93 Werner Busch, in D. Bindman, F. Ogée and P. Wagner, eds, *Hogarth: Representing Nature's Machines* (Manchester, 2001), pp. 195–218.

94 *Essays in Physiognomy*, II, p. 380.

95 'welche Einfachheit und Grössheit in diesem Gesichte!' (*Physiognomische Fragmente*, III, p. 218).

96 'richtiger, schneller Verstand' (*Physiognomische Fragmente*, III, p. 218).

97 'Spuren des kraftvollen Genius' (*Physiognomische Fragmente*, III, p. 218).

98 'Die Nase-voll Ausdrück von Produktivität-Geschmack und Liebe-Das heist, von Poesie' (*Physiognomische Fragmente*, III, p. 218).

99 *Essays in Physiognomy*, II, p. 159.

100 Ibid., II, p. 160.

101 Ibid., II, p. 161.

102 Ibid, II, pp. 161–2, plate 6.

103 *Physiognomische Fragmente*, IV, p. 267.

104 Judith Wechler, 'Lavater, Stereotype, and Prejudice', in Ellis Shookman, ed., *The Faces of Physiognomy: Interdisciplinary Approaches to Johann Caspar Lavater* (Dartmouth College, 1993), pp. 104–25.

105 'Welche Nation hat nichts von dem Bilde der Gottheit' (*Kunstkabinett*, p. 182, fig. 88). See Daniela Lachs, 'National-physiognomien', *Kunstkabinett*, pp. 182–9.

106 'Füttert ihn-so ist er Seelig genug' (*Kunstkabinett*, p. 184, fig. 89).

107 'Thierische Mensceit' (*Kunstkabinett*, p. 185, fig. 90).

108 See p. 15.

109 'im Kopfe eines Mohren, dessen Nase eingedruckt, dessen Augen zum Kopfe heraus ragen, dessen Lippen, so aufgeworden sie sind, kaum die Zähne bedecken, der allenthalben fleischicht und rund ist, die Planete gewogen, und den Lichtstrahl gespaltet hatte' (J. C. Lavater, *Von der Physiognomik*, Zürich, 1772, p. 13). It should be noted that Lavater, in the same passage,

finds the idea of intellect just as improbable in the case of 'eines Stupiden' or in the skull of a Lapp.

110 'Der gesunde Menschenverstand empört sich in der That gegen einen Menschen, der behaupten kann: das Neuton [*sic*] und Leibnitz allenfalls ausgesehen haben könnten, wie ein Mensch im Tollhause … im Kopfe eines Labradoriers, der weiter nicht, als auf sexhse zählen kann, und was drüber geht, unzählbar nennt' (*Physiognomische Fragmente*, I, p. 46).

111 *Essays in Physiognomy*, III, p. 24.

112 Ibid., III, p. 24.

113 Ibid., II, 137.

114 See Reference 50 above.

115 *Essays in Physiognomy*, III, p. 21.

116 Ibid., III, p. 22.

117 Reprinted in *Physiognomische Fragmente*, IV, p. 3f.

118 *Anmerkungen zu einer Abhandlung uber Physiognomik* (trans. as *Essays in Physiognomy*, I, pp. 130–39).

119 'Neutons [sic] Seele sollte in dem Kopf eines Negers sitzen konnen? Eines Engels Seele in einem scheusslichen Korper? warum nicht? … warum sollte Neutons [sic] Seele nicht in dem Kopf eines Negers sitzen konnen? Bist du, elender, denn Richter von Gottes Werken?' (*Physiognomische Fragmente*, IV, p. 5).

120 'Wir urtheilen stündlich aus dem Gesicht, under irren stündlich' (ibid., IV, p. 5).

121 *Essays in Physiognomy*, I, pp. 166–76.

122 *Physiognomische Fragmente*, I, pp. 78–9.

123 Norton, *Beautiful Soul*, pp. 200–03.

124 Ibid., p. 202.

125 'Feinheit, List, Verstand, Geschmack und Bedürfnis nach Klarheit; Aber nicht Grösse der Seele, Genié nicht, Muth nicht, nicht Hoheit' (*Kunstkabinett*, p. 322, fig. 68).

126 'Tiefer, feiner, schlauer, und eleganter der Jude-männlicher, derber, froher, und Kühner, lebendiger, Lessing' (*Kunstkabinett*, p. 322, fig. 69).

127 Boyle, *Goethe*, vol. I, p. 352.

128 'Dass unsre Temperaments- und physiognomische Entheilungen zu Nichts sichern führen, muss jedermann klar einsehn' (*Herders Sämmtliche Werke*, Berlin, 1878, XVII, p. 358).

129 Kant, *Anthropology*, p. 161.

130 Ibid., p. 162.

131 See p. 188.

132 The work consisted of 'all the humorous Sketches which have appeared in that popular Weekly paper "Bell's Life in London" from October 1834, to the present period'.

133 A. Ohage, 'Von Lessings Wust zu einer Wissenschaftsgeschichte der Physiognomik', *Lessing Yearbook*, 21 (1989), pp. 55–8.

134 Graeme Tytler, *Physiognomy in the European Novel: Faces and Fortunes* (Princeton, NJ, 1982).

135 See Norbert Borrmann, *Kunst und Physiognomik: Menschendeutung und Menschendarstellung im Abendland* (Cologne, 1994), pp. 155–82.

136 'il nous chanta lentement une chanson, sans doute anacreontique: scene charmante, & digne du pinceau de Boucher', Louis Antoine de Bougainville *Voyage autour du Monde … en 1766, 1767, et 1769* (Paris, 1771), p. 194.

137 'elle … parut aux eux de tous, telle que Venus se fit voir au berger Phrygien. Elle en avoit la forme celeste … meme dans les pays ou regne encore la franchise de l'age d'or' (ibid.), p. 190.

138 'Venus est ici la deesse de l'hospitalité … Je me croyais transporté dans le jardin d'Eden … Nous trouvions des troupes d'hommes & de femmes assises a l'ombre des vergers; tous nous saluoient avec amitié . . .; par-tout nous voyions regner l'hospitalité, le repos, une joie douce & toutes les apparences du bonheur' (ibid., p. 198).

139 'Le peuple de Taiti[sic] est composé de deux races d'hommes tres-differentes … pour peindre Hercule & Mars, on ne trouveroit nulle part d'aussi beaux modeles. Rien ne distingue leurs traits de ceux des Europeens' (ibid., p. 214).

140 Louis Antoine de Bougainville, *A Voyage round the World … Translated from the French by John Reinhold Forster* (London, 1772).

141 George [*sic*] Forster, FRS, *A Voyage round the World, in His Britannic Majesty's Sloop, Resolution, commanded by Capt. James Cook, during the Years 1772, 3, 4, and 5*, 2 vols (London 1777).

142 Nicholas Thomas, Harriet Guest, Michael Dettelbach, eds, *Johann Reinhold Forster: Observations Made during a Voyage round the World* (Honolulu, 1996), p. lvii.

143 Rolf Reichardt and Genevieve Roche, *Weltbürger-Europäer-Deutscher-Franke: Georg Forster zum 200. Todestag*, Universitätsbibliothek Mainz (1994), p. 3f.

144 Ibid., pp. 17–84.

145 Forster, *Voyage*, p. iv.

146 Thomas, Guest and Dettelbach, eds, *Forster: Observations,* p. lxxviii.

147 Ibid., p. 1.

148 Ibid., p. 9.

149 Ibid., p. 154.

150 Ibid., p. 155.

151 Ibid., p. 9.

152 Ibid., p. 164.

153 Forster, *Voyage,* p. iv.

154 Ibid., p. xi.

155 Ibid., p. xii.

156 Ibid., p. 167.

157 Ibid., p. 38.

158 See Nicholas Thomas in *Forster: Observations*, p. xxxivf.

159 Forster, *Voyage,* p. 212.

160 Ibid., p. 303.

161 Ibid., p. 173.

162 Ibid., p. 390.

163 Ibid., p. 179.

164 Ibid., p. 179.

165 Ibid., p. 364.

166 Ibid., p. 255.

167 Ibid., p. 421.

168 Ibid., p. 421.

169 Ibid., p. 431.

170 Ibid., p. 425.

171 Rüdiger Joppien and Bernard Smith, *The Art of Captain Cook's Voyages*, vol II: *The Voyage of the Resolution and Adventure, 1775* (New Haven and London, 1985), pp. 78–81.

172 Joppien and Smith, *Art of Cook's Voyages*, passim.

173 Forster, *Voyage,* p. 388; For Omai see Harriet Guest, 'Curiously Marked: Tattooing, Masculinity, and Nationality in 18th-century British Perceptions of the South Pacific', in *Painting and the Politics of Culture*, ed. J. Barrell (Oxford, 1992), pp. 101–34.

174 Thomas, Guest and Dettelbach, eds, *Forster: Observations*, p. xxxviii.

THREE DEFINING AND DENYING RACE

1 Quoted in Thomas Clarkson, *The History of the Rise, Progress, and Accomplishment of the Abolition of the African Slave-Trade by the British Parliament* (London, 1808), I, pp. 61–2.

2 Edward Long, *The History of Jamaica* (London, 1774), II, p. 336.

3 Ibid, II, p. 263.

4 Ibid., II, p. 354.

5 Ibid., II, p. 360.

6 Ibid., II, pp. 372 and 365.

7 Wolf Lepenies, *Autoren und Wissenschaftler im 18. Jahrhundert* (Munich and Vienna, 1988), passim.

8 *Kants gesammtelte Schriften,* königlich Preussischen Akademie der Wissenschaften (Berlin, 1912), II, pp. 429–43.

9 Translated with 1795 version in Thomas Bendyshe, ed., *The Anthropological*

Treatises of Johann Friedrich Blumenbach (London, 1865).

10 See References 41 and 43 below.

11 'Aus einer lebenswürdigen Abhandlung Herrn Professor Kant in Königsberg' (Lavater, *Physiognomische Fragmente*, pp. 275–7).

12 Bendyshe, *Anthropological ... Blumenbach*, p. x.

13 For Blumenbach's career at Göttingen, see B. Hauser-Schäublein, Gundolf Krüger, eds, *James Cook: Gifts and Treasures from the South Seas: The Cook/Forster Collection, Göttingen* (Munich, 1998), p. 52f; T. Lenoir, 'The Development of Transcendental Naturphilosophie', in W. Coleman and C. Limoges eds., *Studies in History of Biology* (Baltimore, 1986), pp. 115–54; S. F. Bertolotti, 'The Anthropological Theory of J. F. Blumenbach', in S. Poggi and M. Bossi, eds, *Romanticism in Science* (Dordrecht, 1994), pp. 103–25.

14 Forster was a particularly revered figure in Göttingen. On his first visit in 1778 he was invited to a gathering in honour of the 'Weltumsegler, Otaheiten und weyland Antipoden' (Round-the-world sailor, Tahitian, and former Antipodean'); *The Cook/Forster Collection*, p. 54. Blumenbach, Lichtenberg and Meiners were present at the occasion.

15 'eine nützliche Unterhaltung, als eine mühsame Beschäftigung sein' (*Kants Schriften*, II, p. 429).

16 See pp. 158–9.

17 For Herder and Kant see pp. 163–73.

18 P Guyer ed., *The Cambridge Companion to Kant* (Cambridge, 1992), pp. 40–41.

19 *Kants Schriften*, II, p. 430

20 Ibid., p. 432f.

21 Ibid., p. 434.

22 For a succinct account of the preformation-epigenesis debate, see Michael Hagner, 'Enlightened Monsters' in W. Clark, J. Golinski and S. Schaffer, *The Sciences in Enlightened Europe* (Chicago, 1999), pp. 186–99.

23 J. F. Blumenbach, *An Essay on Generation*, trans. A. Crichton (London, 1792), p. 13.

24 See pp. 173–81.

25 *Noch etwas über die Menschenrassen, Georg Forsters Werke, Sämtliche Schriften, Tagebücher, Briefe*, Akademie der Wissenschaften der DDR (Berlin, 1986–), VIII, p. 130.

26 *Kants Schriften*, VIII, p. 101.

27 Ibid., II, p. 438.

28 See p. 170.

29 Bendyshe, *Anthropological ... Blumenbach*, p. x.

30 See Miriam Claude Meijer, *Race and Aesthetics in the Anthropology of Petrus Camper*, (Amsterdam, 1999), p. 105f.

31 Blumenbach, 1775 (Bendyshe, *Anthropological ... Blumenbach*, p. 82f).

32 Long, *Jamaica*, ii, p. 334.

33 See p. 176.

34 Blumenbach, 1775 (Bendyshe, *Anthropological … Blumenbach*, p. 99).

35 Ibid., p. 99.

36 Ibid., p. 107.

37 Ibid., pp. 116–17.

38 Ibid., p. 121.

39 Ibid., p. 123.

40 Ibid., p. 124.

41 *Bestimmung des Begriffs der Menschenrasse* (a Definition of the Idea of the Races of Man), 1784 (*Kants Schriften*, viii, pp. 89–106, first published *Berliner Monatsschrift*, November 1785, vi). For the debate between Kant, Forster and Herder see: Manfred Riedel, 'Historizismus und Kritizismus: Kants Streit mit G. Forster und J. G. Herder', in B. Fabian, W. Schmidt-Biggemann and R. Vierhaus, *Deutschlands kulturelle Entfaltung: Die Neubestimmung des Menschen* (Munich, 1990), pp. 31–47; W. Schmied-Kowarzik, ' Der Streit um die Einheit des Menschengeschlechts: Gedanken zu Forster, Herder und Kant', in Gerhard Sauder, ed., *Johann Gottfried Herder, 1744–1803* (Hamburg, 1987); H.-J. Lüsebrink, 'Aufgeklärter Humanismus: Philosophisches Engagement am Beispiel der Kontroverse über die 'Menschenrassen', in Rolf Reichardt and Genevieve Roche, *Weltbürger-Europäer-Deutscher-Franke Georg Forster zum 200. Todestag* (Universitäts bibliothek Mainz, 1994), pp. 188–95.

42 *Teutche Merkur* 1788, issue 4 (Berlin, October 1786), pp. 57–86, 150–66 (*Georg Forsters Werke*, viii, pp. 130–56).

43 *Uber den Gebrauch teleologische Principien in der Philosophie* (On the Use of Teleological Principles in Philosophy, 1788) (*Kants Schriften*, viii, pp. 157–84, first published *Teutscher Merkur*, 1788, First Quarter, nos 1 and 2).

44 'kalten, leeren Eishimmel'. From a letter from Herder to Hamann, cited in Jens Heise, *Johann Gottfried Herder zur Einführung* (Hamburg, 1998), p. 9. For much of what follows, see: Wulf Koepke, 'Kulturnation and its Authorisation through Herder', and Katherine Arens, 'History as Knowledge: Herder, Kant, and the Human Sciences', in Wulf Koepke, ed., *Johann Gottfried Herder: Academic Disciplines and the Pursuit of Knowledge* (Columbia, sc, 1996).

45 Heise, *Herder zur Einführung*, p. 9.

46 *Herders Sämmtliche Werke* (Berlin, 1878), p. xiii, 98: 'das eine organische Principium der Natur, das wir jetzt bildend, treibend, jetzt empfindend, jetzt künstlich bauend nennen und im Grunde nur eine und dieselbe organische Kraft ist, in mehr Werkzeuge und verschiedentliche Glieder verteilt ist, je mehr es in denselben eine eigene Welt hat'.

47 'Der Bau des Weltgebaudes sichert also den Kern meines Daseins, mein inneres Leben, auf Ewigkeiten hin', *Herders Sämmtliche Werke*, XIII, p. 73.

48 Heise, *Herder zur Einführung*, p. 9.

49 *Herders Sämmtliche Werke*, XIII, p. 74.

50 Ibid., XIII, p. 111.

51 'ihr Hauptgebilde, die menschliche Schönheit' (*Herders Sämmtliche Werke*, XIII, p. 115).

52 H. B. Nisbet, *Herder and the Philosophy and History of Science* (Cambridge, 1970), p. 230.

53 'Kurz, weder vier oder funf Racen, noch ausschliessende Varietaten giebt es auf der Erde. Die Farben verlieren sich in einander' (*Herders Sämmtliche Werke*, XIII, p. 258).

54 *Herders Sämmtliche Werke*, XIII, p. 234.

55 J. G. Herder, translated T. Churchill, *Outlines of a Philosophy of the History of Man* (London, 1800), p. 133.

56 Ibid., p. 136.

57 Ibid., p. 137.

58 Ibid., p. 141.

59 Ibid., pp. 142–3.

60 Ibid., p. 146.

61 Ibid., p. 148.

62 Ibid., p. 151.

63 Ibid., p. 155.

64 Ibid., p. 362.

65 Ibid., p. 363.

66 'Unser *bürgerliches* Volk, die Antipoden der *Menschheit*', from a letter to Hamann, cited in Heise, *Herder zur Einführung*, p. 20.

67 See Reference 41 above for a bibliography of this work.

68 'Es liegt gar viel daran, den Begriff, welchen man durch Beobachtung aufklären will, vorher selbst wohl bestimmt zu haben, ehe man bedarf die Erfahrung befragt' (*Kants Schriften*, VIII, p. 91).

69 Ibid., p. 92: 'allein die Schwarze übrig bleiben, die ihm durch seine Geburt zu Theil ward, die er weiter fortpflanzt, und die daher allein zu einem Klassenunterschiede gebraucht werden kann'.

70 Ibid., pp. 94–5.

71 Ibid., p. 103.

72 Ibid., p. 100: 'Der Begriff einer Race ist also der Klassenunterschied der Thiere eines und desselben Stammes, so fern er unausbleiblich erblich ist'.

73 Ibid., p. 102: 'der Philosophie wenig gerathen sein'.

74 Heise, *Herder zur Einführung*, p. 16; Kant, *Recensionen von J. G. Herders Ideen zur Philosophie der Geschichte der Menschheit*, first published in 1785 in

Allgemeine Litteraturzeitung (*Kants Schriften*, VIII, pp. 43–66).

75 'eine zusammengelesene Beschreibung der Völker nach sogennanten Racen, Varietäten, Spielarten, Begattungsweisen u.f. diesen Namen noch nicht verdiene' (*Herders Sämmtliche Werke*, XVIII, pp. 246–7).

76 'Der Neger hat so viel Recht, den Weissen für eine Abart, einen gebohrenen Kackerlacken zu halten, als wenn der Weisse ihn für eine Bestie, fur ein schwarzes Thier hält. So der Amerikaner, so der Mungale' (*Herders Sämmtliche Werke*, XVIII, p. 248). A *Kakerlak* is a cockroach in modern German, but has an earlier usage as an Albino (see F. Kluge, *Etymologisches Wörterbuch der deutschen Sprache*, Berlin, 1989).

77 'Nicht verschiedene Keime, (ein leeres und der Menschenbildung widersprechendes Wort) aber verchiedene Kräfte hat sie in verschiedener Proportion ausgebildet'.

78 'Das Urbild, der Prototyp der Menschheit liegt also nicht in einer Nation eines Erdstriches'.

79 S. T. Soemmerring, *Über die Körpliche Verschiedenheit des Negers vom Europäer*, 1785.

80 *Georg Forsters Werke*, VIII, pp. 130–31.

81 'Es wäre doch gut wenn der Schuster bei seinen Leisten bliebe! Kant ist ein vortrefflicher Kopf, und doch kommt der verzweifelte Paradoxismus, der den Philosophen von Profession eigen ist, auch über ihn, die Natur nach ihren logischen Distinktionen modeln zu Wollen' (*Georg Forsters Werke*, XIV, p. 486; quoted in H.-J. Lüsebrink, 'Aufgeklärter Humanismus: Philosophisches Engagement am Beispiel der Kontroverse über die "Menschenrassen"', in Rolf Reichardt and Genevieve Roche, *Weltbürger-Europäer-Deutscher-Franke: Georg Forster zum 200. Todestag*, Universitäts bibliothek Mainz (1994), p. 189.

82 *Georg Forsters Werke*, VIII, p. 132.

83 Compare his use of the same simile in *Journey around the World*. See p. 128.

84 *Georg Forsters Werke*, VIII, p. 133.

85 Ibid., p. 134.

86 Ibid., p. 135.

87 Soemmerring, *Verschiedenheit des Negers*, passim.

88 *Georg Forsters Werke*, VIII, p. 142.

89 Ibid., pp. 141–2.

90 Ibid., pp. 142–3.

91 Ibid., pp. 143.

92 Ibid., pp. 147.

93 Ibid., pp. 147.

94 Ibid., pp. 150.

95 Ibid., pp. 154.

96 Ibid., pp. 155.

97 Rolf Reichardt, 'Zwischen Deutschland und Frankreich: Georg Forster als Mittler der französischen Aufklärungs- und Revolutionskultur', in Reichardt and Roche, *Georg Forster zum 200*, pp. 225–45.

98 *Georg Forsters Werke*, VIII, pp. 156.

99 'kleinen Versuche über die Menschenracen' (*Kants Schriften*, VIII, p. 159).

100 Ibid., p. 161.

101 Ibid., p. 162.

102 Ibid., p. 163.

103 Ibid., p. 164.

104 Ibid., p. 166.

105 Ibid., p. 168.

106 'In einem Stamme eingepflanzter zweckmässiger erster Anlagen' (*Kants Schriften*, VIII, p. 169).

107 Ibid., p. 172.

108 Ibid., p. 177.

109 F. P. van de Pitte, *Kant as Philosophical Anthropologist* (The Hague, 1971).

110 Ibid., p. 12.

111 H. H. Rudnick, ed., *Anthropology from a Pragmatic Point of View*, trans. V. L. Dowdell, (Carbondale, IL, 1996), pp. 236–7.

112 Ibid., p. 236.

113 See p. 152.

114 Kant, *Beautiful and Sublime*, p. 45.

115 Immanuel Kant, *Critique of Judgement*, trans. J. H. Bernard (New York, 1951), pp. 38–45.

116 Ibid., p. 45f.

117 Ibid., pp. 65–73.

118 Ibid., p. 53.

119 Ibid., p. 55.

120 Ibid., p. 45.

121 Ibid., p. 54.

122 Ibid., pp. 62–5.

123 Ibid., pp. 66–7.

124 Ibid., p. 65.

125 Ibid., p. 68.

126 Ibid., pp. 69–70.

127 Ibid., p. 70.

128 Ibid., p. 71.

129 Ibid., p. 71.

130 Ibid., p. 71.

131 Ibid., pp. 72–3.

132 Ibid., p. 73.

133 Joshua Reynolds, *Seven Discourses delivered in the Royal Academy by the President* (London, 1778), p. 79f.

FOUR THE SKULL'S TRIUMPH

1 J. F. Blumenbach, 1795 (Thomas Bendyshe, ed., *The Anthropological Treatises of Johann Friedrich Blumenbach*, London, 1865, p. 150).

2 See pp. 157–8.

3 W. Engelmann, *Daniel Chodowieckis sämmtliche Kupferstiche* (Leipzig, 1857), xviii, no. 586, p. 310.

4 Hagner in W. Clark, J. Golinski and S. Schaffer, *The Sciences in Enlightened Europe* (Chicago, 1999), p. 195.

5 Ibid., p. 198.

6 Jörg Traeger, *Philipp Otto Runge und sein Werk* (Munich, 1975), pp. 43–76.

7 Blumenbach, 1795 (Bendyshe, *Anthropological ... Blumenbach*, p. 168).

8 Hagner in Clark, Golinski and Shaffer, *Sciences in Enlightened Europe*, pp. 191–3.

9 Blumenbach, 1795 (Bendyshe, *Anthropological ... Blumenbach*, p. 168).

10 'Wo mich nun nicht alles trügt, so glaube ich die Weichheit dieses Mittel gefässes (parenchyma) zu den hauptvorzügen des Menschen rechnen zu muessen, durch welche er vor den uebrigen Säeugthieren sich auszeichnet. Denn da dieses Netz einerseits von der Haut an ueber den ganzen Koerper bis zu dessen Innersten sich verbreitet, und gleichsam als gemeinsames Band, zwischen alle und jede Theile der ganzen Machine, eingewebt ist; so ist es mir ausgemacht, dass der Mensch eben dieser nachgiebigen Weichheit des netz förmigen Schleimes es verdanke, dass er leichter, als irgend ein anderes Säugethier an jedes Klima sich gewoehnen, und unter jedem Himmelstriche leben kann.' Blumenbach, 1795 (Bendyshe, *Anthropological ... Blumenbach*, 1865, pp. 180–81).

11 'Völkern und mancherlei Nationen der Menschen' (Bendyshe, *Anthropological ... Blumenbach*, 1865, p. 188).

12 Bendyshe, *Anthropological ... Blumenbach*, 1865, p. 193.

13 Ibid., pp. 207–8.

14 Ibid., pp. 209–10.

15 Ibid., p. 226f.

16 Ibid. p. 228.

17 S. J. Gould, *The Mismeasure of Man* (London, 1996), pp. 405–6: 'Blumenbach was the least racist, most egalitarian, and most genial of all Enlightenment writers on the subject of human diversity'.

18 Nancy Stepan, *The Idea of Race in Science, 1800–1960* (London, 1982), p. 26.

19 Lorna Schiebinger, *Nature's Body: Gender in the Making of Modern Science* (Boston, 1993), p. 117.

20 Bernard Siegfried Albinus, *de sede et causa Coloris Aethiopum et Caeterorum Hominum* (Leiden, 1737).

21 Miriam Claude Meijer, *Race and Aesthetics in the Anthropology of Petrus Camper* (Amsterdam, 1999), p. 20.

22 *The Works of the late Professor Camper, on the Connexion between the Science of Anatomy and the Arts of Drawing, Painting, Statuary, &c. &c.*, trans. T. Cogan (London, 1794), p. 11.

23 See p. 108.

24 Stepan, *Idea of Race*, pp. 9–10.

25 *Works of Camper*, p. 33f.

26 Ibid., p. 36.

27 'I look upon Linnaeus as a mere Catalogist, and the most superficial Naturalist I ever knew' (quoted in Meijer, *Petrus Camper*, p. 157).

28 Meijer, *Petrus Camper*, p. 184.

29 Ibid., p. 190.

30 *Works of Camper*, p. 32.

31 Ibid., 42.

32 Ibid., title-page.

33 Ibid., p. x.

34 Ibid., p. 2.

35 Ibid., p. 20.

36 See Judy Egerton, *George Stubbs, 1724–1806*, exh. cat., Tate Gallery (London, 1984), p. 183.

37 Henriette s'Jacob, *Idealism and Realism: A Study of Sepulchral Symbolism* (Leiden, 1954), p. 191.

38 Alex Potts, *Flesh and the Ideal: Winckelmann and the Origins of Art History* (New Haven and London, 1994), p. 84.

39 *Works of Camper*, p. 4.

40 Ibid., p. 99.

41 Michel Foucault, *The Archaeology of Knowledge* (London, 1972), p. 31.

42 Blumenbach, 1795 (Bendyshe, *Anthropological ... Blumenbach*, 1865, p. 235f.).

43 Gerda Mraz and Uwe Schögl, eds, *Das Kunstkabinett des Johann Caspar Lavater* (Vienna, 1999), p. 344, nos 82a–x.

44 Inscribed on the von Mechel print.

45 J. C. Lavater, *Essai sur la physiognomie*, 4 vols (The Hague, 1781–1803).

46 Mraz and Schögl, *Kunstkabinett ... Lavater*, p. 344, nos 82a–x.

47 'mais rien dans ce genre ne mérite autant d'etre relu qu'une dissertation de Camper, pleine de profondeur & de sagacité, sur la différence naturelle des linéamens du visage' (vol. IV, p. 319).

48 Winthrop D. Jordan, *White over Black: American Attitudes toward the Negro, 1550–1812* (New York, 1977), p. 498.

49 Charles White, *An Account of the Regular Gradation in Man, and in Different Animals and Vegetables; and from the Former to the Latter* (1799), p. 41.

50 Ibid., p. 42.

51 Ibid, p. 41.

52 Ibid., p. 56.

53 Ibid., p. 55.

54 Ibid., p. 139f.

55 Jordan, *White over Black*, p. 501.

56 Ibid., p. 502.

57 Friedrich Lotter, 'Christoph Meiners und die Lehre von der unterschiedlichen Wertigkeit der Menschenrassen', in H.Boockmann and H. Wellenreuther, eds, *Geschichtswissenschaft in Göttingen* (Göttingen, 1987).

58 L. Poliakov, *The Aryan Myth* (New York, 1996), p. 179.

59 *Göttingisches Historisches Magazin*, VIII (1790), p. 119f.

60 'Kurze Vergliechung des nördlichen und südlichen Teutschlands', *Göttingisches Historisches Magazin*, IV (1789), pp. 193–243.

61 'Eins der wichtigsten Kennzeichen von Stämmen und Völkern ist *Schönheit* oder *Hässlichkeit,* entweder des ganzen Cörpers, oder des Gesichts' (quoted Peter Martin, *Schwarze Teufel, edle Mohren*, Hamburg, 1993, p. 241).

62 Meiners offered, in addition to skin colour and skull shape, a long list of potentially differentiating characteristics between races: body size, relative corpulence, bodily strength, bodily movement, colour and nature of skin, hair growth, head and skull form, facial expression, the form of ears, forehead, eyes, cheekbones, noses, mouths, lips, teeth, chin, neck, shoulders, waist, stomach, hips, sexual organs, legs, feet, posture. He also included mental attributes: senses, memory, imagination, understanding, talent for art and science, gift for languages, inclinations and instincts, moral sense, sense of honour, levels of culture; but also living patterns: food and drink, forms of dwelling, clothing and cleanliness, the position of women, upbringing, pleasures, distinctive habits, forms of rule and constitutions, laws, warfare, slavery, property rights, criminal law, marriage laws, moral laws and codes of honour.

63 'bestimmte Grenze zwischen diesen Nuancen'.

64 *Göttingisches Historisches Magazin*, VI (1790), pp. 385–456.

65 Baron Georges Cuvier, *The Animal Kingdom* (London, 1812), p. 97.

EPILOGUE

1 Stepan, *Idea of Race*, p. 5.

2 Ibid., p. 128.

3 George L. Mosse, *Towards the Final Solution* (London, 1978), p. 43.

4 Stepan, *Idea of Race*, p. 42f.

5 Francis Galton, 'The Comparative Worth of Different Races', in *Hereditary Genius* (London, 1869), pp. 326–30.

6 Robert Knox, *Races of Men* (1850), cited in Mosse, *Final Solution*, p. 67.

7 See Stephen Jay Gould, *The Mismeasure of Man* (London, 1997), chap. 3: 'Measuring Heads: Paul Broca and the Heyday of Craniology', pp. 105–41.

8 Karl Pearson, *The Life, Letters and Labours of Francis Galton* (Cambridge, 1914–30), vol. II, p. 286f.

9 Ibid., p. 294.

10 Ibid., p. 286.

11 Martin Bernal, *Black Athena*, vol. I (London, 1991), p. 214.

12 Sander L. Gilman, *Making the Body Beautiful: A Cultural History of Aesthetic Surgery* (Princeton, NJ, 2001), p. 152f.

13 Cited in G. L. Hersey, *The Evolution of Allure: Sexual Selection from the Medici Venus to the Incredible Hulk* (Cambridge, MA, 1996), p. 64.

14 Mosse, *Final Solution*, pp. 68–9.

15 According to Taylor Downing in *Olympia* (BFI Film Classics, London, 1992), p. 52, the whole idea of the Torch Ceremony and the carrying of the flame from Olympia was the invention of Carl Diem, the Secretary of the Berlin Organizing Committee.

Select Bibliography

M. H. Abrams, 'From Addison to Kant: Modern Aesthetics and the Exemplary Art', in Ralph Cohen, ed., *Studies in Eighteenth-century British Art and Aesthetics* (Berkeley, CA, 1985), pp. 16–48

Actes du Colloque international pour le bicentenaire de la mort de Buffon, Paris, Montbard, Dijon, 14–22 June 1988 (Paris, 1988)

Bernard Siegfried Albinus, *De sede et causa Coloris Aethiopum et Caeterorum Hominum* (Leiden, 1737)

S. Alpers and M. Baxandall, *Tiepolo and the Pictorial Intelligence* (New Haven and London, 1994)

H. F. Augstein, ed., *Race: The Origins of An Idea* (Bristol, 1996)

A. J. Barker, *The African Link* (London, 1978)

F. M. Barnard, *J. G. Herder on Social and Political Culture* (Cambridge, 1969)

Alexander Gottlieb Baumgarten, *Theoretische Ästhetik: Die grundlegenden Abschnitte aus der 'Aesthetica'*, trans. H. R. Schweizer (Hamburg, 1980)

—, *Texte zur Grundlegung der Ästhetik* (Hamburg, 1989)

Aphra Behn, *Oroonoko* (1688, reprint 1886)

Thomas Bendyshe ed., *The Anthropological Treatises of Johann Friedrich Blumenbach* (London, 1865)

Martin Bernal, *Black Athena*, vol. 1 (London 1991)

D. Bindman, '"Am I not a man and a brother?": British Art and Slavery in the Eighteenth Century', *RES*, 26 (Autumn 1994), pp. 68–82

—, '"A Voluptuous Alliance between Africa and Europe": Hogarth's Africans', in *The Other Hogarth: Aesthetics of Difference*, ed. Bernadette Fort and Angela Rosenthal (Princeton, NJ, 2001), pp. 260–69

—, F Ogée and P Wagner, eds, *Hogarth: Representing Nature's Machines* (Manchester, 2001)

Thomas Blackwell, *An Enquiry into the Life and Writings of Homer* (London 1735)

J. F. Blumenbach, *De Generis Humani Varietate Nativa* (Göttingen 1775)

—, *An Essay on Generation*, trans. A. Crichton (London, 1792)

Pim den Boer, 'Europe to 1914: The Making of an Idea', in K. Wilson and J. van der Dussen, eds, *The History of the Idea of Europe* (London, 1995)

D. F. Bond, ed., *Critical Essays from The Spectator* (Oxford, 1970)

Norbert Borrmann, *Kunst und Physiognomik: Menschendeutung und Menschendarstellung im Abendland* (Cologne, 1994)

Nicholas Boyle, *Goethe: The Poet and the Age*, 2 vols (Oxford 1992, 2000)

Edmund Burke, *A Philosophical Enquiry into the Origin of our Ideas of the Sublime and Beautiful* (7th edn, London 1773)

W. F. Bynum, 'The Great Chain of Being after Forty Years: An Appraisal', *History of Science*, XIII (1975), pp. 1–28

Petrus Camper, *The Works of the late Professor Camper, on the Connexion between the Science of Anatomy and the Arts of Drawing, Painting, Statuary, &c. &c.*, trans. T. Cogan (London, 1794)

Petrus Camper, 1722–1789, onderzoeker van nature, exh. cat., Universiteits Museum, Groningen (1989)

Vere Chappell ed., *The Cambridge Companion to Locke* (Cambridge, 1994)

W. Clark, J. Golinski and S. Schaffer, *The Sciences in Enlightened Europe* (Chicago, 1999)

Thomas Clarkson, *The History of the Rise, Progress, and Accomplishment of the Abolition of the African Slave-Trade by the British Parliament* (London, 1808)

David Brion Davis, *The Problem of Slavery in Western Culture* (Harmondsworth, 1970)

Daniel Defoe, *Robinson Crusoe,* ed. John Mullan (London, 1992); ed. Pat Rogers (London and Boston, 1979)

J. B. Du Bos, *Reflexions critique sur la poesie et sur la peinture* (Paris 1719)

Terry Eagleton, *The Ideology of the Aesthetic* (Oxford, 1990)

W. Engelmann, *Daniel Chodowieckis sämmtliche Kupferstiche* (Leipzig, 1857)

R. N. Essick, *William Blake's Commercial Book Illustrations* (Oxford, 1991)

E. C. Eze, ed., *Race and the Enlightenment: A Reader* (Cambridge, MA, 1997)

Susan L. Feagin and Patrick Maynard, eds, *Aesthetics* (Oxford, 1997)

I. Barta Fliedl and C. Geissmar, *Die Beredsamkeit des Leibes* (Salzburg, 1992)

George [sic] Forster, FRS, *A Voyage round the World, in His Britannic Majesty's Sloop, Resolution, commanded by Capt. James Cook, during the Years 1772, 3, 4, and 5*, ed. Nicholas Thomas and Oliver Berghof (Honolulu, 2000)

Georg Forsters Werke, Sämtliche Schriften, Tagebücher, Briefe, Akademie der Wissenschaften der DDR (Berlin, 1986–)

Georg Forster in interdisciplinärer Perspektive, ed. C.-V. Klenke (Kassel, 1993)

Johann Reinhold Forster, *Observations Made during a Voyage Round the World*, ed. Nicholas Thomas (Honolulu, 1996)

C. Fox, R. Porter and R. Wokler, eds, *Inventing Human Science: Eighteenth-Century Domains* (Berkeley, CA, 1995)

T. Frängsmyr, ed., *Linnaeus: The Man and his Work* (Canton, MA, 1994)

Peter Fryer, *Staying Power: The History of Black People in Britain* (London and

Sydney, 1984)

John Gascoigne, *Joseph Banks and the English Enlightenment* (Cambridge, 1994)

Henry Louis Gates, 'Writing "Race" and the Difference it Makes', *Critical Inquiry*, 12/1 (Autumn 1985), pp. 3-12

Brigitte Geonget ed., *Emmanuel Kant, Remarques touchant les Observations sur le Sentiment du Beau et du Sublime* (Paris, 1994)

Sander L. Gilman, *On Blackness without Blacks: Essays on the Image of the Black in Germany* (Boston, 1982)

—, *The Jew's Body* (London, 1991)

E. H. Gombrich, *Meditations on a Hobby Horse* (London, 1963)

Göttingisches Historisches Magazin (Göttingen, 1792–98)

Stephen Jay Gould, *The Mismeasure of Man* (London, 1996)

N. Grindle, '"Our own imperfect knowledge": Petrus Camper and the Search for an "ideal form"', *RES*, 31 (Spring 1997), pp. 139–48

P. Guyer ed., *The Cambridge Companion to Kant* (Cambridge, 1992)

Norman Hampson, *The Enlightenment* (London, 1990)

T. L. Hankins, *Science and the Enlightenment* (Cambridge, 1985)

I. Hannaford, *Race: The History of an Idea in the West* (Washington, DC, 1996)

B. Hauser-Schäublein and Gundolf Krüger, eds, *James Cook: Gifts and Treasures from the South Seas; The Cook/Forster Collection, Göttingen* (Munich, 1998)

Jens Heise, *Johann Gottfried Herder zur Einführung* (Hamburg, 1998)

Andrew Hemingway, 'The "Sociology" of Taste in the Scottish Enlightenment', *Oxford Art Journal*, XII/2 (1989), pp. 3–34

John Godfrey Herder, translated T. Churchill, *Outlines of a Philosophy of the History of Man* (London, 1800)

Herders Sämmtliche Werke (Berlin, 1878)

Herders Werke in fünf bänden (Weimar, 1963)

Johann Gottfried Herder, *Werke in zehn Bänden*, vol. VI: *Ideen zur Philosophie der Geschichte der Menschheit* (Frankfurt, 1989)

George L. Hersey, *The Evolution of Allure* (Cambridge, MA, 1996)

Elfriede Heyer and Roger C. Norton eds., *J. J. Winckelmann: Reflections on the Imitation of Greek Works in Painting and Sculpture* (La Salle, IL, 1987)

W. J. Hipple, Jr, 'Philosophical Language and the Theory of Beauty in the Eighteenth Century', in *Studies in Criticism and Aesthetics, 1660–1800: Essays in Honour of SH Monk*, ed. H. Anderson and J. S. Shea (Minneapolis, 1967)

Judith Feyertag Hodgson, *Human Beauty in Eighteenth-century Aesthetics*, University Microfilms (Ann Arbor, MI, 1973)

Hugh Honour, *The New Golden Land* (New York, 1975)

Peter Hulme, *Colonial Encounters* (London, 1986)

D. Hume, *Essays and Treatises of Several Subjects* (new edn, London 1822), vol. I: Essay XXI, 'Of National Characters'

Francis Hutcheson, *An Inquiry into the Original of our Ideas of Beauty and Virtue* (2nd edn, London 1726)

Rüdiger Joppien and Bernard Smith, *The Art of Captain Cook's Voyages*, vol. II: *The Voyage of the Resolution and Adventure* (New Haven and London, 1985)

Winthrop D. Jordan, *White over Black: American Attitudes toward the Negro, 1550–1812* (New York, 1977)

Kants gesammtelte Schriften, königlich Preussischen Akademie der Wissenschaften (Berlin, 1912)

Immanuel Kant, *Observations on the Feeling of the Beautiful and Sublime*, trans. John T Goldthwait (Berkeley, CA, 1991)

—, *Critique of Judgement*, trans. J. H.. Bernard (New York, 1951)

—, *Anthropology from a Pragmatic Point of View*, trans. V. L. Dowdell (Carbondale, IL, 1996)

L. E. Klein *Shaftesbury and the Culture of Politeness* (Cambridge, 1994)

Wulf Koepke, ed., *Johann Gottfried Herder: Academic Disciplines and the Pursuit of Knowledge* (Columbia, SC, 1996)

—, ed., *Johann Gottfried Herder: Language, History, and the Enlightenment* (Columbia, SC, 1990)

J. L. Larson, *Interpreting Nature: The Science of Living from Linnaeus to Kant* (Baltimore, 1994)

J. C. Lavater, *Von der Physiognomik* (Zurich, 1772)

—, *Essay on Physiognomy*, 5 vols (London, 1789–98)

—, *Essai sur la physiognomie*, 4 vols (The Hague, 1781–1803)

—, *Physiognomische Fragmente, zur Beförderung der Menschenkenntnis und Menschenliebe* (Leipzig and Winterthur, 1775–78)

Wolf Lepenies, *Autoren und Wissenschaftler im 18. Jahrhundert* (Munich and Vienna, 1988)

G. C. Lichtenberg, *Ammerkungen zu einer Abhändlung über Physiognomik,* Göttinger Taschenkalender aufs Jahr 1778

—, *Über Physiognomik; wider die Physiognomen* (Göttingen,1778)

Georg Christoph Lichtenberg, 1742–99: Wagnis der Aufklärung, exh. cat. (Darmstadt and Göttingen, 1992)

Uli Linke, *Blood and Nation: The European Aesthetics of Race* (Philadelphia, 1999)

John Locke, *Some Thoughts concerning Education* (London, 1695)

—, *Two Treatises of Government* (London, 1690)

—, *Essay on Human Understanding* (19th edn, London 1793)

Edward Long, *The History of Jamaica* (London, 1774)

H. A. MacDougall, *Racial Myth in English History: Trojans, Teutons, and Anglo-Saxons* (Hanover, NH, 1982)

Peter Martin, *Schwarze Teufel, edle Mohren* (Hamburg, 1993)

Paul Mattick, ed., *Eighteenth-century Aesthetics and the Reconstruction of Art*

(Cambridge, 1993)

Ronald Meek, *Social Science and the Ignoble Savage* (Cambridge, 1976)

Miriam Claude Meijer, *Race and Aesthetics in the Anthropology of Petrus Camper* (Amsterdam, 1999)

Christopher L. Miller, *Blank Darkness: Africanist Discourse in French* (Chicago, 1985)

C.-L. de Montesquieu, *Lettres Persanes* (Paris, 1721)

Gerda Mraz and Uwe Schögl, eds, *Das Kunstkabinett des Johann Caspar Lavater* (Vienna, 1999)

H Müller-Sievers, *Self-Generation: Biology, Philosophy, and Literature around 1800* (Stanford, CA, 1997)

G. Felicitas Munzel, *Kant's Conception of Moral Character* (Chicago, 1999)

H. B. Nisbet, *Herder and the Philosophy and History of Science* (Cambridge, 1970)

Robert E. Norton, *Herder's Aesthetics and the European Enlightenment* (Ithaca, NY, and London, 1995)

—, *The Beautiful Soul: Aesthetic Morality in the Eighteenth Century* (Ithaca, NY, and London, 1995)

Oeuvres complètes de Buffon, vol. III: *Variétés dans l'espèce humaine* (Paris, 1839)

A. Ohage, 'Von Lessings Wust zu einer Wissenschaftsgeschichte der Physiognomik', *Lessing Yearbook,* 21 (1989), pp. 55–87

Dorinda Outram, *The Enlightenment* (Cambridge, 1995)

H. E. Pagliaro, ed., *Racism in the Eighteenth Century* (Cleveland, OH, 1973)

M. D. Paley ed., William Blake, *Jerusalem,* William Blake Trust (London 1991)

—, *The Continuing City: William Blake's Jerusalem* (Oxford, 1983)

F. P. Van de Pitte, *Kant as Philosophical Anthropologist* (The Hague, 1971)

Michael Podro, *The Critical Historians of Art* (New Haven and London, 1982)

L. Poliakov, *The Aryan Myth* (New York, 1996)

Nicholas Phillipson, *Hume* (London, 1989)

Alex Potts, 'Winckelmann's Construction of History', *Art History,* v (December 1982), pp. 377–403

—, *Flesh and the Ideal: Winckelmann and the Origins of Art History* (New Haven and London, 1994)

Rolf Reichardt and Genevieve Roche, *Weltbürger-Europäer-Deutscher-Franke: Georg Forster zum 200. Todestag,* Universitätsbibliothek Mainz (1994)

G. S. Rousseau and Roy Porter, *The Ferment of Knowledge* (Cambridge, 1980)

H. H. Rudnick, ed., *Anthropology from a Pragmatic Point of View,* trans. V. L. Dowdell (Carbondale, IL, 1996)

G. Sauder ed., *Johann Gottfried Herder 1744–1803* (Hamburg, 1987)

Lorna Schiebinger, *Nature's Body: Gender in the Making of Modern Science* (Boston, 1993)

H. R. Schweizer, ed., *Alexander Gottlieb Baumgarten: Theoretische Ästhetik*

(Hamburg, 1986)

Anthony Ashley Cooper, 3rd Earl of Shaftesbury, *Characteristics of Men, Manners, Opinions, Times*, ed. L. E. Klein (Cambridge, 1999); ed. John M. Robertson (London, 1900)

Ellis Shookman, ed., *The Faces of Physiognomy: Interdisciplinary Approaches to Johann Caspar Lavater*, Dartmouth College (Hanover, NH, 1993)

P. R. Sloan, 'The Buffon–Linnaeus Controversy', *Isis*, 67 (1976), pp. 359-64

Bernard Smith, *The European Vision and the South Pacific* (New Haven and London, 1985)

Roger Smith, *The Fontana History of the Human Sciences* (London, 1997)

S. T. Soemmerring, *Über die Körpliche Verschiedenheit des Negers vom Europäer, 1785*, ed. S. Oehler-Klein, *S. T. Soemmerrings Werke,* vol. xv (Kassel, 1998)

O.H.K. Spate, *Paradise Found and Lost* (Minneapolis, 1988)

Joan K. Stemmler 'The Physiognomical Portraits of J. C. Lavater', *Art Bulletin,* LXXV (1993), pp. 151–68

Nancy Stepan, *The Idea of Race in Science, 1800–1960* (London, 1982)

Nicholas Thomas, Harriet Guest and Michael Dettelbach, eds, *Johann Reinhold Forster: Observations Made during a Voyage round the World* (Honolulu, 1996)

Dabney Townsend, *Hume's Aesthetic Theory* (London and New York, 2001)

Jörg Traeger, *Philipp Otto Runge und sein Werk* (Munich, 1975)

L. Uhlig, *Griechenland als Ideal: Winckelmann und seine Rezeption in Deutschland* (Tübingen, 1998)

R.P.W. Visser, *The Zoological Works of Petrus Camper* (Amsterdam, 1985)

Eric Voegelin, *The History of the Race Idea from Ray to Carus*, ed. Klaus Vondung, trans. Ruth Hein [1933] (Baton Rouge, LA 1998)

Karl Vorländer, *Kant: Der Mann und das Werk* (Hamburg, 1977)

Shearer West, ed., *The Victorians and Race* (Aldershot, 1997)

Roxann Wheeler, *The Complexion of Race* (Philadelphia, 2000)

E. M. Wilkinson and L. A. Willoughby, eds, *Friedrich Schiller: On the Aesthetic Education of Man* (Oxford, 1982)

J. J. Winckelmann, *Geschichte der Kunst des Altertums,* Bibliothek Klassischer Texte (Darmstadt, 1993)

Martha Woodmansee, *The Author, Art and the Market* (New York, 1994)

John H. Zammito, *Kant, Herder, and the Birth of Anthropology* (Chicago and London, 2002)

Susanne Zantop, *Colonial Fantasies: Conquest, Family, and Nation in Precolonial Germany, 1770–1870* (Durham, NC, 1997)

Carsten Zelle, *Angenehmes Grauen* (Hamburg, 1987)

Photographic Acknowledgements

The author and publishers wish to express their thanks to the below sources of illustrative material and/or permission to reproduce it:

G. Boerner: 15; British Library, London (photos © British Library Reproductions): 21, 41; British Museum, London (photo © British Museum): 43, 50; Hickey & Robertson/Menil Foundation: 9; Keith Hudson/Castle Howard Estate Ltd: 45; Image of the Black in Western Art Project, Harvard: 2, 3; Photo courtesy of the Institute of Jamaica, Kingston: 5; The J. Paul Getty Museum, Los Angeles: 4; Kunsthalle, Hamburg: 49; Menil Foundation Collection, Houston, TX: 9; National Maritime Museum, London (photos © National Maritime Museum): 33, 36, 37, 38, 39; National Portrait Gallery, London (photo NPG Picture Library): 34; The National Trust (Saltram House, Devon): 6; Österreichisches Nationalbibliothek, Vienna: 29, 30, 42; Prof. Hans-Jörg Rheinberger: 35; Statens Museum for Kunst, Copenhagen: 13; Wellcome Library, London: 1, 10, 11, 12, 14, 16, 19, 20, 22, 23, 24, 25, 26, 27, 28, 31, 32, 40, 44, 46, 47, 48, 53, 56; Victoria and Albert Museum, London: 5; Yale Center for British Art (Paul Mellon Collection): 8, 54 (photo Richard Caspole), 55 (photo Richard Caspole); and the author: 51, 52.

Index

Numerals in *italics* refer to pages with illustrations